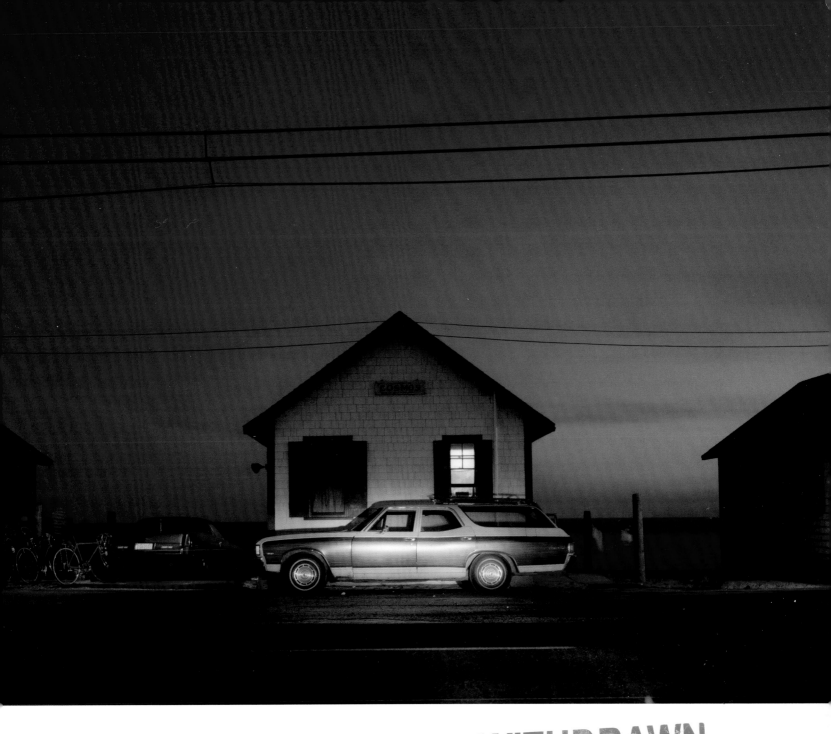

Joel Meyerowitz

Between the Dog and the Wolf

September 7th – October 21st

HOWARD GREENBERG GALLERY 41 East 57th Street Suite 1406 New York NY 10022 tel 212 334 0010 www.howardgreenberg.com

Dana Lixenberg, DJ, 1993, © Dana Lixenberg. Courtesy of the artist and Grimm, Amsterdam

DEUTSCHE BÖRSE PHOTOGRAPHY FOUNDATION PRIZE 2017

SOPHIE CALLE
DANA LIXENBERG
AWOISKA VAN DER MOLEN
TAIYO ONORATO &
NICO KREBS

APERTURE GALLERY

OPENING RECEPTION:
NOV 15, 2017

EXHIBITION ON VIEW:
NOV 15, 2017–JAN 11, 2018

aperture

Aperture Foundation
547 West 27th St, 4th Floor
New York, NY 10001
212.505.5555 aperture.org

Gallery and Bookstore Hours
Monday–Saturday: 10 a.m.–5:30 p.m.
Closed Sunday

DEUTSCHE BÖRSE
PHOTOGRAPHY FOUNDATION

THE PHOTOGRAPHERS' GALLERY

Elements of Style

2017 Aperture Gala

Oct 30

An evening of art and entertainment celebrating four artists at the intersection of photography, style, and human potential.

**Kwame Brathwaite
Zackary Drucker
Inez & Vinoodh**

At the IAC Building
555 West 18th Street, New York City

aperture.org/gala

Fall 2017

Words

Pictures

Front

Back

Front cover:
Pieter Hugo, *Gong Yining,
Beijing*, 2015–16,
from the series
Flat Noodle Soup Talk
Courtesy the artist;
Stevenson, Cape Town and
Johannesburg; Yossi Milo
Gallery, New York; and
Priska Pasquer, Cologne

Aperture, a not-for-profit foundation, connects the photo community and its audiences with the most inspiring work, the sharpest ideas, and with each other—in print, in person, and online.

Aperture (ISSN 0003-6420) is published quarterly, in spring, summer, fall, and winter, at 547 West 27th Street, 4th Floor, New York, N.Y. 10001. In the United States, a one-year subscription (four issues) is $75; a two-year subscription (eight issues) is $124. In Canada, a one-year subscription is $95. All other international subscriptions are $105 per year. Visit aperture.org to subscribe. Single copies may be purchased at $24.95 for most issues. Subscribe to the Aperture Digital Archive at aperture.org/archive. Periodicals postage paid at New York and additional offices. Postmaster: Send address changes to Aperture, P.O. Box 3000, Denville, N.J. 07834. Address queries regarding subscriptions, renewals, or gifts to: Aperture Subscription Service, 866-457-4603 (U.S. and Canada), or email custsvc_aperture@fulcoinc.com.

Newsstand distribution in the U.S. is handled by Curtis Circulation Company, 201-634-7400. For international distribution, contact Central Books, centralbooks.com. Other inquiries, email orders@aperture.org or call 212-505-5555.

Help maintain Aperture's publishing, education, and community activities by joining our general member program. Membership starts at $75 annually and includes invitations to special events, exclusive discounts on Aperture publications, and opportunities to meet artists and engage with leaders in the photography community. Aperture Foundation welcomes support at all levels of giving, and all gifts are tax-deductible to the fullest extent of the law. For more information about supporting Aperture, please visit aperture.org/join or contact the Development Department at membership@aperture.org.

Library of Congress Catalog Card No: 58-30845.

ISBN 978-1-59711-420-2

Printed in Turkey by Ofset Yapimevi

Generous support for Aperture magazine is provided in part by the Anne Levy Fund, and public funds from the National Endowment for the Arts, the New York State Council on the Arts with the support of Governor Andrew M. Cuomo and the New York State Legislature, and the New York City Department of Cultural Affairs in partnership with the City Council.

National Endowment for the Arts
arts.gov

ART WORKS.

OFSET
YAPIMEVİ

aperture

The Magazine of Photography and Ideas

Editor
Michael Famighetti

Managing Editor
Brendan Wattenberg

Editorial Assistant
Annika Klein

Copy Editors
Clare Fentress, Donna Ghelerter

Production Managers
Nelson Chan, Bryan Krueger

Work Scholars
Emma Kennedy, Angelina Lin, Lucas Vasilko

Art Direction, Design & Typefaces
A2/SW/HK, London

Publisher
Dana Triwush
magazine@aperture.org

Director of Brand Partnerships
Isabelle McTwigan
212-946-7118
imctwigan@aperture.org

Advertising
Elizabeth Morina
917-691-2608
emorina@aperture.org

**Executive Director,
Aperture Foundation**
Chris Boot

Minor White, Editor (1952–1974)

Michael E. Hoffman, Publisher and Executive Director (1964–2001)

aperture.org

FONDATION D'ENTREPRISE **HERMÈS**

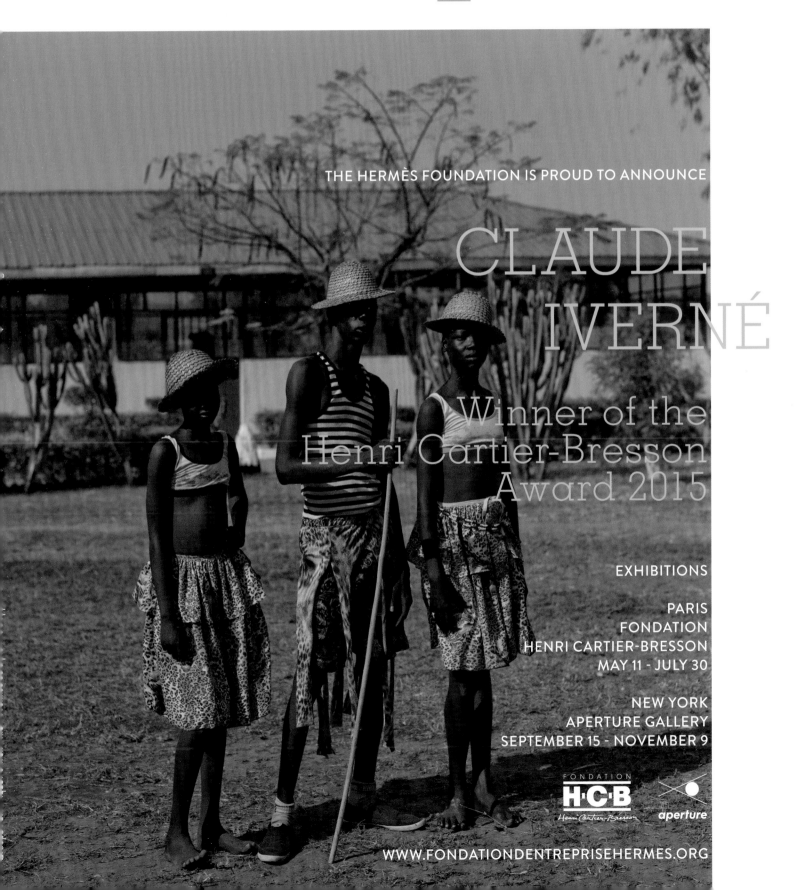

THE HERMÈS FOUNDATION IS PROUD TO ANNOUNCE

CLAUDE IVERNÉ

Winner of the
Henri Cartier-Bresson
Award 2015

EXHIBITIONS

PARIS
FONDATION
HENRI CARTIER-BRESSON
MAY 11 - JULY 30

NEW YORK
APERTURE GALLERY
SEPTEMBER 15 - NOVEMBER 9

FONDATION
H·C·B
Henri Cartier-Bresson

aperture

WWW.FONDATIONDENTREPRISEHERMES.ORG

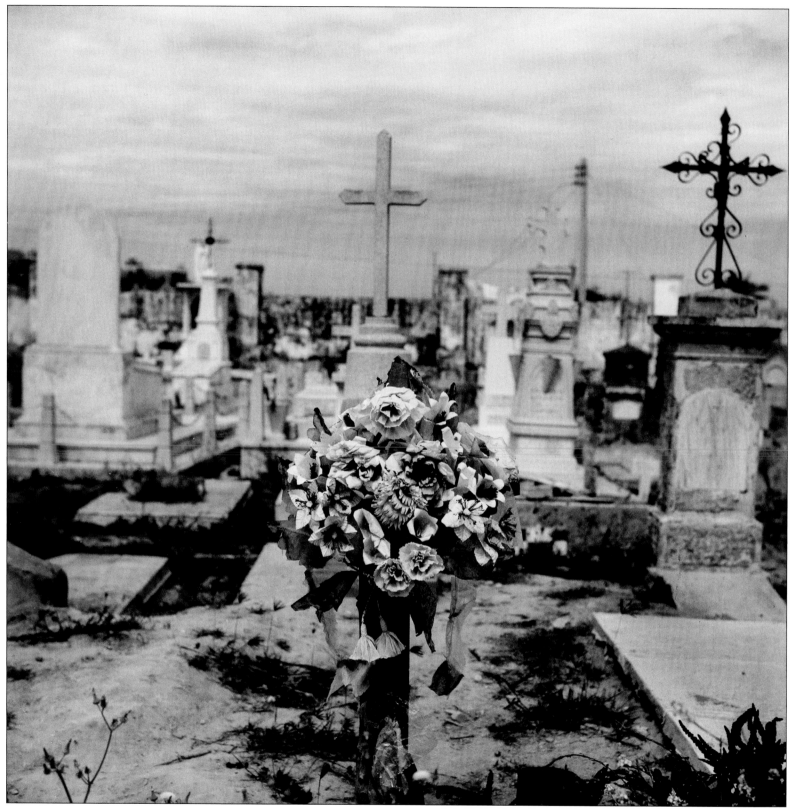

Agenda
Exhibitions to See

Thomas Ruff at Whitechapel Gallery

Organized by Iwona Blazwick, the first major London retrospective of Thomas Ruff's work features more than a dozen of the German photographer's series, spanning from the 1970s to the present. Investigations of portraits, machines, and surveillance are seen in some series, while others allude to the current political climate in their explorations of the role of press photography. The early 1990s *Newspaper Photographs* separates archival news images from their context, while Ruff's recent work in *press++* focuses on editorial and crop markings on photographs taken from decades of American newspapers.

Thomas Ruff at Whitechapel Gallery, London, September 27, 2017–January 21, 2018

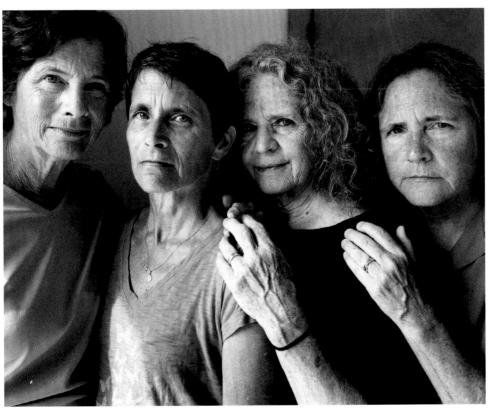

Left: Nicholas Nixon, *The Brown Sisters, Truro, Massachusetts*, 2016 © the artist and courtesy Fraenkel Gallery, San Francisco

Above: Thomas Ruff, *Interieur 1A (Interior 1A)*, 1979 © the artist and courtesy David Zwirner, New York/ London

Nicholas Nixon at the ICA, Boston

In large-format, yet intimately scaled black-and-white photographs, Nicholas Nixon has documented his wife and her three sisters since 1975, in four decades of annual portraits. *Persistence of Vision* will present *The Brown Sisters* in its entirety, punctuated by images taken by Nixon in the corresponding years of each photograph. Coupling his long-term series with scenes of landscapes, rural poverty, and city life in Boston, where he is based, the exhibition underscores Nixon's constant preoccupation with the elusive passages of time.

Nicholas Nixon: Persistence of Vision at the ICA, Boston, December 13, 2017–April 22, 2018

Viviane Sassen at Fotografiska

Umbra, a solo exhibition of the Dutch photographer Viviane Sassen, takes its title from the Latin word for shadow, defined contemporarily as the shadow's darkest place, where light is completely obstructed. While Sassen moves seamlessly between fashion and personal photography, *Umbra* considers eight series in which she deals with forms, light, and color to create experiences of metaphoric abstraction. Light and sound installations expand the presentation of Sassen's startling perceptions.

Viviane Sassen: Umbra at Fotografiska, Stockholm,
September 1–November 12, 2017

Photography in Argentina, 1850–2010 at the Getty Museum

Argentina has assumed a distinctive identity in contemporary Latin America, which has been particularly visible in images and visual culture. As part of the Pacific Standard Time: LA/LA initiative, the Getty Museum will mount an ambitious survey covering more than a century of Argentine photography. The exhibition is organized around four themes—Civilization and Barbarism, National Myths, Aesthetic and Political Gestures, and New Democracy to Present Day—that trace the role of photography, from the advent of the medium to current times, in reflecting the country's issues, trends, and ideals.

*Photography in Argentina, 1850–2010: Contradiction
and Continuity* at the Getty Museum, Los Angeles,
September 16, 2017–January 28, 2018

WALKER EVANS

Sep 30–Feb 4

SF MO MA San Francisco Museum of Modern Art

Walker Evans is organized by the Centre Pompidou, Paris, in collaboration with the San Francisco Museum of Modern Art. Major support is provided by Randi and Bob Fisher.

Walker Evans, *Roadside Stand Near Birmingham/Roadside Store Between Tuscaloosa and Greensboro, Alabama*, 1936; collection of the J. Paul Getty Museum, Los Angeles; © Walker Evans Archive, The Metropolitan Museum of Art, New York

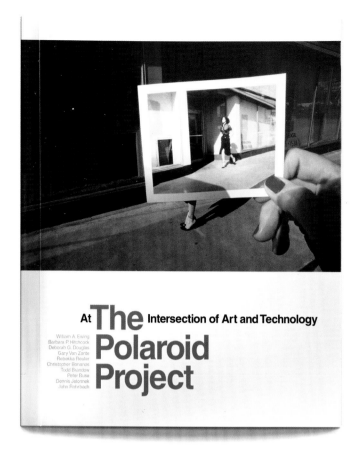

Instantly **fun**.
Forever **iconic**.

The Polaroid Project
At the Intersection of Art and Technology
Edited by William A. Ewing and
Barbara P. Hitchcock et al.

288 pages, 350 color images
Hardcover, 9 x 11, $50.00

Published to accompany a major traveling exhibition, this richly designed volume provides a unique perspective on the Polaroid phenomenon—a technology, an art form, a convergence of both—and its enduring cultural legacy. *The Polaroid Project* showcases not only the myriad and often idiosyncratic approaches taken by such photographers as Dennis Hopper, Robert Mapplethorpe, Andrea Wolff, Vicki Lee Ragan, and Chuck Close, but also a fascinating selection of the technical objects and artifacts that speak to the sheer ingenuity that lay behind the art.

Contributors: William A. Ewing, Barbara P. Hitchcock, Deborah G. Douglas, Gary Van Zante, Rebekka Reuter, Christopher Bonanos, Todd Brandow, Peter Buse, Dennis Jelonnek, and John Rohrbach.

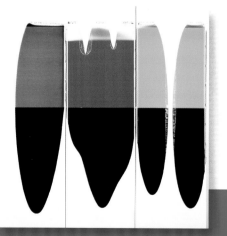

Ellen Carey (b. 1952)
Pulls (CMY), 1997
Polaroid 20 x 24
© Ellen Carey, Courtesy of Jayne H. Baum Gallery
(NY, NY) and M+B (LA, CA)

Barbara Crane (b. 1928)
Private Views, 1981
Polaroid Polacolor 4x5 film Type 58
© Barbara Crane

André Kertész (1894–1985)
August 13, 1979, 1979
Polaroid SX-70
© The Estate of André Kertész, courtesy Stephen
Bulger Gallery

Redux
Rediscovered Books and Writings

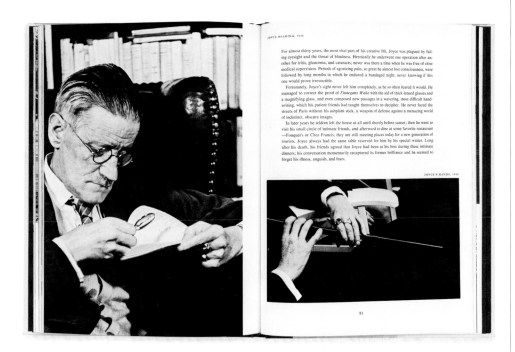

In *James Joyce in Paris,*
a portrait of the artist as an old man
Eric Banks

For all its outsize place in creative history, the Paris literary scene of the 1920s and '30s was intimate, taking form in the shops and salons of a handful of publishers, booksellers, and critics. Gisèle Freund, for instance, was introduced to James Joyce at a dinner party in 1936 given by one such gatekeeper, Adrienne Monnier, the owner of the legendary Left Bank bookstore La Maison des Amis des Livres. That year, Freund's scholarly study of nineteenth-century photography—made under Theodor Adorno's direction— had, like Joyce's *Ulysses,* been translated into French by Monnier. From this

introduction, Freund recalled two things about the Irish author: he was on a diet, and light and shadow danced on his lean face. What a portrait he would make.

She got her chance two years later. As Joyce was finishing *Finnegans Wake, Life* magazine commissioned Freund to make a black-and-white photographic essay of the author in the seventh arrondissement habitat that surrounded his fame: getting out of a taxi on the rue de l'Odéon, reviewing proofs with his American-born supporter Eugene Jolas, conversing with Monnier and Sylvia Beach

at the latter's Shakespeare and Company. It is a portrait of the artist as an old man.

Looking at the photographs from the late 1930s that punctuate Freund's book *James Joyce in Paris: His Final Years* (1965), with commentary by V. B. Carleton, you have to remind yourself that Joyce was only fifty-six when the earliest were taken (he would die three years later). As captured by Freund's forensic silhouettes, he looks years older. Freund loved to catch her writers, philosophers, and artists in contemplative action, reading or waving cigarettes when they weren't grasping their heads with viselike hands. She memorialized Walter Benjamin in one such pose. In *James Joyce in Paris,* the most astonishing photographs are those of the Irish author joking with his grandson or playing the piano for his son, Giorgio, who peers across at his father with what seems a mix of filial piety and bilious anger.

Freund's one-two punch simultaneously monumentalized her subjects while cutting them down to size. Her 1968 Paris retrospective was titled *Au pays des visages*—in the land of the faces— an apt description for the large-scale photographic gestures that turned her Gides, Colettes, and Eliots into literary Rushmores. When, in 1939, she projected her portraits at massively enlarged size at Monnier's bookstore, many of her subjects were said not to recognize themselves. Jean-Paul Sartre claimed, "We all look as if we'd just come back from the war."

Freund's black-and-white work, rather than her signature color, provides stark continuity with the dark images of the ghostly city interlarding the book. Joyce's Paris seems more like that of Charles Baudelaire (and Benjamin) than the up-and-coming Sartre and Simone de Beauvoir. Beggars mingle behind the Bourse, and sidewalk hustlers vend rags. The juxtaposition of literary celebrity and urban hurly-burly is powerful. Freund never forgets her Frankfurt School roots, and *James Joyce in Paris* makes it hard to picture either Joyce or Paris without the other.

Eric Banks is Director of the New York Institute for the Humanities.

Spread from *James Joyce in Paris: His Final Years* (New York: Harcourt, Brace & World, 1965)

★★★★★ RATED **10/10** ON RESELLERRATINGS.COM

mpb.com

Taken by MPB's **Ian Howorth**

THE WORLD'S BEST MARKETPLACE FOR USED CAMERAS & LENSES

HUNDREDS OF PRODUCTS ADDED **EVERY DAY**

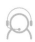 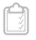

5 star
customer service

16 point system
for grading equipment

Six month warranty
on used products

Super fast payment
for sellers

True market value
when buying or selling

#MYMPB

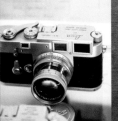 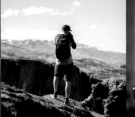

FIVE STAR CUSTOMER SERVICE · TRUE MARKET VALUE WHEN BUYING OR SELLING · SIX MONTH WARRANTY

SIMPLE SELLING AND TRADING · FREE COLLECTION · 16 POINT EQUIPMENT GRADING SYSTEM · PRODUCTS ADDED DAILY

mpb.com

Backstory
Peter Hujar

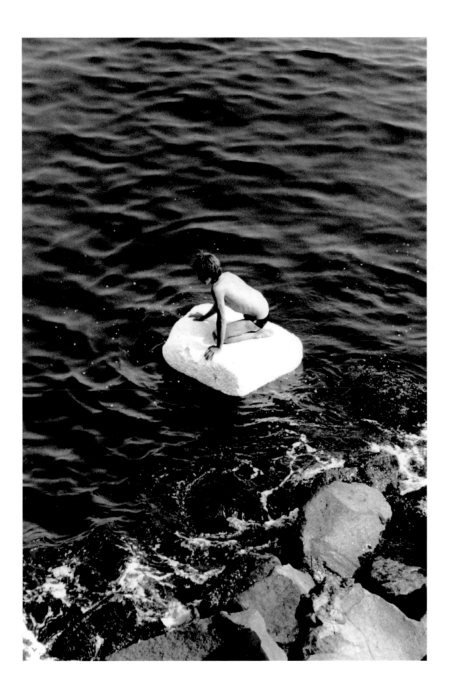

**From the underground art star,
a delicate picture of youth**
Joel Smith

In the early 1970s, in New York, Peter Hujar shuttered the commercial studio on Madison Square he'd been operating for a few years, moved into the East Village loft he would call home for the rest of his life, and turned his back on the hustle of fashion photography. Hujar's enduring status as an underground art star is owed to what he called his "personal work," which consumed him from then until his death in 1987—in particular, portraits of the famous and infamous among his generation of artists based downtown (which, by some counts, was the last).

But to associate Hujar only with portraits is to miss out on an oeuvre of great depth and variety. Rather than being a portraitist who did other work besides, he was a well-rounded artist for whom portraiture provided a moral anchor: it was his model for art making as the fixing and framing of a moment of intense identification with a subject. Empathy was Hujar's emotive signature, whether he was shooting a drag performer under studio lights, the dappled surface of the Hudson River, or a cube of compacted scrap metal.

Hujar photographed this teenager on a chunk of Styrofoam in an Italian coastal town in the summer of 1978. A look at the contact sheet (one of over fifty-seven hundred of Hujar's at the Morgan Library & Museum) reveals that artist and subject occupied separate spaces: Hujar was on the promenade, watching locals roughhouse on the rocky shore below. The boy—who appears in just one frame, marked with a red dot—is exposed to the elements, but to the camera he gives only a deeply shaded profile. Anonymity makes him readable as a focus of either desire or projection: self-portrait as a youth on a precarious raft.

Hujar was forty-three that summer, with one book to his name (the largely overlooked *Portraits in Life and Death* from 1976), and he was intensely aware that the slow maturation of his art had left him behind the curve of such nakedly ambitious peers as Robert Mapplethorpe. But here, under the warm natural light of a place where no one knew him, he was at his freest and at his fullest strength, and the world of beauty was his oyster.

Joel Smith is the Richard L. Menschel Curator of Photography at the Morgan Library & Museum and contributor to *Peter Hujar: Speed of Life* (Aperture, 2017).

Curriculum

A List of Favorite Anythings
By Gregory Crewdson

"These days," Gregory Crewdson says, "whether I like something or not comes down to one basic question: Did it make me cry?" Known for meticulous, cinematic, and psychologically charged photographs that conjure scenes from the work of Edward Hopper and Alfred Hitchcock, Crewdson produced his most recent series, *Cathedral of the Pines* (published by Aperture in 2016), in the trails and forests of Becket, Massachusetts. Crewdson is intrigued by the darker side of the American dream. For this issue's Curriculum, he chose the things that made him cry in 2017. "Your only barometer is your emotions," he says.

Mark Steinmetz, *Athens, Georgia (girl on hood of car)*, 1996

Athens, Georgia (girl on hood of car) exhibits the masterful simplicity and perfect formal balance of Mark Steinmetz's work. Evoking a tone of quiet longing and loneliness, the image presents a pale teenage girl reclining against the windshield of a nondescript car, illuminated by what appears to be a streetlamp in a shopping-center parking lot. Steinmetz renders an everyday act as an arresting moment of extraordinary beauty and grace. The girl is lost in space.

The Five Movements dance from *The OA*

The through line in *The OA* often seems almost too absurd to continue watching, but nonetheless the storytelling is beguiling and captivating from its first scene. Ultimately, the series delivers an unforgettable payoff: a scene where five motley characters perform a synchronized dance rite that preternaturally diverts a gunman in a high school. What first appears to be an act of complete narcissism turns out to be an act of true altruism. It's art triumphing over evil through something as unlikely as modern dance.

Agnes Hailstone

Just when you think you're an alive and fully functioning human being, Agnes Hailstone appears on your television to put everything in perspective. Hailstone, a native Inupiaq living many miles north of the Arctic Circle and a character on National Geographic Channel's *Life Below Zero*, embodies strength, stoicism, and thousands of years of the ways of the Inupiaq people. What makes her narrative so powerful, though, is the love story at its core. Hailstone is married to Chip, who is white and originally from the lower forty-eight. How Chip wandered into Hailstone's life and world is a bit vague, but they now have seven children, and he has fully committed himself to her way of living. Hailstone hunts, fishes, forages, digs up mammoth fossils, and harvests meat, teaching their children at every step. Chip, almost always at her side, is clearly in awe.

Songs of the Humpback Whale, 1970

When a turntable was recently bestowed on me as a gift, I brought the iconic albums of my youth out of storage after thirty years: *Pet Sounds*, *The White Album*, *Who's Next*, *Exile on Main St.*, *London Calling*, and *Songs of the Humpback Whale*. My greatest emotional response listening to this vinyl collection was to the sounds of whales sending communiqués to other whales hundreds of miles away: haunting, beautiful, lonely. It immediately brought back the experience I had listening to it as a ten-year-old in my parents' living room, positioning myself between the speakers to get the stereophonic effect. Hearing the hissing and crackle of the needle on the aged record adds a layer of nostalgia.

Larry Sultan, *Dad on Bed*, 1984

In his seminal book from 1992, *Pictures from Home*, Larry Sultan photographs his parents with a perfect combination of alienation, reverence, fascination, and a foreboding sense of loss. *Dad on Bed* is clearly the product of a negotiation between sitter and photographer, father and son. Sultan, who passed away eight years ago, wrote of these images, "Behind all the peering, the good pictures, the rolls of film and the anxiety about my project is the wish to take photography literally: to stop time. I want my parents to live forever." His futile act is evident in this picture, and is perhaps even more poignant in the book's expanded 2017 edition.

A1 conditions

I cannot live without open-water swimming. That's baseline for a pulse. My favorite lake: Upper Goose Pond in Becket, Massachusetts. I swim there one hour every day in the summer, rain or shine. Only lightning keeps me out. I always hope for ideal weather conditions, which I call "A1." A1 means the water is like glass. No wind. The sky is overcast. But A1 days are rare, and fleeting. At the end of each season they can be counted on one, maybe two hands.

Robert Redford, *Ordinary People*, 1980

When I first encountered the movie *Ordinary People* in 1980 as an eighteen-year-old, I discounted it as conventional melodrama. Rewatching it, I found it completely devastating. The film could be considered a period piece in retrospect, expertly capturing repressive façades circa 1980, particularly the disturbing, perfectly measured moments in the family portrait scene. Tension is at a fever pitch when the father (Donald Sutherland) poses mother and son (Mary Tyler Moore and Timothy Hutton), then delays and delays as they stand trying to smile; finally, the son erupts, "Give her the goddamn camera." It's completely emblematic of the family's growing inability to pretend everything is okay, even for one instant.

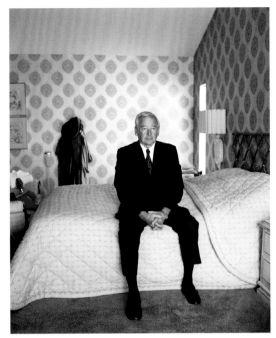

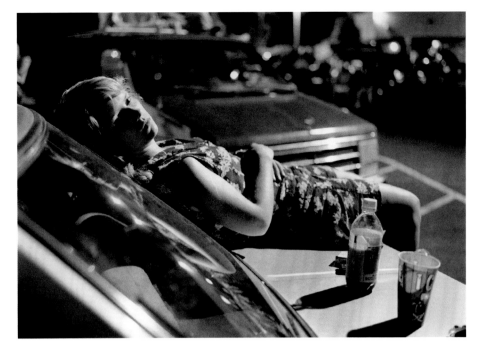

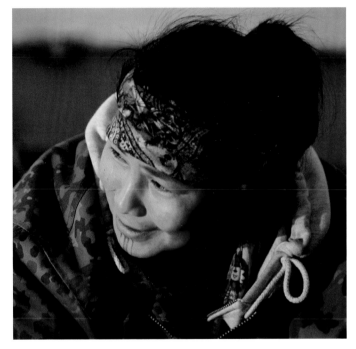

Songs of the Humpback Whale

Clockwise from top left: Sultan: Courtesy the Estate of Larry Sultan and Casemore Kirkeby, San Francisco; Steinmetz: Courtesy Yancey Richardson Gallery, New York; Hailstone: Courtesy National Geographic and BBC Worldwide Ltd.; Ordinary People: © Paramount Pictures and courtesy the Everett Collection; The OA: © Netflix

East of the Mississippi

1

2

CLARENCE H. WHITE AND HIS WORLD
The Art & Craft of Photography, 1895-1925

3

Irving Penn | CENTENNIAL

4

ROBERT ADAMS

ART
CAN
HELP

5

JIM GOLDBERG
DONOVAN WYLIE

6

LEE FRIEDLANDER WORKERS THE HUMAN CLAY

7

LEE FRIEDLANDER PARTIES THE HUMAN CLAY

8

1 East of the Mississippi: Nineteenth-Century American Landscape Photography; By Diane Waggoner; with Russell Lord and Jennifer Raab; Published in association with the National Gallery of Art, Washington, D.C. **2** Raghubir Singh: Modernism on the Ganges; By Mia Fineman; with contributions by Amit Chaudhuri, Shanay Jhaveri, and Partha Mitter; Published by The Metropolitan Museum of Art / Distributed by Yale University Press **3** Clarence H. White and His World: The Art and Craft of Photography, 1895–1925; By Anne McCauley; with contributions by Peter C. Bunnell, Verna Posever Curtis, Perrin Lathrop, Adrienne Lundgren, Barbara L. Michaels, Ying Sze Pek, and Caitlin Ryan; Distributed for the Princeton University Art Museum **4** Irving Penn: Centennial; By Maria Morris Hambourg and Jeff L. Rosenheim; with contributions by Alexandra Dennett, Philippe Garner, Adam Kirsch, Harald E. L. Prins, and Vasilios Zatse; Published by The Metropolitan Museum of Art / Distributed by Yale University Press **5** Art Can Help; By Robert Adams; Distributed for the Yale University Art Gallery **6** Candy/A Good and Spacious Land By Jim Goldberg and Donovan Wylie; With contributions by Chris Klatell and Laura Wexler; Distributed for the Yale University Art Gallery **7** Workers: The Human Clay; By Lee Friedlander; Distributed for the Yale University Art Gallery **8** Parties: The Human Clay; By Lee Friedlander; Distributed for the Yale University Art Gallery

Yale UNIVERSITY PRESS

art + architecture
yalebooks.com/art

international limited-residency
MFA PHOTOGRAPHY

www.hartfordphotomfa.org

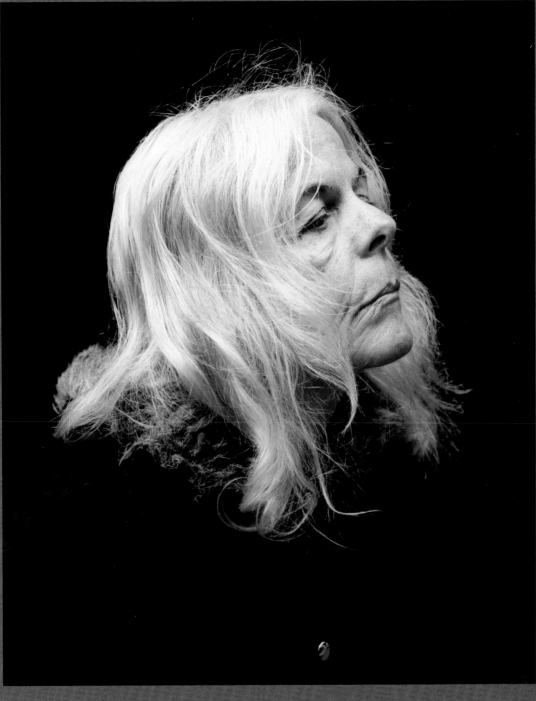

Photo © 2017 Zach Callahan

Faculty and Lecturers Include:

Robert Lyons - Director, Michael Vahrenwald, Dr. Jörg Colberg, Alice Rose George, Michael Schäfer, Mary Frey, Susan Lipper, Mark Steinmetz, Ute Mahler, Dru Donovan, John Priola, Alec Soth, Thomas Weski, Felix Hoffman, Lisa Kereszi, Hiroh Kikai, Tod Papageorge

Join us on Facebook:
Hartford Art School – MFA Photo

Alumni Include:

Bryan Schutmaat (USA), Dorothee Deiss (Germany), Felipe Russo (Brazil), Daniel Claus Reuter (Iceland), Matt Eich (USA), Adam J Long (USA), Dagmar Kolatschny (Germany), Leo Goddard (UK), Sebastian Collette (USA), Ward Long (USA), Matthew Casteel (USA), Lucy Helton (UK), Amanda James (USA), Morgan Ashcom (USA), Nicolas Silberfaden (Argentina), Chikara Umihara (Japan)

UNIVERSITY OF HARTFORD

HARTFORD ART SCHOOL 200 Bloomfield Avenue | West Hartford, Connecticut 06117

Elements of Style

"There is a saying: 'Make one picture for "them" and another for yourself,'" Collier Schorr remarks in this issue. But, she adds, "Slowly try to make them want the pictures that you want." Schorr is referring to her insistence on expanding the spectrum of desire seen in commercial fashion advertising, notably through her recent campaign for Saint Laurent, which cast queer women of color. Attuned to how the media images that populate our daily lives shape our vision of who we are—and who we might become—Schorr wants to remake that pictorial landscape. "When I first started making art," she says, "I wanted to essentially make a billboard in a gallery that talked about visibility and representation at a time when there was no real lesbian representation in the art world."

Decades earlier, in 1960s Harlem, Kwame Brathwaite also sought to expand the vocabulary of beauty and desire, observing that even in the pages of *Ebony* the models adhered to white ideals of beauty—straight hair and light skin. Together with various collaborators, he deployed photography to propel the iconic political slogan "Black is beautiful" to popular heights. Brathwaite's images, a singular fusion of style politics and social consciousness, are only now being fully appreciated. Indeed, his work might be seen as a precursor for younger photographers Jalan and Jibril Durimel or Nadine Ijewere, whose fashion photography, sartorial exuberance, and collaboration with subjects from Los Angeles to Lagos reframe narratives of the African diaspora.

Originally trained in the commercial gaze, Walter Pfeiffer uses a glossy skill set to make unabashedly playful and queer imagery. Radical for its time in the 1970s, Pfeiffer's work has inspired subsequent generations of photographers. As Alistair O'Neill notes, Pfeiffer anticipated nearly all of the contemporary creative strategies for queer representation by more than two decades. Pfeiffer regularly shoots for cult fashion titles, and his output is a reminder of the essential role of the fashion editorial in creating enduring images, reflecting a zeitgeist, or offering up a dose of wit.

In the late 1990s, *Vogue Hommes International* commissioned photographers from the worlds of art and documentary to produce stories that were globally engaged. "A fashion image can be many things, but for me in these shoots, they are allegories of and for our time," artist Hannah Starkey says of her work for the fashion title during that era. The magazine also featured spreads by photographers such as Youssef Nabil, Koto Bolofo, and Joseph Szabo. Nabil's seemingly vintage, hand-tinted portraits of elegant Egyptian men are reminiscent of the mysterious studio portrait photographer Van Leo, who brought Hollywood sheen and glamour to midcentury Cairo. Van Leo saw his studio as a space for fantasy and self-invention—often making himself the subject of myriad transformations.

"To achieve style," E. B. White writes in *The Elements of Style*, "begin by affecting none." From Helga Paris's East German youths and Joel Meyerowitz's Provincetown beachgoers, both of the 1980s era, to Pieter Hugo's millennial artists in Beijing, many of the subjects in this issue aren't affecting a pose or selling a product; they are fashioning themselves—on their own terms. As Antwaun Sargent writes of Durimel's portraits, "They communicate the power, beauty, and importance of their lives, and yours."
 —**The Editors**

Collier Schorr Humanity, Visibility, Power

A Conversation with Matthew Higgs

Celebrated in the worlds of art and fashion, Collier Schorr has pushed photography to examine desire, sexuality, and beauty. From her work with teenage wrestlers, to her provocative advertising campaigns, to her exploration of the artist-muse relationship, she has exposed the fluidity and ambiguity of gender. In her images, boys appear girlish, and vice versa. Now sought after for her signature command of the gaze, Schorr's interrogation of identity has broad reach—and great influence—in the pages of fashion magazines. Here she speaks about the evolving language of the fashion image and how her work challenges convention. Is the world finally ready for Collier's women?

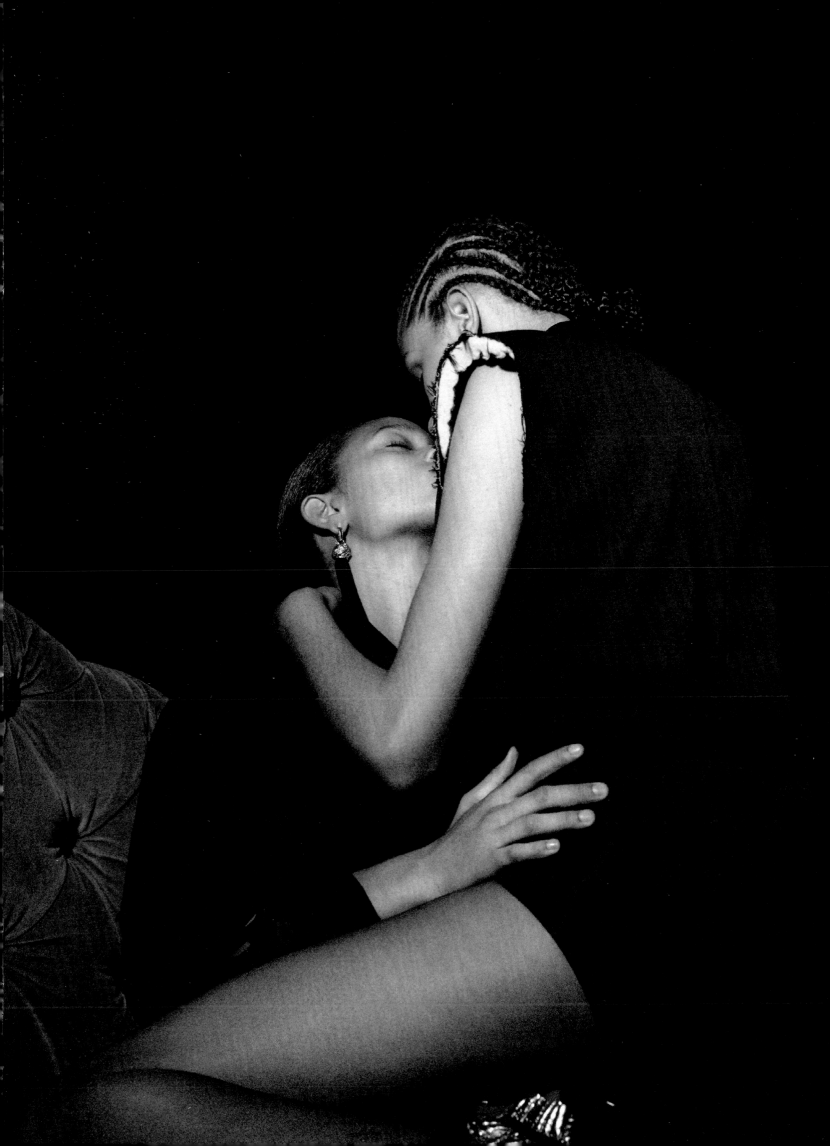

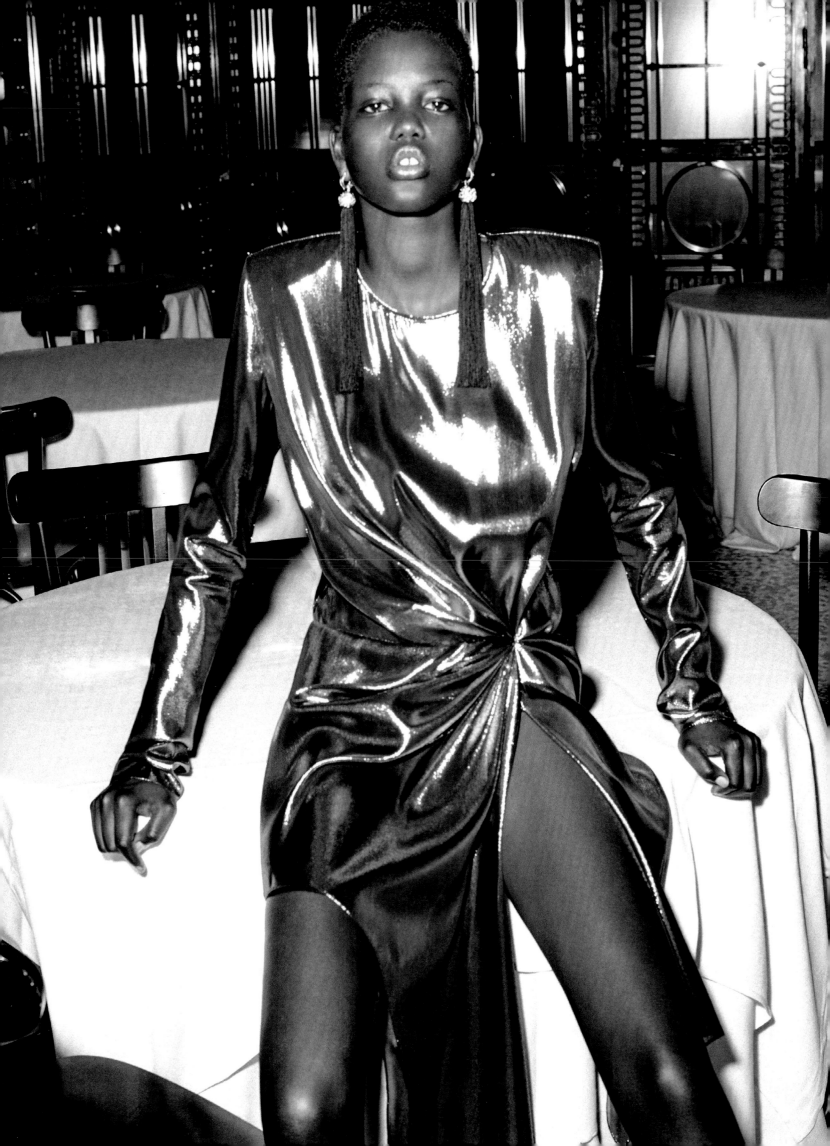

Matthew Higgs: **I am going to start with a quote you put on your Instagram feed. It says: "For anyone who wonders why I wanted to make fashion pictures, now you know." And there is the hashtag #humanityvisibilityequalspower. What animated that? I think it's worth mentioning that this conversation is taking place two days after Trump's executive order on immigration.**

Page 25 and opposite: Images for Saint Laurent women's summer campaign, 2017

This page: Image for Saint Laurent men's autumn campaign, 2017

Collier Schorr: For me, Instagram is a dual platform for showing your work and for showing what you stand for. The picture I made for Saint Laurent, which accompanied the post, was more typical of a documentary picture than a fashion advertisement. Any one element could be seen as typical, but the models were styled and encouraged to perform and play outside of what is traditionally seen: heteronormal women.

We all know that fashion is theater. But it felt like a real moment when I was with those models, Selena Forrest and Hiandra Martinez. Because I was working alongside filmmaker Nathalie Canguilhem, who was also directing them, I could watch as though I were a voyeur. Or, more correctly, there was a performance that seemed to be happening outside of my command. I wasn't prepared for what it would feel like to see that image as a billboard. It took me back to when I first started making art. I wanted to essentially make a billboard in a gallery that talked about visibility and representation at a time when there was no real lesbian representation in the art world.

MH: **Your imagery circulates in the context of both the art world and the larger world of fashion. How would you characterize the differences between these cultural, social, and, I guess, political spheres?**

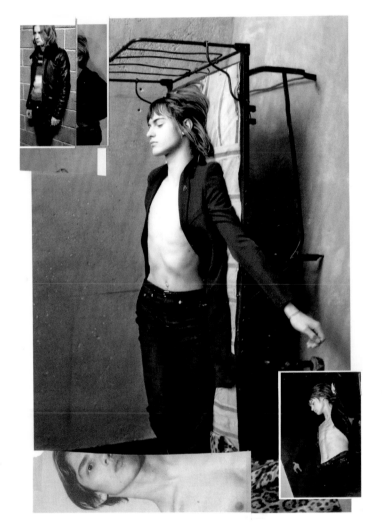

CS: They are both places where you have an audience. I don't really distinguish between the two audiences, because for the most part, they are the same people. More people look at advertising than go to galleries. But everybody who goes to a gallery looks at advertising.

MH: **Do you think there's a resistance, still, from the art context to artists who choose to work in the realm of fashion?**

CS: I've always dealt with resistance, though not based on commercial work, but on making too many pictures of men and being seen as romantic. Or based on being an American artist working in Germany. Or not showing in Germany because the work was too American or because it was too dangerous. I've never had "permission" or been associated with a collective or a movement. The politics of the work left people uncertain of my identity. Was I a gay male? If I had been a gay male, I think there would have been more support for the work, because there is a tradition of gay men making work about male beauty.

MH: **But that's sort of the uncertain nature of the work in its totality. It remains disruptive to the stability the art world has sought.**

CS: The last gallery show I did, *8 Women* (2014), which was seventy percent archival commissioned work and thirty percent work that I made before I started doing fashion, was the most successful show I've had. It sold the most. It sold to museums. I walked away thinking, Oh, of course it did well. They're pictures of women, and that's always been a comfortable spot for art. I did feel like I was being radical by bringing in commercial work, but I was being really traditional by bringing in female nudes.

MH: **It seems almost every decade there's an attempt to align or embrace the fashion image in the art world. There are**

I've never had "permission" or been associated with a collective or a movement. The politics of the work left people uncertain of my identity.

As boys have become more objectified, we are left with an ambiguous fashion body that is both male and female.

This page:
Jennifer (Head),
2002–14

Opposite:
Auto-Portrait, 2010–14

exhibitions that address this, and everyone feels like it's been done, and then a decade later it's addressed again. Whereas now it seems it's at its most interesting, most widespread, and hopefully—or potentially—most complex.

CS: In terms of destabilizing, my situation might be the result of not having an identity as an artist, a photographer, painter, et cetera. I became an artist really—I wouldn't say "by accident," but I didn't study art. I didn't train. I just had friends who were artists, and I worked in a gallery. I thought I was a writer. And I made work simply because I thought that the photo- and text-appropriation world made it possible for somebody to make something without having any talent.

I was working for Peter Halley and Richard Prince, and I had the opportunity to curate a show at 303 Gallery of friends of mine. I put myself in the show because there was a hole, a kind of representation, or protest, that wasn't yet included. So I appropriated fashion imagery. It was a way of interacting with those images that I was drawn to from magazines. What I'm doing today is still the same thing. I never believed in a high-art position because I never fantasized about being an artist.

MH: **But a distinction would be that you're producing those images now, as opposed to working with those images.**

CS: Well, yes and no. My current Saint Laurent men's campaign is collage. The images were shot as an advertising campaign, but by printing them out and cutting them up, they became commentary, a secondary text breaking down an original, static conceit. It's an infiltration of representation, by bringing together a bunch of pictures made under one umbrella to create a dialogue on representation. The clothing is cut up, cut out; the characters become more important and have more authority. As though I were taking some Guess ads out of *Vogue* from 1989 and collaging them for an artwork. That was the proposition of my show *8 Women*—images go out into the world in magazines, and then I take back those that I want to have a second comment on. I restage their being looked at.

MH: **The commercial imperative of the fashion business dictates that it's constantly in flux. Then there's the market-driven flux, and the commercial realities of fashion. Is it possible to think about that when you're trying to create an image within those structures?**

CS: I think almost everything that's bad about working in fashion is also good, depending upon the day. The fact that it moves. The fact that it's disposable. The fact that you are so invested in something that you're willing to have a huge fight over it. Then it gets thrown in the garbage. No matter how bad or no matter how good a picture is, it evaporates after six months. It's not enshrined. I guess I keep what I love, by putting it into a frame.

MH: **In the work you've done with Saint Laurent, do you have increasing license to make—this is a crude way to put it—more complicated images?**

CS: I have the encouragement to do that, and that's very rare. The designer at Saint Laurent, Anthony Vaccarello, was very interested and invested in seeing pictures come from the artist's imagination rather than from the position of merchandising.

MH: **To return to #humanityvisibilityequalspower, that Instagram hashtag, what do you think about recent shifts in fashion casting and the bodies we're seeing in this context?**

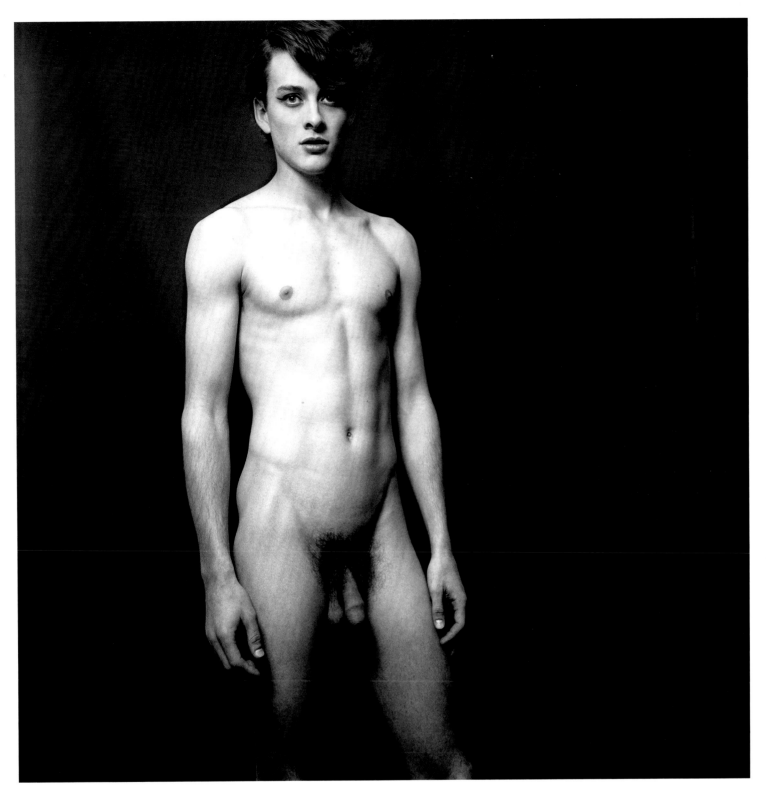

CS: There is a real push toward diversity, but I think the fashion world has treated diversity in casting as a smoke bomb, because there is very little diversity in production. There are very few black fashion photographers in mainstream magazines. There are not that many black designers. But the casting revolution has been great because it's releasing people who were stuck having to be represented by a certain ideal of beauty. I'm still very much concerned with the general ways I/we present women and sell an idea about them. How to shift what objectification does, how it functions. I'm suspect of merely propping up a picture by suggesting the woman has power.

MH: **How do you approach the space of editorial work? To me, it's substantially different from your approach to making a book, or making an exhibition, or even working with a client like Saint Laurent. The continuous narrative of editorial opens up a different agenda.**

CS: For me, the best-case scenario of editorial work is being in a kind of consensual relationship with somebody else in which I can explore who they are, what they look like, and why they're desirable.

MH: **And the other person is the model?**

CS: The other person is the model. Sometimes it's a fleeting relationship, and sometimes it's a sustained relationship. I'm really interested in a certain kind of seduction or flirtation. Like, you're at a club, and you find your person, and you make this conversation, and then you get to do everything you want with them in this very consensual way. We fall in love with someone who is in love with themselves, and then we fall in love with our version of them. They can love you for a minute for recognizing them. Then some kid rips it out of a magazine, puts it on their bedroom wall, and has someone to dream about.

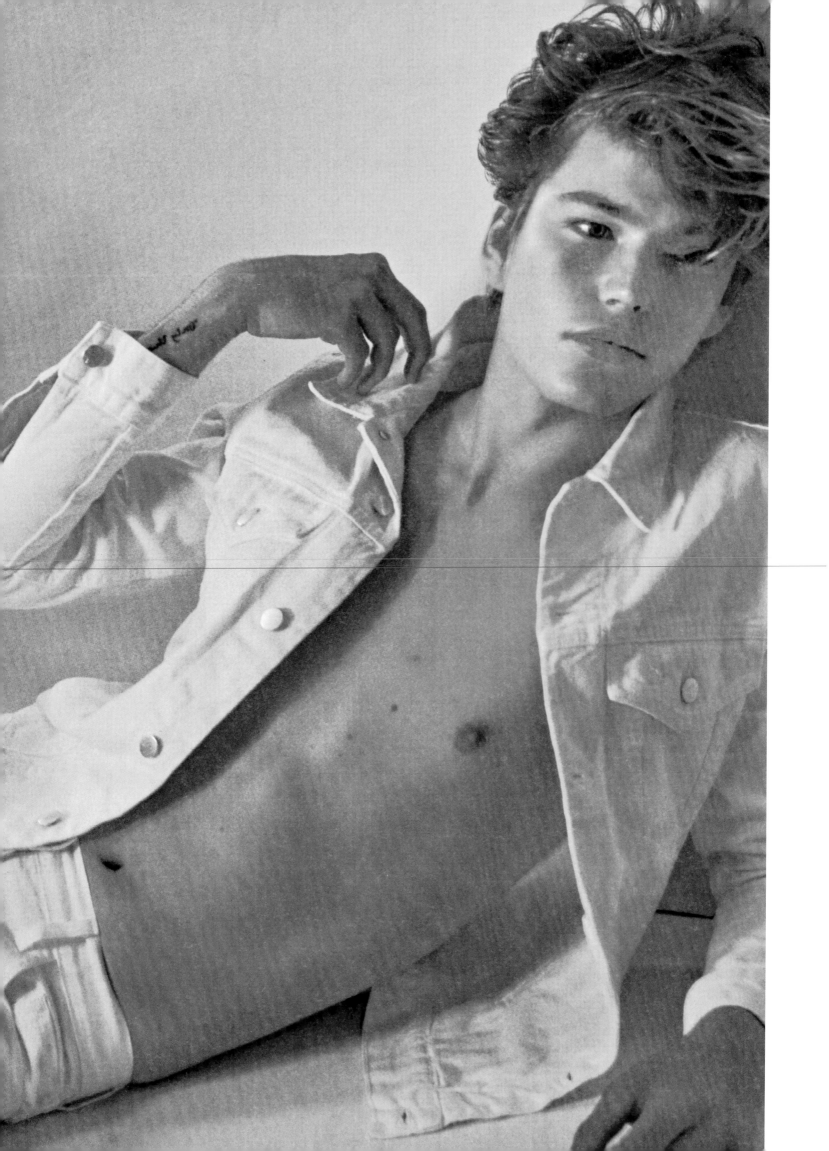

MH: **The early weeks of the Trump administration left many people—and commentators, in the broader sense, including artists—stunned. How do you see fashion in relation to the current political reality?**

CS: I've always had a really simple idea about what I wanted for my fashion pictures, because I think that they can only do so much based on the fact that it's all fake, for the most part. Is it intimacy? Is intimacy a kind of gaze of empowerment, inclusion, and warmth?

Fashion basically promised me one day I would have a girlfriend, and she might be like that model in a sailor shirt with short bleached hair. She might not. But I could fantasize about it. And, at the same time, I could be repulsed by fashion images. I could be hurt by fashion images. And, I could be scarred by fashion images. I wanted to replace the pictures I found alienating with my pictures, so that I would somehow create a healthier pictorial environment for kids. I think you see trends in personal relationships and sexuality more than politics, probably.

MH: **There was a great essay in the early '80s by Rosetta Brooks where she was writing about Guy Bourdin and Helmut Newton, and specifically about Bourdin's lingerie catalog for Bloomingdale's, and there was a critical pushback against certain kinds of commercial imagery that were counter, in that case, to a feminist narrative.**

CS: I have a lot to say about that essay, which, of course, I read when it came out. I think that's the genesis of my dilemma and ultimately my position. As an art maker in the late '80s, I was raised on French postfeminism and Laura Mulvey, and Silvia Kolbowski and Barbara Kruger, and all these ideas that essentially told me that representation of women was forbidden, that representations of women in the media had caused so much damage. That's why I started making pictures of boys, and didn't make a photograph of a girl until 1995 or something.

MH: **These later works include projects like *Jens F.* (2005), your photographs of wrestlers (1999–2004), and *Americans* (2012)?**

CS: Yes. I had been working on a project exploring gender in poses by posing a boy as Andrew Wyeth's model Helga Testorf. The book *Jens F.* traces all these painters' ideas about a woman's body. By making a boy pose as a woman, I thought it might make him more vulnerable. It didn't. Boys are boys, and they don't suddenly emote tons if they hold their hands behind them and arch their backs. Toward the end of that project, which took six years, I met a woman who looked exactly like Wyeth's muse, and I shot her naked in some of those same poses. I finally felt that working with the boy for all those years was repressive and exclusionary and that there wasn't a solution to representation. There never will be.

That was a huge moment for me, because I felt really guilty about it, and then really free. My issue with everything I learned is that it was funneled through heterosexual feminism. They had no use for the beautiful fashion woman—that was an image that made their relationships with men difficult. Well, if you're not having a relationship with a man, and in fact you desire women, you have a very different reaction to that image. My work is a continuation of what those women were interested in, but it doesn't take patriarchy into consideration in the same way. My problem with some of that stuff was that it erased desire for the female gaze. I wouldn't have had an early gay identity if it wasn't for fashion. Those images worked really differently on me, because I didn't have to live up to that girl. I just could hope to meet her. I could look in a mirror and know that I was not going to be her. And, if I chose,

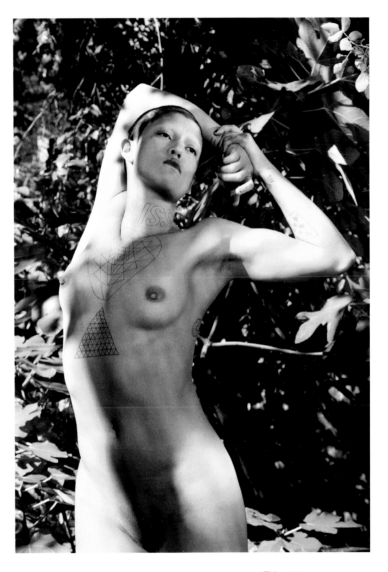

This page:
Where are you Going?,
2013

When I first started, clients would say, "Do you think she's going to make the model look like a lesbian?" Now they say, "We want Collier's woman."

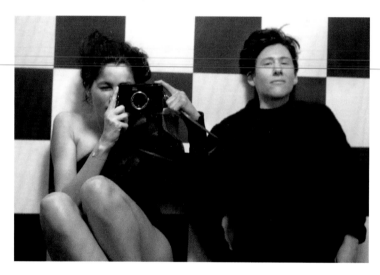

This page:
Laetitia with Leica, 2016

I could take on that Helmut Newton woman. I could reengage with those ideas.

MH: **I've noticed a reemergence of nudity in fashion editorials. It's just absolutely widespread.**

CS: It's a tits bonanza. I was talking about it with the model Freja Beha, whom I have shot topless many times. We both agree that for us, it's not about showing breasts, but about being free of breasts enough to take your shirt off like a boy. It's a rejection of having to hide. My first pictures, the ones of the boy in lipstick, were all about the desire to be shirtless.

MH: **I was curious about this reappearance of the naked body, aligned with the fact that different kinds of people now participate in the construction of these images and different people are the subject of these images. And it's clearly not Helmut Newton nudity, or Guy Bourdin nudity.**

CS: But sometimes it's based on those nudities. It would be interesting for me to go through every nude picture I've done, or seminude picture, and point to when I think it's an interesting, ambiguous, fuck-you, sexy, lesbian-gaze picture, or when it's making a picture for somebody else. I do think as boys have become more objectified and sexualized over the years, we are left with a somewhat ambiguous fashion body that is both male and female.

MH: **Nudity takes many forms, like when Juergen Teller starts to appear naked in his own images.**

CS: I was just reading about Juergen, and he said that he knew he looked like shit and he didn't care. He had gained weight. Maybe, on some level, he felt he should be subjected to the same harsh light as his subjects. Men and women are really different. It's difficult to find a woman who would feel okay about feeling like they look like shit, and getting kind of a last laugh by making the picture. I think about Francesca Woodman and Ana Mendieta, even Carolee Schneemann; these women looked good. I think it's also a way of branding that male artists have often done, to great success, in ways that female artists, besides Cindy Sherman, have not been able to do. The male body is afforded a lot more flexibility. It is more acceptable in all shapes and sizes.

MH: **It seems so repetitive now. If it had a purpose or a function, or if it were seeking to establish a kind of tension, that would all be gone. But then, I think male nudity feels disruptive within fashion publishing.**

CS: Seeing a naked man feels more disruptive, for sure. It feels more interesting. I've taken more male nudes than female nudes in the last couple of years. But like anything, familiarity breeds discontent.

MH: **With the boy with the lipstick and the desire to be shirtless, is that something that's just there? Or is it something that's quite self-conscious in the work you're doing in fashion, and its relationship to the self, self-portraiture, self-identity, projection of the self?**

CS: When I'm photographing somebody, I start to think I look like them. I start to talk like them. I'm looking at them so much through the camera, and having these kinds of reverberations from adolescence, when I looked at pictures and wanted to look like that. I'd want to wear those clothes. In the beginning, my first pictures

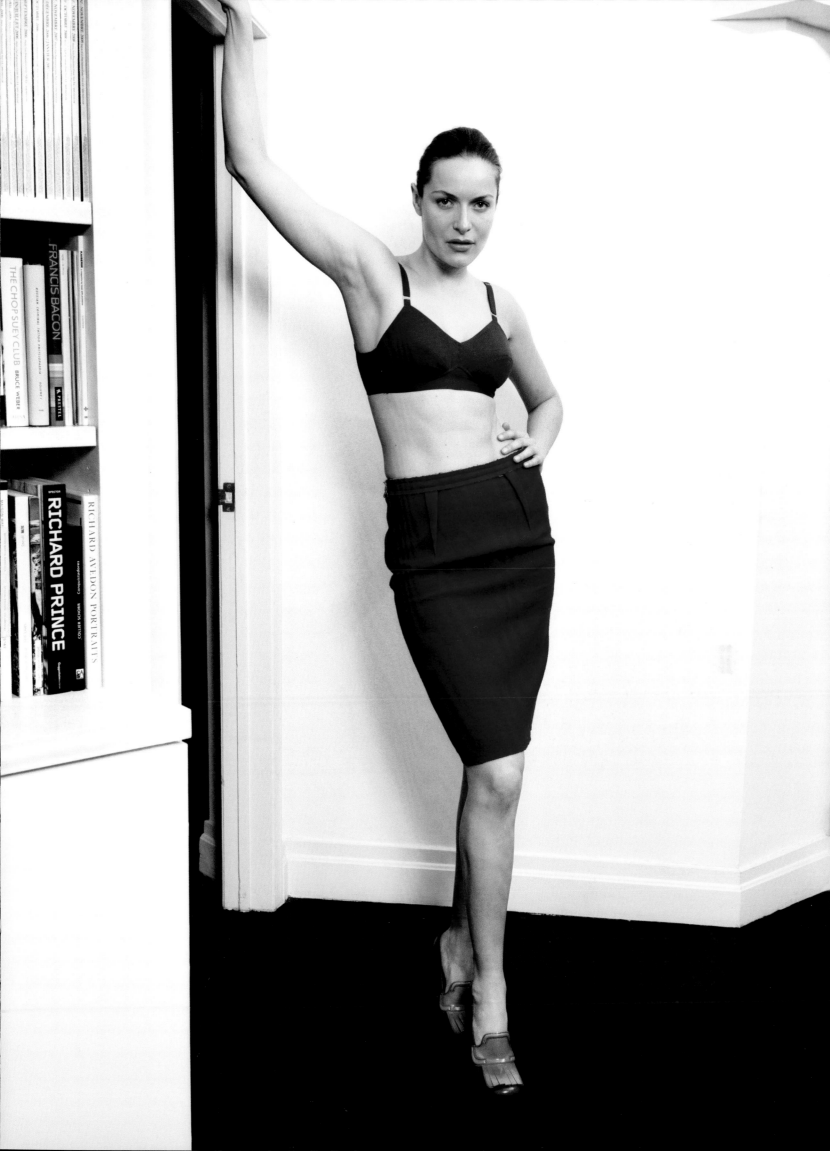

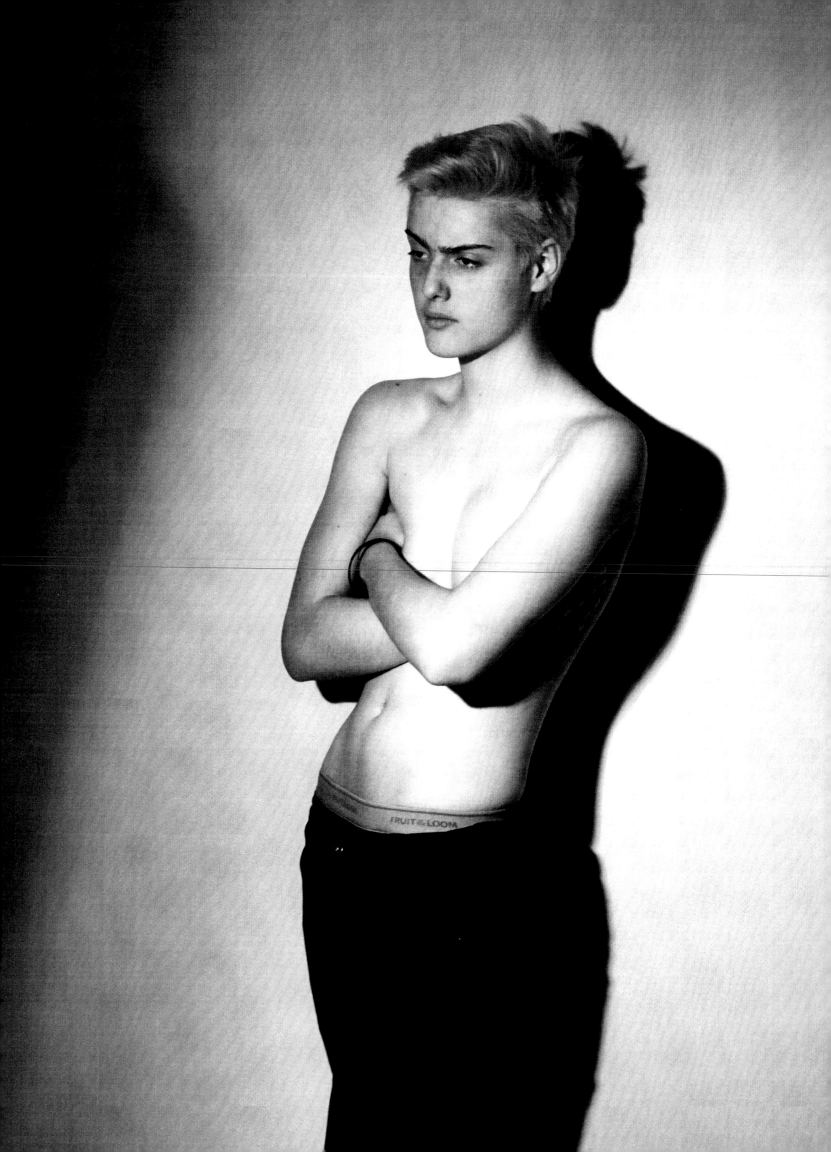

were like, I wish I were a boy and that's the boy I would be. Then it became, I wish that I were in World War II and I captured a Nazi, and this is how I would treat him.

MH: **Do you ever suppress that subjectivity in the work?**

CS: Sometimes it's less about me and more about the person. I work with a model named Casil McArthur, who just got trans surgery. I met Casil at sixteen, when he was biologically a girl identifying as a boy. Now he's eighteen, and he doesn't have the breasts. As much as I saw myself in him, it wasn't me. I was never a boy really; I just liked things boys had. Because he is a fashion model, and has been one since he was thirteen, I shot him for fashion magazines, but I don't see them as exclusively any one thing. Self-portraits using a surrogate? A continuation of that first shirtless boy? Editorializing? Documentary?

MH: **A more objective way.**

CS: Yes. It had less to do with me, because it wasn't even something that I had wanted for myself. It was just feeling like I was suddenly in the presence of something that was very different from my own identity, but connected to viability and visibility.

MH: **I always like looking at Bruce Weber's pictures because you can see what he's enjoying. It doesn't have to be a naked guy. It could be a dog. There's a real pleasure for the viewer that's mutual, even if you're not fixated on what he's fixated on. But it seems to me very honest photography.**

CS: Well, that's what's being sold to you, isn't it? When I left Art + Commerce and didn't have an agency, Shea Spencer, my current agent, looked at my work and said, "Ask yourself: Why is Bruce Weber so successful?" I said, "I don't really know." Shea said, "Because everybody wants to be in that picture. They want to be in that place. It's sunny. People are smiling. People are clean. It's easygoing." And then he said, "Only a handful of intellectuals want to be in your world. Only some leather queens want to be in your world, and those people are not going to support you. Just because they love you, they're still not going to be able to support you."

When I first started, clients would say, "Well, we really love her work, but do you think she's going to make the model look like a lesbian?" Now they come and they say, "We want Collier's woman." I'm not the only one doing Collier Schorr women now. Men who used to photograph women with their legs spread up in the air are also doing Collier Schorr women. There is a saying: "Make one picture for 'them' and another for yourself." Slowly try to make them want the pictures that you want.

Matthew Higgs is Director and Chief Curator of White Columns, New York.

This page:
Image for Saint Laurent women's summer campaign, 2017
All photographs © the artist and courtesy 303 Gallery, New York

ON
THE
BEACH

Joel Meyerowitz

Thessaly La Force

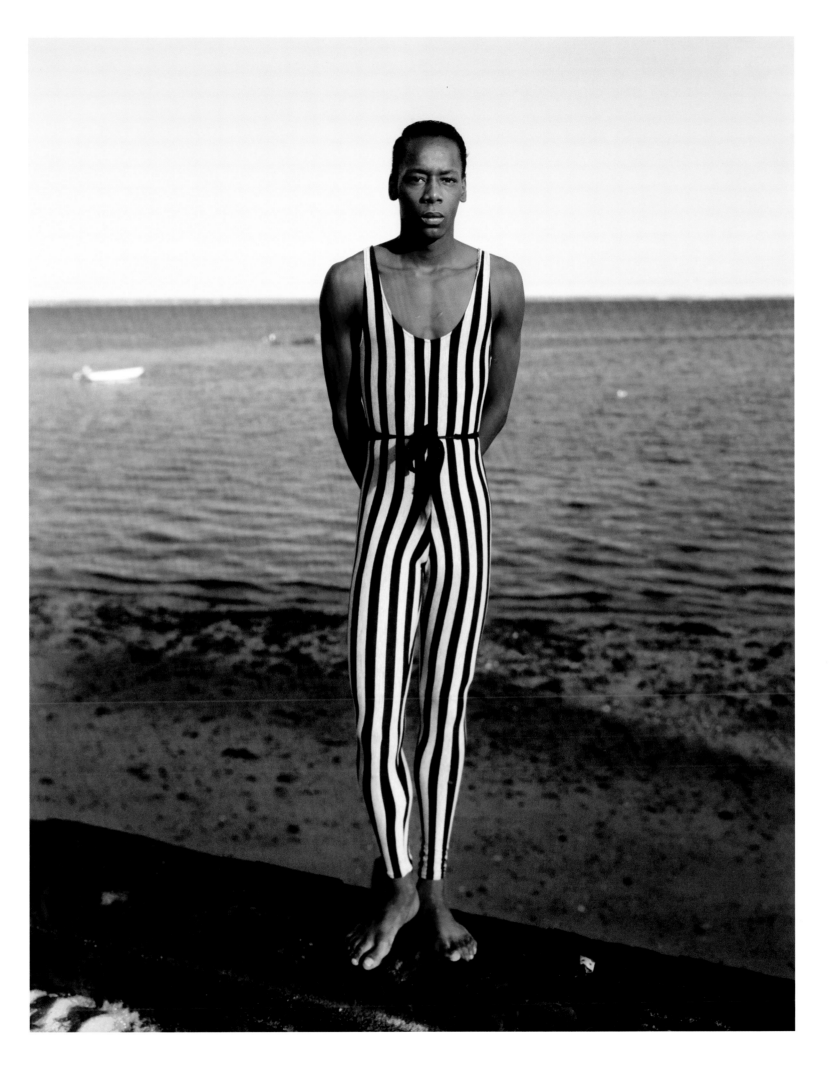

If you somehow manage to make it all the way to the northern tip of Cape Cod, as far as you can go, really, on Route 6 before falling straight into the Atlantic Ocean, you'll eventually reach Provincetown. It was once a New England fishing and whaling village; as the industry collapsed over a century ago, it slowly evolved into a welcoming artists' community. After the Greenwich Village artists and writers arrived in the 1910s, followed by the hippies in the 1960s, Provincetown became a gay mecca, where rainbow flags fly proudly over Commercial Street and drag queens in glitter platforms stroll to the dairy parlor for an afternoon milkshake. Being there can feel like standing at the very end of the earth, nothing in sight but the harbor, which beautifully unfurls along the northern coastline of the cape like the sail of a boat. For the photographer Joel Meyerowitz, Provincetown was also where he spent his summers with his family every year beginning in the '70s.

Meyerowitz, who is now seventy-nine years old, first got his start shooting on a 35mm camera on the streets of New York, where instincts are rewarded and decisions have to be swift. Out on the cape, he switched to a large-format view camera. "As soon as I carried a six-foot-tall wooden camera on legs, people were fascinated," he explained. "They wanted to know why I had this wooden camera, and big dark cloth over my head, and suddenly I became highly visible. It changed my strategy. I began looking at them in a very direct way rather than being more furtive and physical on the streets. As soon as I did that I became interested in them." He started to create portraits, and these became the body of work published here in this portfolio, taken in the 1980s.

Though Meyerowitz said he had no objective in photographing the people of Provincetown, his work makes it impossible to ignore the place's refusal to conform to the conventions of the upper class, an attitude that stands in stark contrast to what one might glimpse in the affluent enclaves of Martha's Vineyard or Hyannis Port. Here there are no pearls and pastels, no Nantucket red slacks, no boat shoes. "Provincetown had always been considered land's end, so people could go there to free themselves and act any way they wanted," Meyerowitz said. When asked about the young man whose T-shirt has slipped off his shoulder, revealing a large, patterned tattoo, Meyerowitz reflected: "I saw the town changing—even though summer style is T-shirts and shorts and rags, more or less—I kept on seeing what was the style of the times. I remember that at that point in the '80s, people were just beginning to tattoo or pierce themselves. It was the start of the wave of self-decoration." The man, Elias, stares straight into the lens, young and noble—the embodiment of Provincetown's fierce spirit of independence, but also, too, an innocent artifact of gay culture before the devastating AIDS crisis occurred later that decade. "I would say I was aware of small currents that were entering the psyche of our times, and I just responded," Meyerowitz added. "I wasn't aiming at any definitive cultural description. I was soaking up what was in my immediate vicinity."

Thessaly La Force is the editor in chief of *Garage* magazine.

Previous page:
Darrell, Provincetown, Massachusetts, 1983

Opposite:
Polly and Juliette, Provincetown, Massachusetts, 1981

Overleaf:
Elias, Provincetown, Massachusetts, 1981; Caitlin and Daisy, Provincetown, Massachusetts, 1986

Pages 42–43:
Stephen, Lynette, and Jack Pierson, Provincetown, Massachusetts, 1981; Denise, Provincetown, Massachusetts, 1985

Pages 44–45:
Ethan and Tom, Truro, Massachusetts, 1984; Cathe, Provincetown, Massachusetts, 1981
All photographs courtesy the artist and Howard Greenberg Gallery, New York

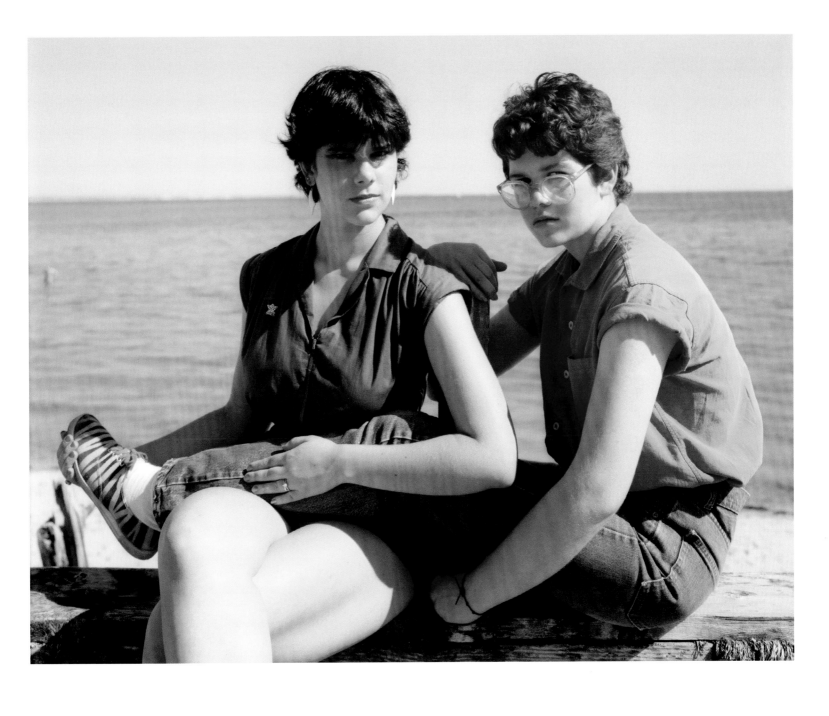

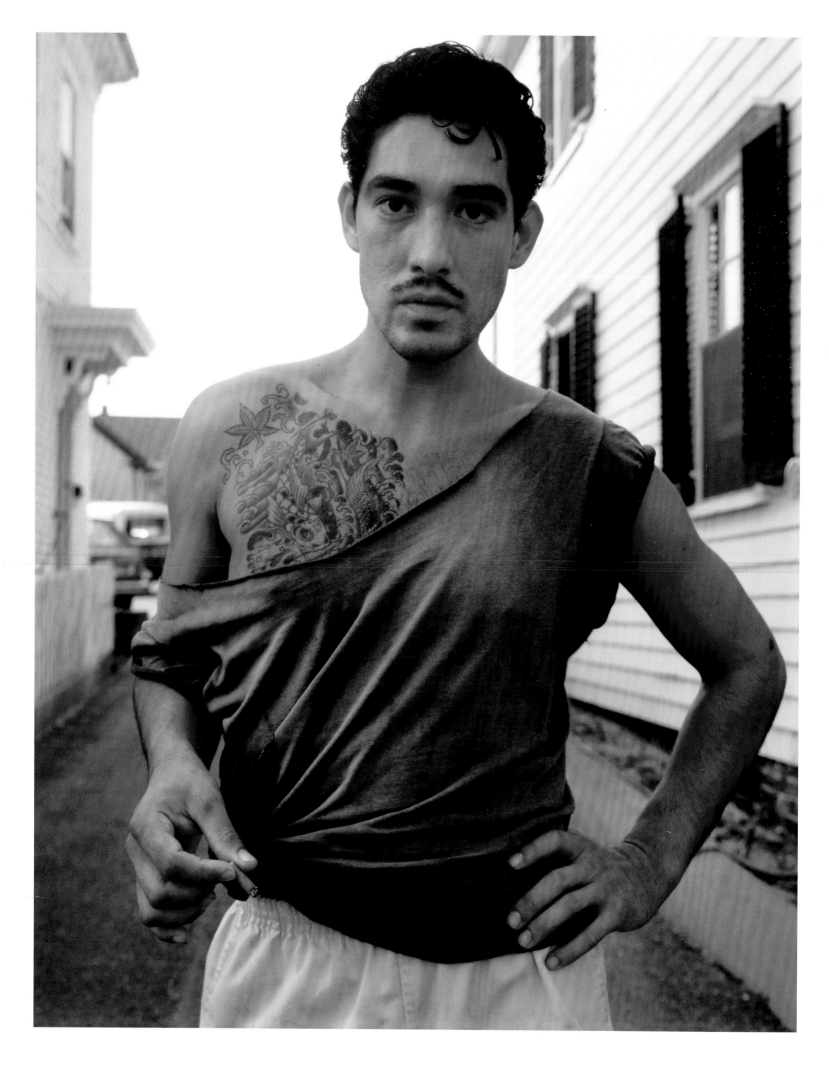

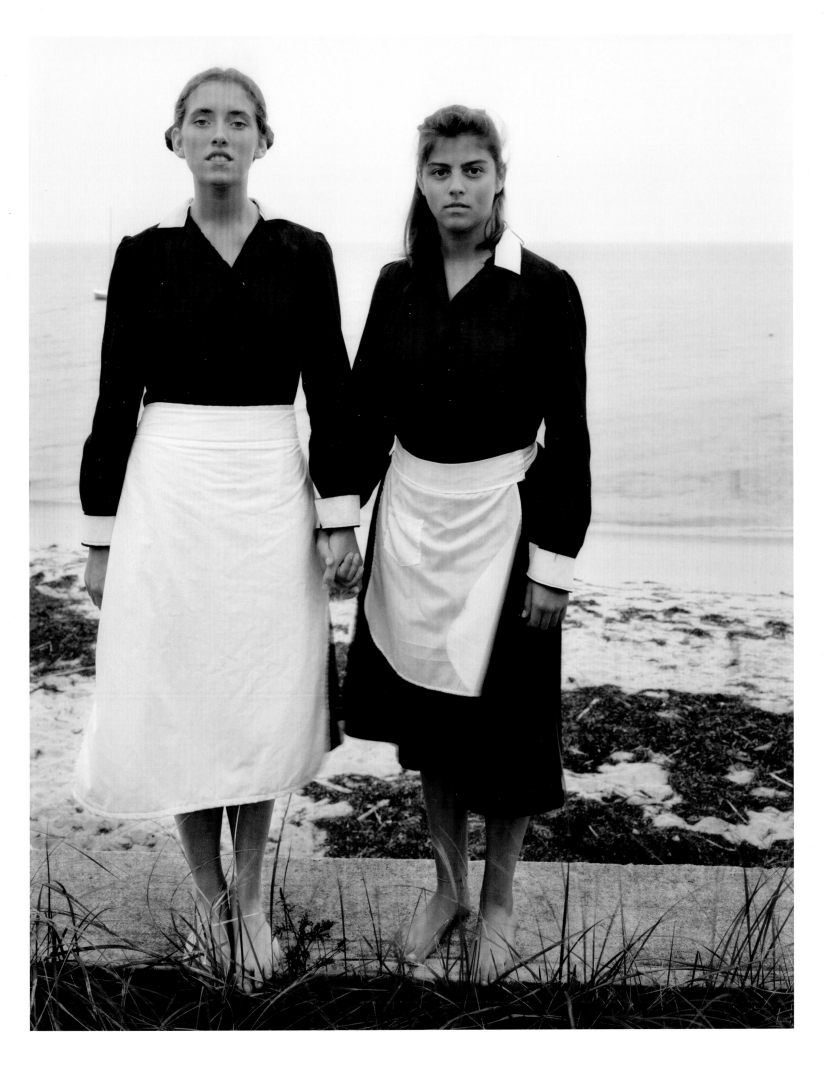

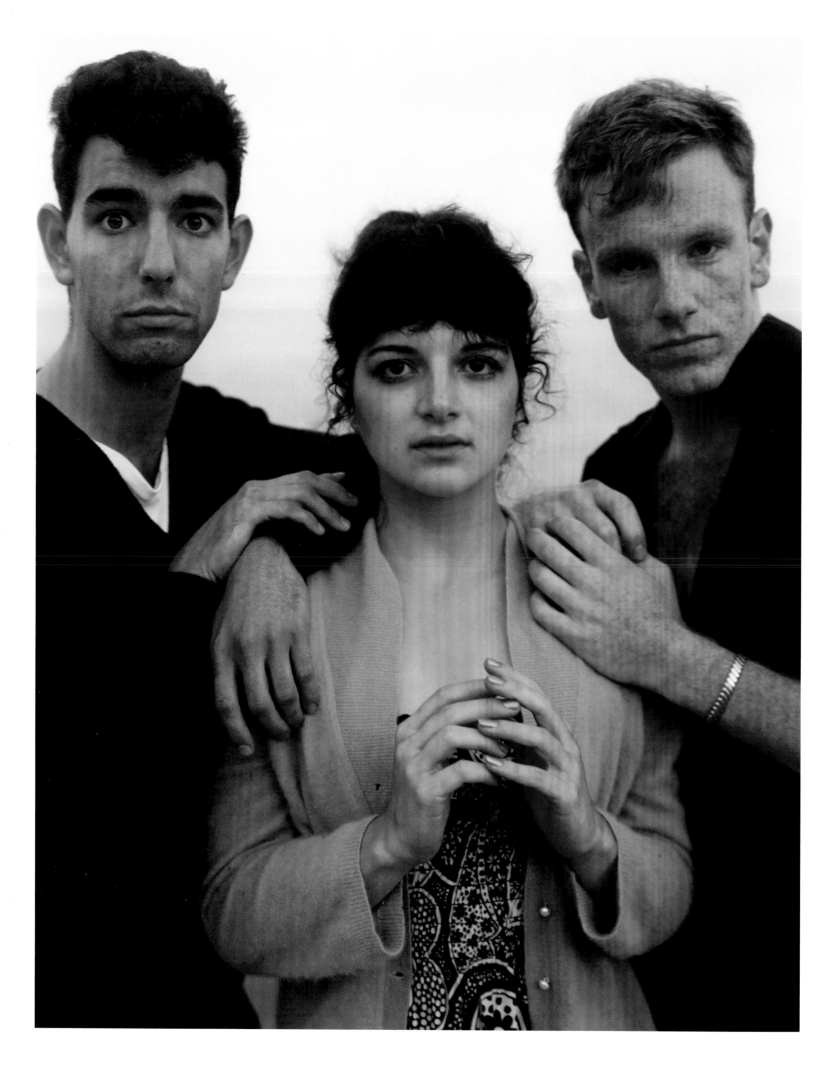

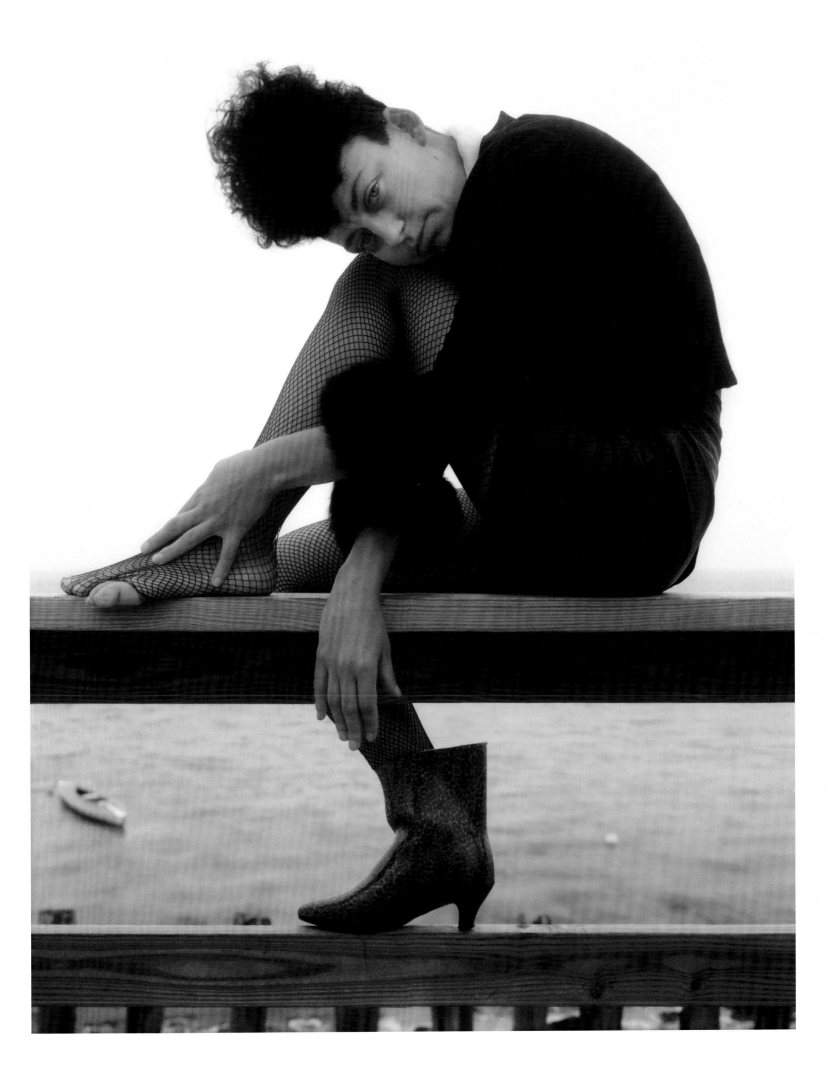

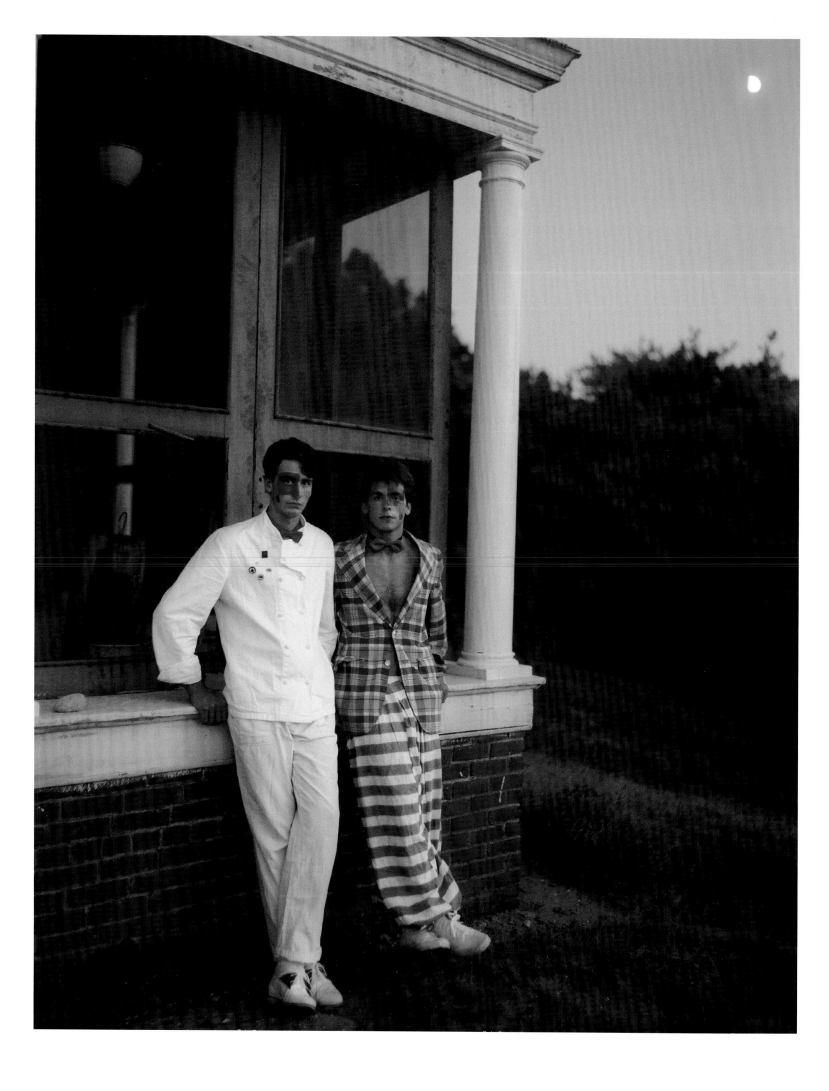

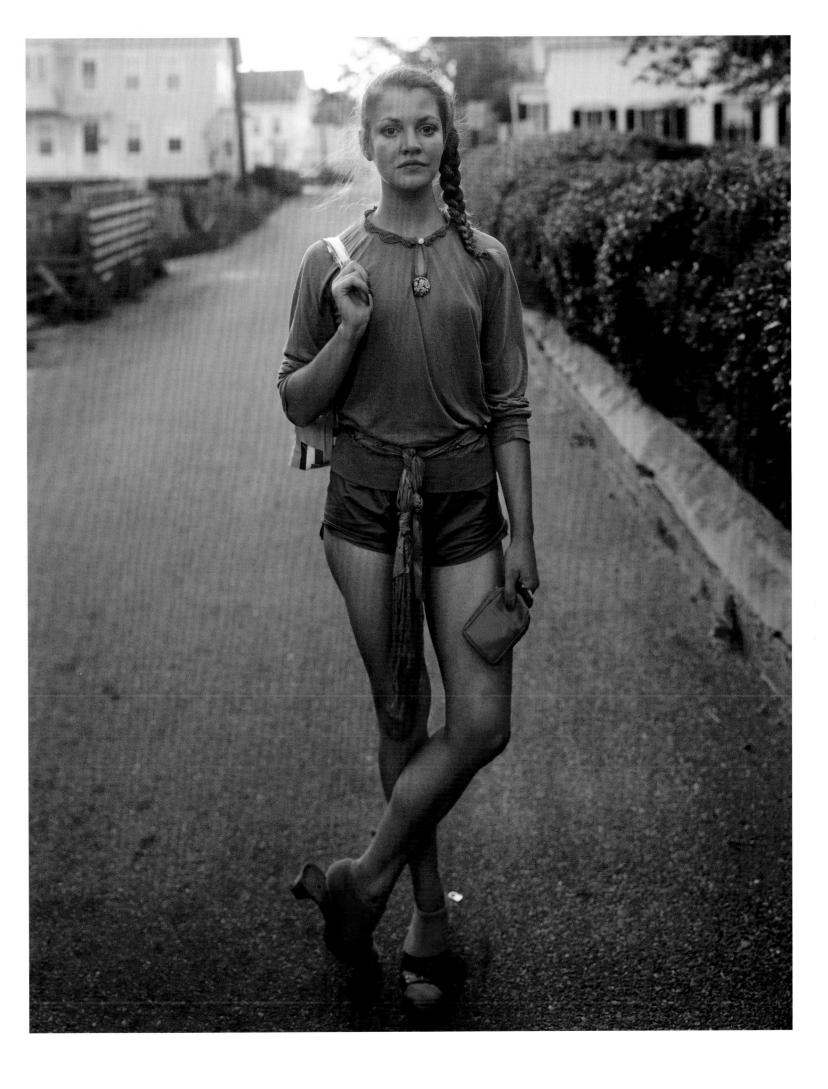

Kwame Brathwaite Black Is Beautiful

Tanisha C. Ford

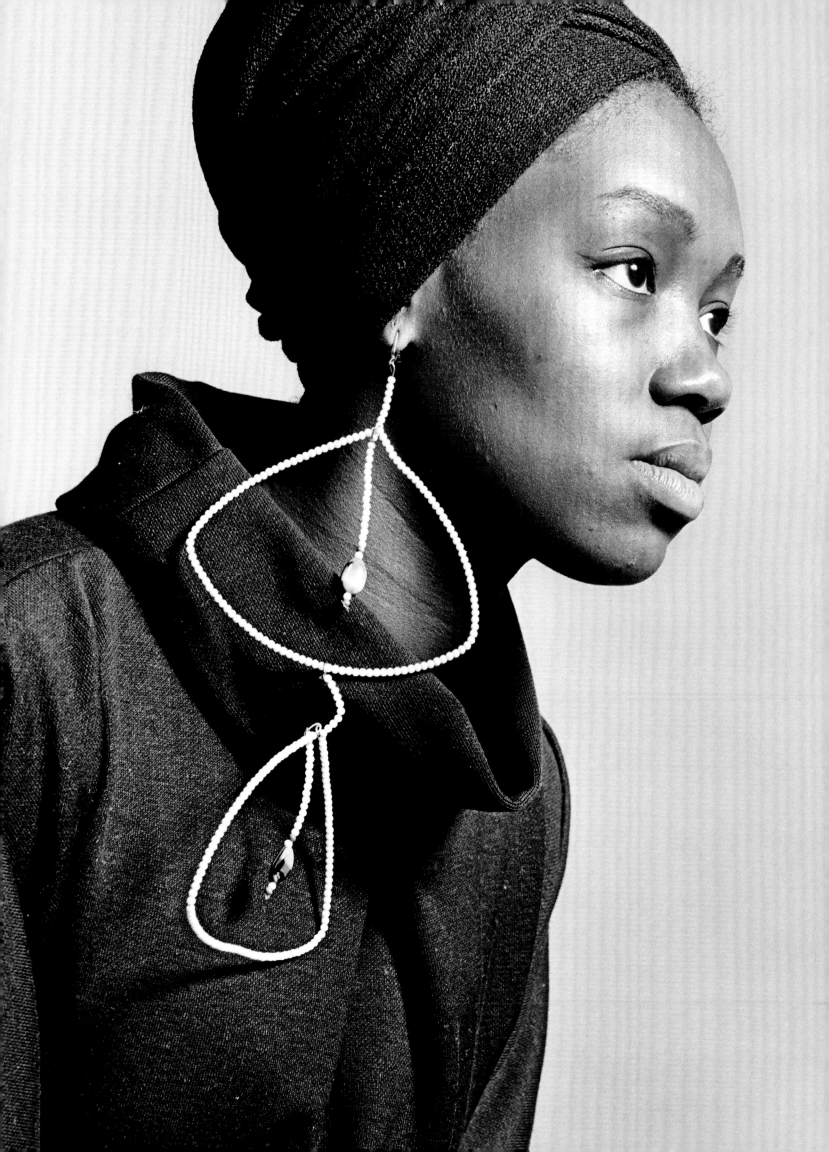

This page:
Naturally '68 photo
shoot in the Apollo Theater
featuring Grandassa
models and AJASS
founding members
(except the photographer).
Center from left: Frank
Adu, Elombe Brath,
and Ernest Baxter, 1968

Opposite:
Sikolo Brathwaite wearing
a beaded headpiece by
Carolee Prince, ca. 1967

Everyone knows the phrase "Black is beautiful," but very few have heard of the man who helped to popularize it. Brooklyn-born black photographer Kwame Brathwaite has lived most of his life behind the camera, devoted to capturing the lives of others on film. Spending much of the 1960s in his tiny darkroom in Harlem, he perfected a processing technique that made black skin pop in a photograph, with a life and energy as complex as that decade. Known by friends and comrades as the "Keeper of the Images," Brathwaite has logged thousands of hours in the darkroom, dipping his fingers into harsh developing chemicals so often over the decades that the grooves of his fingertips have become worn. His labor reflects his deep commitment to black freedom and radical cultural production. With every dip, measurement of solution, and timing of exposure, Brathwaite styles blackness. His images, carefully calibrated to reflect a moment precisely, made black beautiful for those who lived in the 1960s, and continue to do so for a generation today who might only now be discovering his work.

I first stumbled upon Brathwaite's photographs in 2009 at the Schomburg Center for Research in Black Culture in Harlem. There I found a series of provocative images of black picketers taken at an August 1963 protest of a white-owned beauty supply store in Harlem called Wigs Parisian. The black women and men in the photographs carry placards that boldly declare: "We Don't Want Any Congo Blondes!" and "He's Got Straight Hair, but He's Still an Ape!" Drawings of dark-complexioned women with large lips sporting blonde wigs and an ape with slicked hair dressed in a tuxedo accompany the texts. The photographs are riveting and unlike any that I had previously associated with the protests of the early 1960s, when slogans such as "Freedom now" and "One man, one vote" were rallying cries. They touch a sensitive nerve. They confront our collective feelings of pain and shame. Those feelings about our hair and bodies that we adopted in childhood and still fight to keep at bay. These piercing images, locked away in a small box in Harlem, represent a history that I had never learned in college or graduate school. I wanted to know: Who *was* this photographer? Who were these protestors? Google searches yielded little; Brathwaite seemed to exist only in the photography of the past and in minor quotes in black nationalist publications such as *Muhammad Speaks* and the *Liberator*. My countless email requests for an interview with Brathwaite went unanswered, until I was able to speak with him last winter for this article.

Brathwaite found photography through his love of the rollicking rhythms of hard bop jazz. In 1956, he and his teenaged friends, all recent graduates of the School of Industrial Art (now the High School of Art and Design) in Manhattan, formed the African Jazz-Art Society and Studios (AJASS), a radical collective of playwrights, graphic artists, dancers, and fashion designers. Jazz societies were common at this time, and AJASS modeled itself after the well-established Modern Jazz Society. They opted to use the then much less common word *African*, which made their group distinct and referenced their political leanings.

Years earlier, Brathwaite and his older brother Elombe Brath, a graphic artist, had heard activist Carlos Cooks espousing the politics of black nationalist leader Marcus Garvey: "Take back our land!" "Go back to Africa!" "Black is beautiful!" His message of black empowerment and economic independence resonated with the brothers, and they joined Cooks's African Nationalist Pioneer Movement. "We weren't fond of just being colored folks, being under the yoke of anybody else," Brathwaite told me when I interviewed him. AJASS members were the "woke" set of their generation, calling themselves *African* and *black* when most people were still using the now passé *colored* or *negro*. In jazz, they found a similarly rebellious spirit, a music that communicated emotions that could not otherwise be articulated.

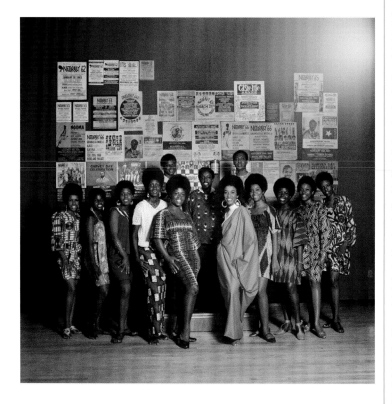

These piercing images, locked away in a small box in Harlem, represent a history that I had never learned.

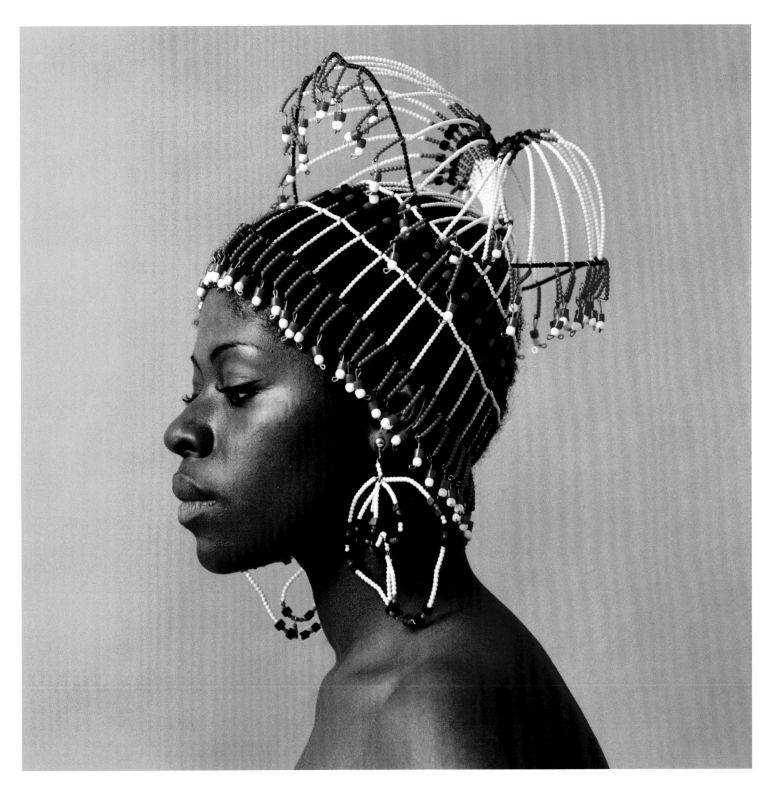

AJASS members spent most of their weekends promoting concerts at the legendary Club 845 on Prospect Avenue in the Bronx, the epicenter of the borough's jazz scene, where they began booking rising stars like John Coltrane, Lee Morgan, and Philly Joe Jones. "We could pick some of the best musicians in the world," Brathwaite recalls. "We'd have good, packed houses all the time." One evening in 1956 Brathwaite strolled into the club, greeted customers perched at the bar, then headed toward the back of the venue and into the cavernous performance space, the sound intensifying as he neared the stage. One of his school friends was snapping pictures in the dimly lit club, and Brathwaite was astonished that he was not using a flash or any additional light source. Nothing. Brathwaite, the advertising-arts major who had never really worked with a camera, asked his friend, "How do you do that with no flash?" His friend's professional camera and Kodak Tri-X film (the film that revolutionized photojournalism because of its speed and versatility) were far superior to the camera Brathwaite

had received as a gift at graduation. "I couldn't do what he was doing with that," Brathwaite told me as he swatted the air in a dismissive gesture.

And just like that, Brathwaite was hooked. He used his earnings from the jazz shows to buy a professional camera and devoured every photography book he could find. Jazz set the rhythm for his photography, which became central to his artistic approach. "You want to get the feeling, the mood that you're experiencing when they're playing," he explains. "That's the thing. You want to capture that." But translating the moody blue notes of jazz onto film is not a skill one can learn from a book; it is sensory knowledge that comes from an understanding of jazz culture—the syncopated rhythms, the elasticity of sound, the spirit of improvisation. The temperament of jazz is the lifeblood of Brathwaite's work.

The new camera became young Brathwaite's closest companion, kept within reach so he could take a snap whenever something intriguing crossed his line of sight. Most of his early images were

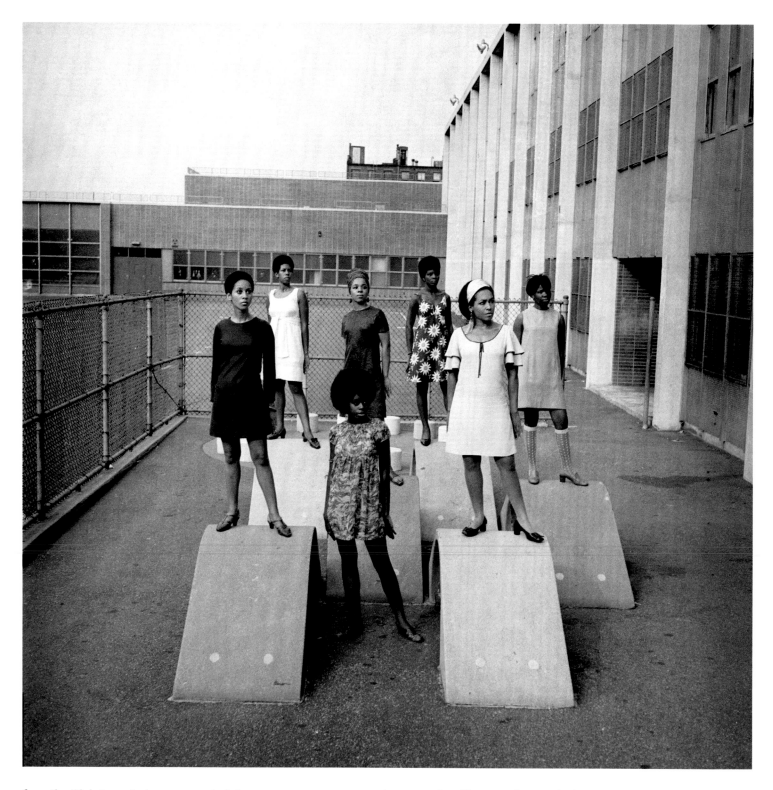

from the Club 845 sets: jazzmen on their horns, spectators enthralled by the music. He also photographed the quiet intimacy of the musicians' lives. "I'd go to Coltrane's house at times. He would be playing the soprano sax in his kitchen with his T-shirt on. I got some shots," Brathwaite told me. As the unofficial photographer of New York's annual Marcus Garvey Day celebration, he quickly learned that photography required fearlessness. During the parade, Brathwaite would bend and contort his lithe body, often throwing himself into the crowd in order to document the extravagance and pageantry of the lively event.

As Brathwaite perfected his camera skills, taking hundreds of photographs each week in those early years, the movement for black freedom was erupting on the Harlem and Bronx streets around him, as much as it was in the American South. The federal government had overturned "separate but equal," but black Americans like Brathwaite and his peers still felt the cold fear and unease of stepping too close to the invisible line of Jim Crow

segregation. Photography was the insurgent technology through which everyday people and professional photojournalists alike captured the wild violence of police billy clubs and the quiet threat of "Whites only" signs in shopwindows from downtown Manhattan to Montgomery, Alabama.

The "Black is beautiful" movement really started to coalesce in and around Harlem in late 1963, after the Wigs Parisian protest. "That's when we started promoting 'Black is beautiful' even more. We had entertainment with fashion shows and concerts and stuff like that, which made us very popular in the community," Brathwaite said. They began using "Black is beautiful" and other slogans such as "Think black" and "Buy black" on event flyers and other ephemera.

Brathwaite wore his "Keeper of the Images" title with great pride and conviction, allowing his brother to take the lead as the public voice of their movement. Yet, the mostly male group realized that beauty and body issues affected black women

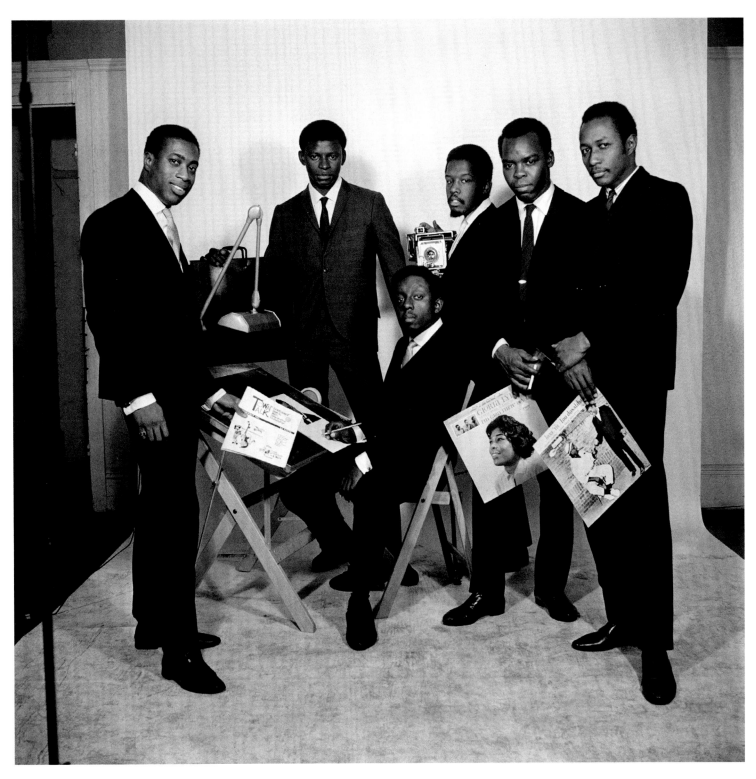

differently. "We said, 'We've got to do something to make
the women feel proud of their hair, proud of their blackness,'"
Brathwaite explained to me. In order to truly communicate why
black was inherently beautiful, they needed women at the helm.
With the help of a well-connected AJASS member, Jimmy Abu,
they began recruiting teenage and young adult women to model
in a community-based fashion show. They named the group
Grandassa, drawing from the word *Grandassaland*, which Carlos
Cooks used to describe the African continent. The original models
had deep chocolate skin, full lips and noses, and wore their hair
in "natural" styles that highlighted their kinky textures.

The Grandassa models dazzled the crowd of mostly black
folks from Harlem and the surrounding neighborhoods who
assembled at the Purple Manor on January 28, 1962, for Naturally
'62: The Original African Coiffure and Fashion Extravaganza
Designed to Restore Our Racial Pride and Standards. Actor Gus
Williams served as host alongside jazz singer and activist Abbey

The temperament of jazz is the lifeblood of Brathwaite's work.

Brathwaite was challenging the ubiquitous presence of lighter-complexioned, straight-haired black models in black-owned publications.

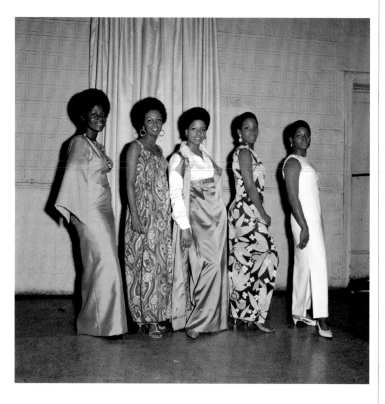

Grandassa models
after the Naturally fashion
show, Rockland Palace,
ca. 1968

Lincoln, while her husband, jazz drummer Max Roach, led the house band. The models sashayed across the makeshift catwalk in vibrant dresses, skirts, and sophisticated blouses constructed from fabrics with intricate prints. Each woman accessorized her look with large hoop earrings, chunky bracelets, and kitten-heeled mules and sandals.

The event was a smash. AJASS soon produced more shows, eventually making Naturally an annual event. "We started picking up designers, black fashion designers," Brathwaite said, noting that Carolee Prince, who created headdresses for famed singer Nina Simone, also showcased her original pieces in the Naturally shows.

Brathwaite and his crew realized they were now at the center of a brewing national conversation on colorism and race pride within the black community. The Grandassa models were not simply countering the images of pale and frail British models such as Twiggy and Jean Shrimpton who appeared in mainstream U.S. publications. They were also challenging the ubiquitous presence of lighter-complexioned, straight-haired black models in black-owned publications such as *Ebony*. "There was lots of controversy because we were protesting how, in *Ebony* magazine, you couldn't find an ebony girl," Brathwaite told me.

Spurred on by the cultural zeitgeist of the moment, Brathwaite transformed AJASS from a band of creative teens into a group of businessmen and -women who could "sell" their vision of blackness to an international audience. In 1964, they signed a lease on a studio space next to the Apollo Theater. Brathwaite and Brath produced "Black is beautiful" ephemera—as well as several Blue Note Records album covers—and charged a sitting fee to photograph local women and men. Later, they operated a café-style meeting space called Grandassa Land, on Seventh Avenue between 135th and 136th Streets, where they hosted poetry nights and plays organized by the AJASS Repertory Theatre. Lincoln and Roach introduced them to club owners in the Midwest who invited AJASS to present Naturally shows in Chicago and Detroit. Images of the stylish Grandassa models appeared in black publications in the United States, Britain, Nigeria, and Rhodesia (now Zimbabwe).

The popularity of Grandassa and AJASS made Brathwaite a sought-after photographer for international magazines. His photographs of megastars such as Stevie Wonder, Muhammad Ali, and Sly Stone were published in Britain's *Ad Lib* and *Blues & Soul* magazines, as well as in publications in Japan. With those early paychecks—much larger than the meager sitting fees he charged neighbors in Harlem—Brathwaite upgraded his equipment and traveled the world. He had encounters that a boy from the Bronx, whose only taste of the international had been his mother's Caribbean coconut bread, could have only dreamed of.

Naturally shows became less frequent as the 1960s drew to a close. Brathwaite and Brath delved deeper into pan-Africanist activism, and they traveled extensively across the African continent, working alongside activists in Ghana, Nigeria, Congo, Namibia, Tanzania, Kenya, Ethiopia, Sudan, and Egypt. Meanwhile, the catchy slogan "Black is beautiful" continued to spread and was used to sell everything from hair-care products and T-shirts to alcohol and cigarettes. The two brothers had helped to usher in this moment, making black nationalism artful and accessible to everyday black folks. But the brothers' absence from the political, social, and artistic scene in the United States, and the ubiquity of soul music and black power imagery in the early 1970s, meant that most people never came to know them, AJASS, Grandassa, or the vibrant history of the second-wave Harlem Renaissance, of which they were at the center. Brathwaite's photographs, which provide much-needed texture to our understanding of the black freedom movement, never became part of the movement's

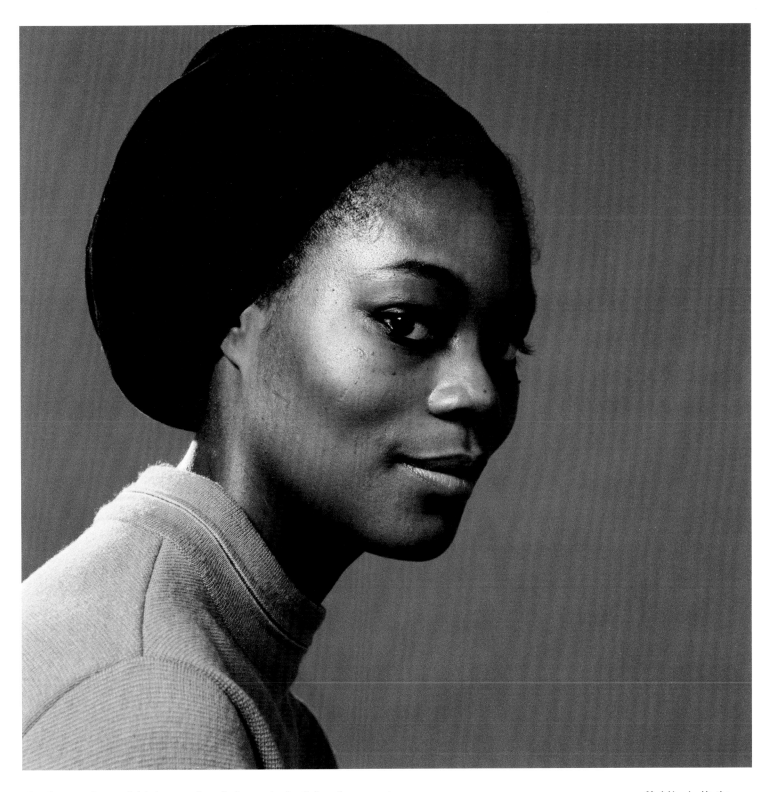

**Model inspired by the
Grandassa photo shoot
at AJASS, ca. 1965**
All photographs courtesy
the artist and Cherry
and Martin, Los Angeles

visual canon. Instead, his images found a home in the Schomburg
Center in Harlem, not far from where the AJASS studio was located,
where they lay in wait for an eager researcher to access them
and understand their significance. There were no retrospectives,
no splashy write-ups.

And Brathwaite was fine with this. He never pursued
photography for the accolades. He enjoyed the quiet life outside
of the spotlight. Elombe Brath died in 2014, after suffering a series
of debilitating strokes. The loss upended Brathwaite's world.
His brother was always the voice, the one who could galvanize
the crowd with his booming speeches. With his passing, and that
of most others in their collective, Brathwaite realized that he was
not only the "Keeper of the Images"; he was now the keeper of the
stories, too. If he didn't share this history, it would be lost to time.
At seventy-nine years old, Brathwaite is now telling the tale of
how he—the son of West Indian immigrants—and a crew of black
teens from the Bronx styled the world.

**Tanisha C. Ford is Associate Professor of
Africana Studies and History at the University
of Delaware and the author of *Liberated
Threads: Black Women, Style, and the
Global Politics of Soul* (2015).**

Jalan & Jibril Durimel

Antwaun Sargent

It all began in front of the camera. In 2012, the French photography duo Jalan and Jibril Durimel created their street-style Tumblr *Durimel*. The blog announced the then eighteen-year-old twins to the world as a creative pair who ran around the streets of Paris taking pictures of themselves in the latest trends. They gained a following. Later that year, when they settled in Los Angeles for college, the twin brothers began modeling in campaigns for American Apparel, AXS Folk Technology, and Union Los Angeles, and made an appearance in the Japanese style tome *Popeye*.

As models, Durimel became frustrated by the contemporary reality that the commercial fashion image is dominated by trends and a brand's ability to advertise a closeness to wealth, power, and idealized notions of beauty and cool. It's a form of representation that diminishes the significance dress plays in telegraphing humanity. In an effort to resolve this tension, they stopped modeling and, like Gilbert & George, Doug and Mike Starn, and Inez & Vinoodh, began a collaborative artistic practice. Their mantra is to "help the world to familiarize itself with its neighborhoods" by "creating still beautiful moments."

A Durimel photograph is distinguishable from the typical glossy fashion photography found on billboards as brand advertisements or seasonal editorials. The duo's images are imbued with a surrealism derived from what they call a "sartorial interest in style, texture, color, and silhouette." Pictures such as *Kuoth* (2015) further critique the notion of the promotional fashion image. As in all of Durimel's work, the figures represent everyday black people cast from the streets of Jamaica, Sierra Leone, Miami, and Los Angeles as "characters," not models, in diasporic narratives Durimel tell through dress.

For the R&B singer Sampha's zine *Shy Light*, Durimel, in collaboration with the fashion designer Grace Wales Bonner, took natural images of the *Process* singer's journey in his familial hometown of Freetown, Sierra Leone. Similar storytelling occurs in *Black boys I knew who could self-reflect* (2016), a landscape portrait shot on a grassy knoll in the San Pedro neighborhood of Los Angeles. The keen use of the sartorial grants the picture a transformative quality, challenging all who see it to access ordinary beauty through representations of black humanity.

Over the last several years, Durimel have made character-driven pictures concerned with evoking emotion and identity by blending interests in color theory, composition, and the politics of dress. "Our images share the story of life through blackness," Jalan told me. *Untitled* (2017) and *Daughters* (2017), two images of the same group of women Durimel met while scouting in the historically black neighborhood of Watts in South Los Angeles, provide a glimpse into how the duo uses style in the characterization of blackness.

The conversations these women shared that day about life in public housing and raising children in those conditions resonated with the photographers, who, during high school, lived in public housing in St. Maarten. This dialogue inspired *Daughters*, an image of some of the Watts women, made with Durimel's Pentax 67 medium-format lens, against a sandy-brown backdrop. Most of the women wear black suits, and one holds a baby boy. At first glance, *Daughters* seems like a conventional fashion image found in a magazine. But if you linger on the women's sartorial togetherness and faces, they communicate the power, beauty, and importance of their lives, and yours.

Antwaun Sargent is a writer based in New York.

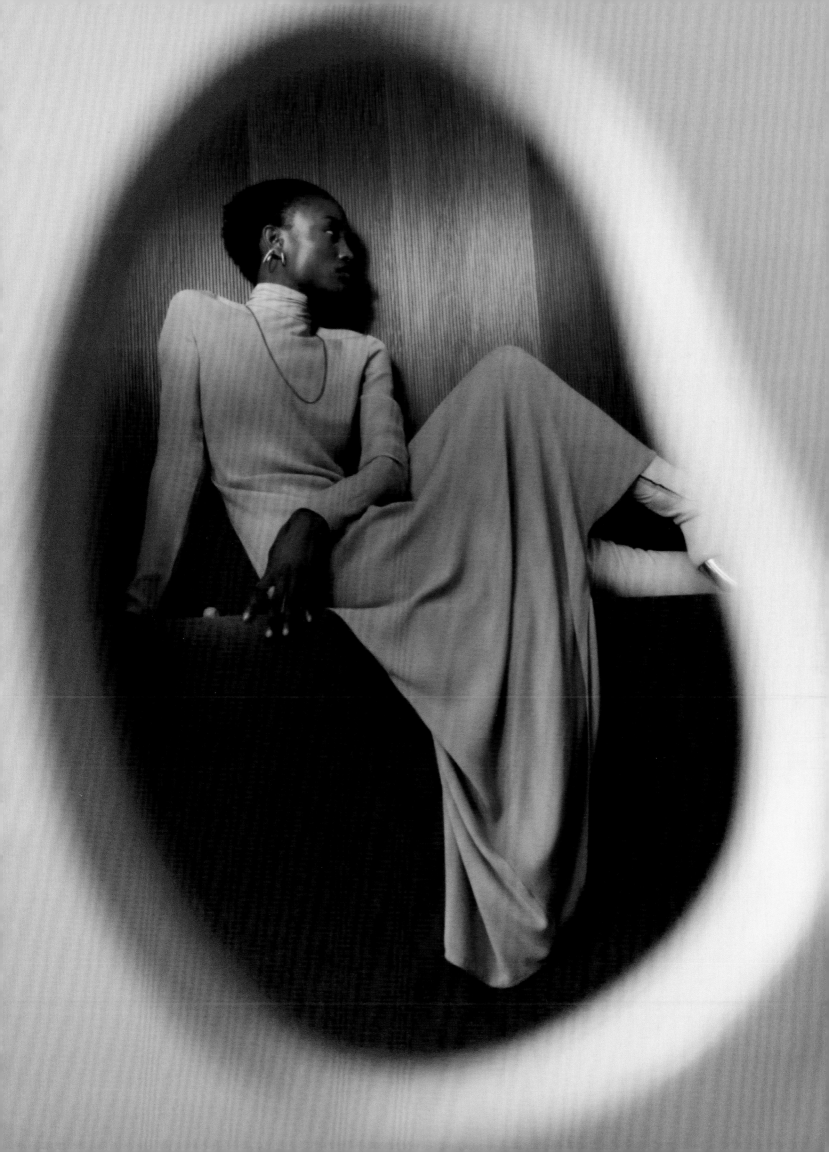

Previous page:
Untitled, 2016

This spread:
Bigger then, Bigger Glenn,
2017

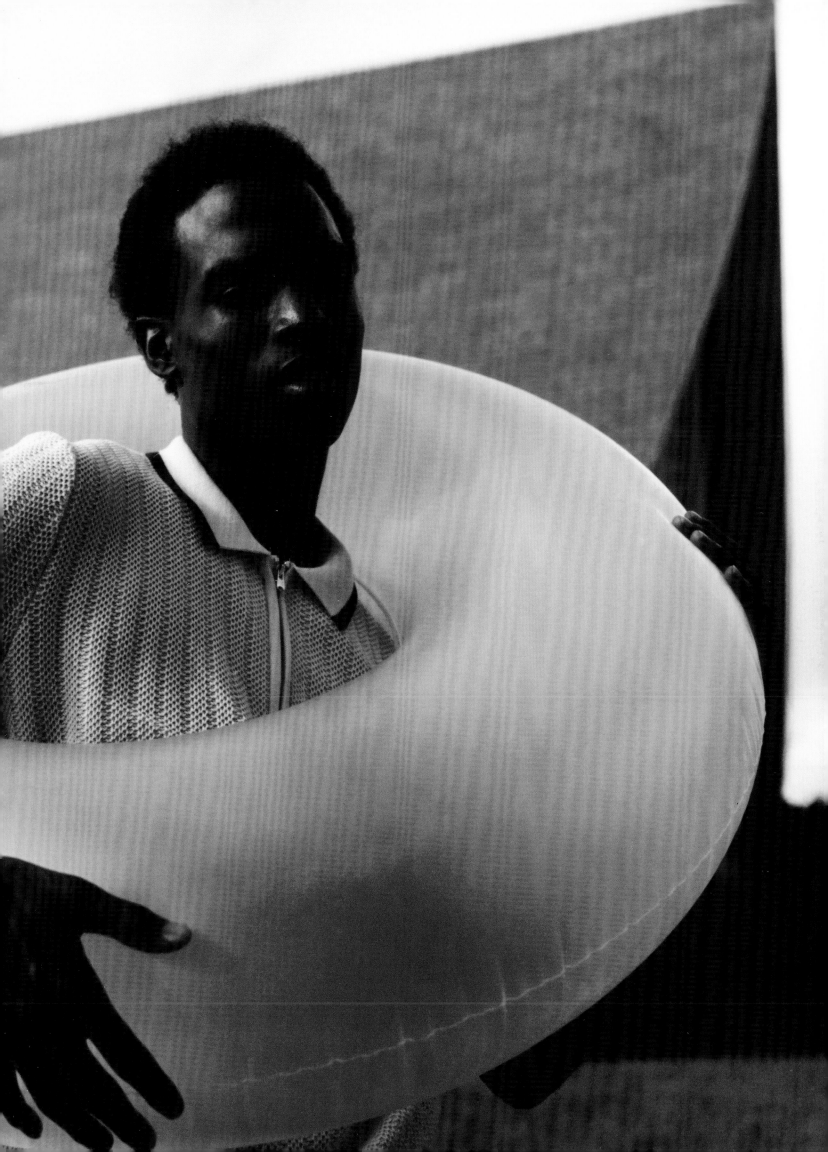

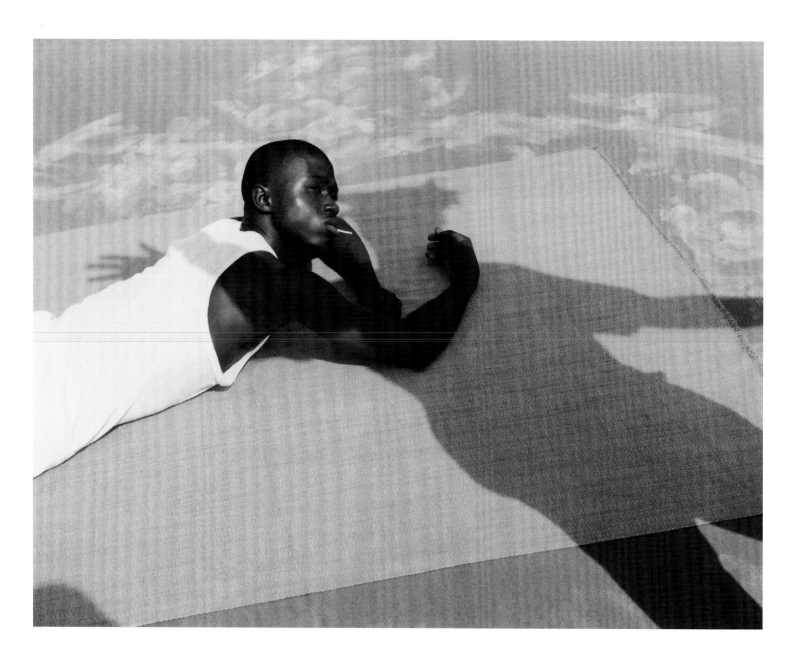

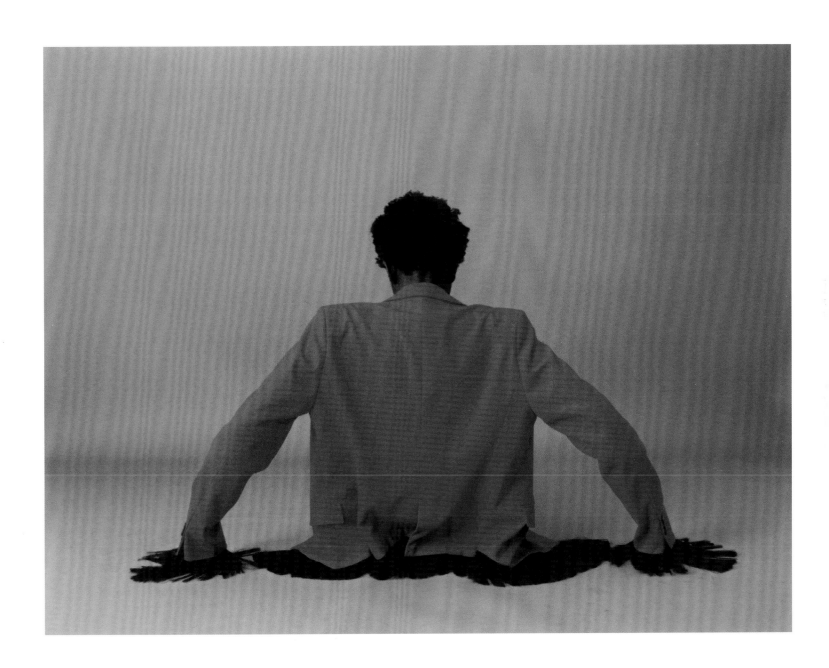

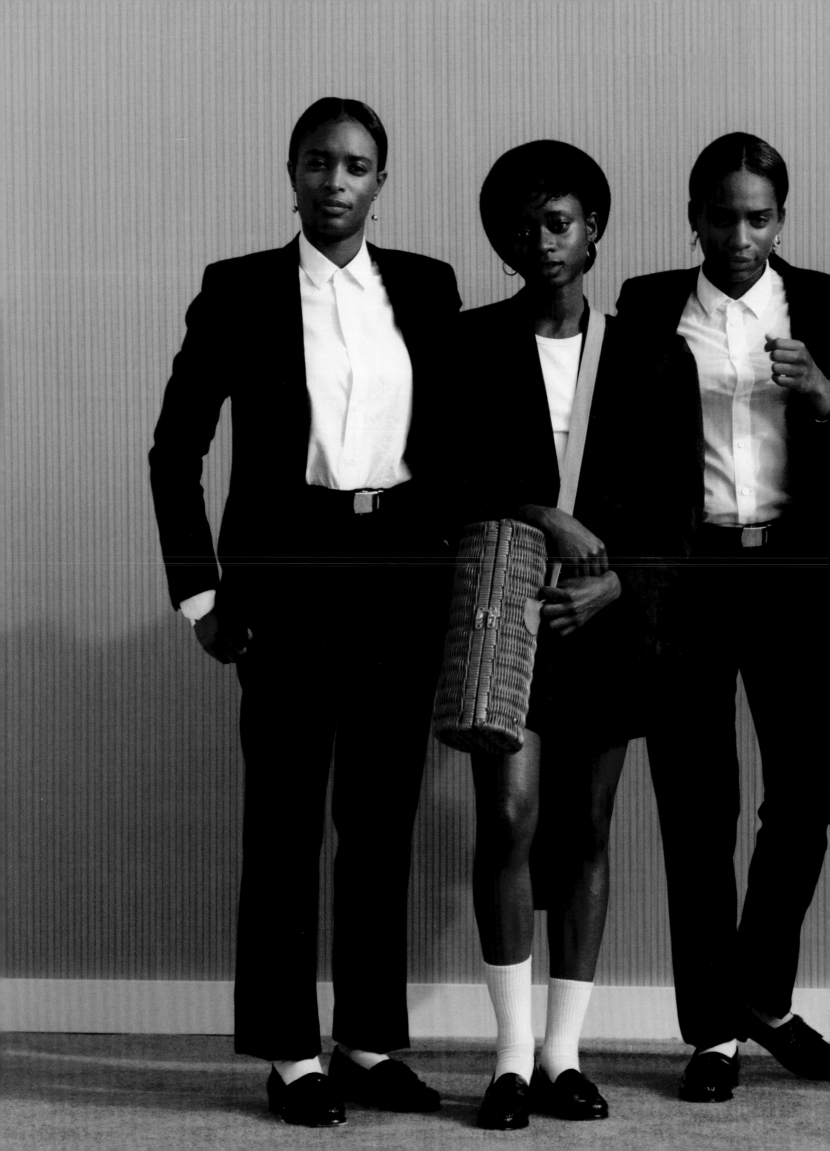

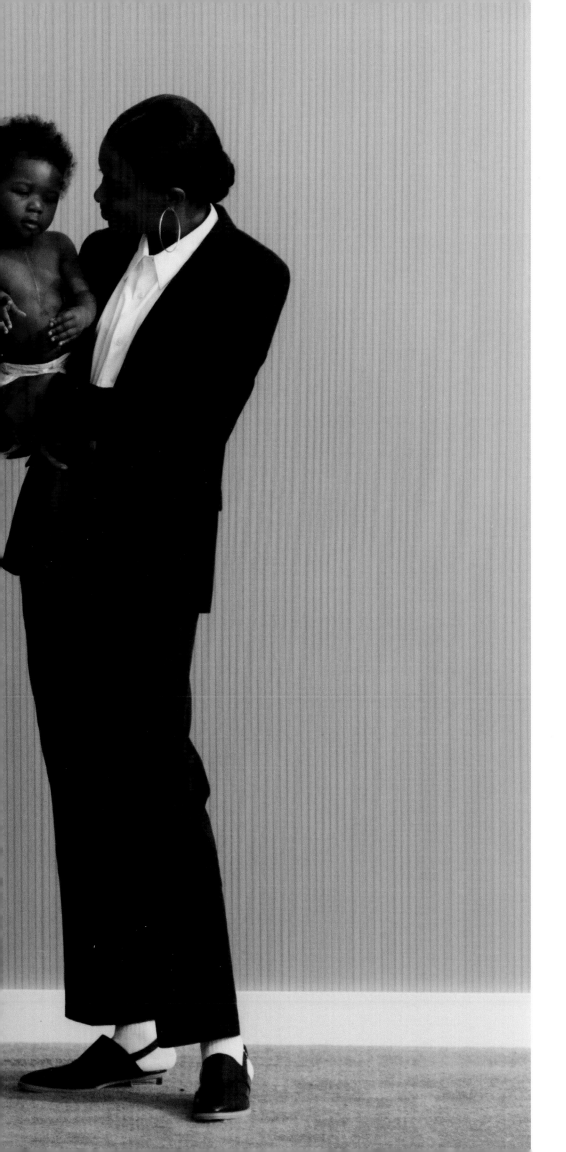

Daughters, 2017
All photographs courtesy
the artists

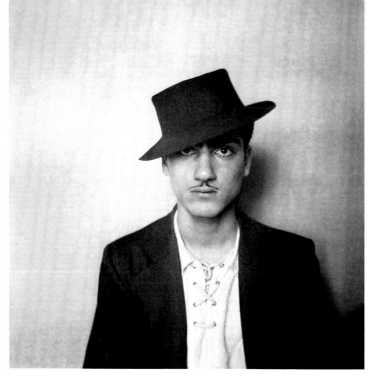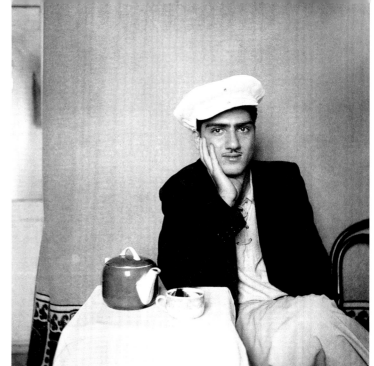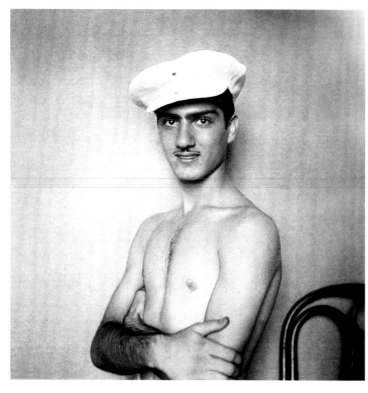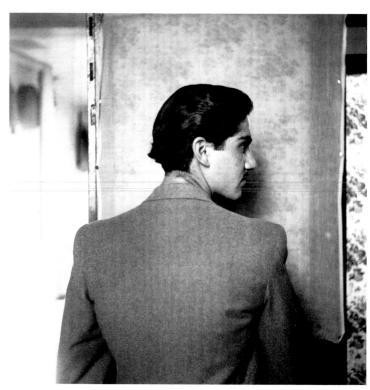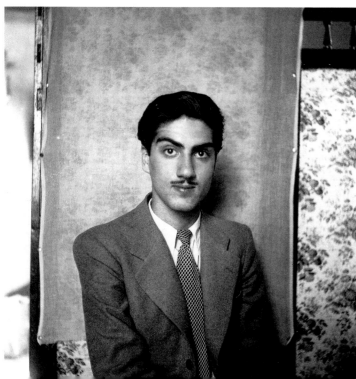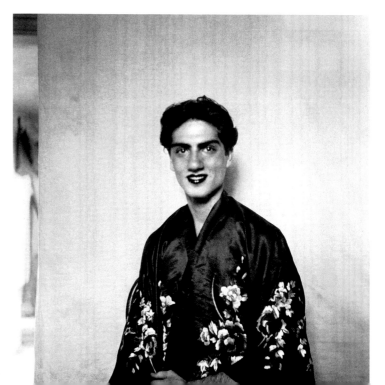

Fascinated by the glamour of midcentury Hollywood, Cairo's most renowned studio photographer turned the camera on himself.

Who Was Van Leo?

Negar Azimi

I have great faith in surfaces. A good one is full of clues.
—Richard Avedon

Who was Van Leo? The question haunts anyone who sets out to write about him. He left behind so much for us to admire. And yet he gave us so very little. Of himself, I mean. So many unanswered questions loom. The temptation to fill the gaping holes is huge. Was he a pioneering modernist, one of the most questing and idiosyncratic photographers the Middle East has known? A man-boy narcissist whose greatest quirk was to close his studio for a few hours each day to snap photographs of himself? A savvy technician with an outsize passion for Hollywood-tinged glamour? An oriental orientalist?

When he passed away, in 2002, at the age of eighty, the Armenian with the fantastical stage name bequeathed a vast treasure trove to the American University in Cairo—several thousand prints and negatives, eclectic props and furniture, Post-it notes and shopping receipts, and drafts and obsessive redrafts of letters,

both sent and unsent. Van Leo had attended the university for only a year or so in the 1930s before dropping out (he'd always been a below-average student), and yet he was convinced that they would soon create a museum in his honor. An overenthusiastic autoarchivist, he told himself that nothing he'd ever touched was insignificant enough to throw out. Still, these life scraps hardly shine a light onto the photographer's soul.

By the time I met Van Leo, in 2001, his studio had been shuttered. His body was broken, and he was living in his childhood home in Cairo, a narrow apartment at 7, 26th July Street. Inside that dark rectangle—dark because he was thrifty and strained to keep his electrical bills down until the end—he no longer walked, but shuffled. He was alone, and there was little, beyond my twenty-year-old presence, to indicate what decade it was. A wall calendar hung crisply in the kitchen from a particular year in the 1940s—I can't remember which. Van Leo himself was cordial, occasionally charming—in at least four languages—but he was wary. Cairo had changed, he said, and he didn't know whom to trust anymore.

※

Levon Boyadjian was born in Jihane, Turkey, on November 20, 1921, the youngest of three children of Alexandre and Pirouz, Armenian émigrés whose family name roughly translates to "one who paints." Like so many Armenians unmoored after the genocide, they moved to Egypt—to Alexandria first, and then on to Zagazig, a medium-size town on the Nile. It's tempting, when looking at images of baby Levon from this period, all dolled up, to see the rumblings of future vanities.

The Boyadjians eventually settled in Cairo, landing on what was then Avenue Fouad, an elegant thoroughfare in the Haussmannian style that extended from the manicured topiary of the Ezbekieh Gardens to the Egyptian High Court of Justice. As a teenager, young Levon interned at Studio Venus, one of dozens of photography studios run by Armenians in that city. (The Armenians had a well-known proclivity toward the craft.) Some say that Levon was pushed out of Venus when the owner—his name was Artinian—began to feel threatened by his young disciple's precociousness. Whether this piece of lore has a kernel of truth to it is unclear. It doesn't really matter; it's the first of so many myths to come.

It should be said that there were two photographers in the Boyadjian household, and when Levon and his brother set up shop in the family apartment in 1941, they called it Studio Angelo, in deference to the chatty older brother. The living room served as the lobby; the bathroom, the darkroom. The pair's first customers were entertainers passing through Cairo during World War II who traded glamour shots for free advertising space in local playbills. Downtown Cairo was brimming with dancers, stage actors and actresses, clowns, and strippers—there to boost the morale of the marooned troops who were stationed in the city, soldiers from across the British Empire, as well as Americans. And yet, from the beginning, Angelo—gregarious, gambling, womanizing—was Dionysus to Levon's bashful Apollo. While the creative partnership might have appeared happy from a distance, the two couldn't have been more opposed.

※

In 1947, the brotherly collaboration fell apart, and Levon set out on his own, taking over a large space a few blocks from the family home, from a photographer who had left Egypt for Armenia. Studio Metro had six big rooms—"six big rooms!" he would intone, over and over, to me and anyone in earshot, decades later. It was there, at 18 Avenue Fouad, that Levon Boyadjian became Van Leo, star maker and star. The name "Van Leo," a fabrication of his own, conjured

certain Dutch masters, lapsed European royalty, and good breeding in general; it had the cadence of greatness. In the archive, there are at least half a dozen typeface experiments for the new, exotic nom de plume—thick and regal, skinny and modern, cursive and confident. Sometimes there's a dash between the "Van" and the "Leo." A persona is finding its way.

Van Leo would never have called himself the Cindy Sherman of Egypt, but between 1939 and 1944, he took hundreds of untitled self-portraits, assuming myriad personae. In these, his own body was putty—he would grow his beard, shave his head, even put on weight, while experimenting with costumes, props, and lighting. He appeared as a gangster or prisoner; as Jesus Christ, the Wolf Man, or Zorro. In one, he has the mien of a young Vladimir Lenin; another evokes the 1940s film *The Thief of Baghdad*. Several are surrealist tinged, betraying Van Leo's encounter with a short-lived Egyptian Surrealist circle of the 1930s and '40s known as Art and Liberty. "My father used to get very angry," he admitted in 1998. "He'd tell me: 'Did you make the studio for yourself or for the customer? Stop making photos of yourself!'" And yet it's precisely these works in which Van Leo turned the camera on himself that began to bring him a measure of international fame in the late 1990s, shortly before we met.

In the photographer's archive, there's a little flip-book with dozens of postcard-size images pasted in. And yet the bulk of the self-portraits had never been printed at all. What purpose did they serve? Did they appeal to his vanity? Were they by-products of his ongoing efforts to hone his craft? Samples to show customers? Flights of fancy? It's impossible to say. The elaborate masks Van Leo wore, one after another, were less transformative than obfuscatory. They open a door to delirious wonders, but don't give us the key.

There are a couple of photographs I love the best, in which a very young Levon, barely a teen, stands against wallpaper with an elaborate floral design. There is no date, but I like to think of them as his very first self-portraits. In some, he's wearing what must be his school uniform, starched collar erect, gazing sternly at the camera. In one, he literally stands out from the surface of that same wallpaper, his face and neck emerging from the flowers. It's an elusive image—the young photographer's coat is nearly identical to the pattern on the wall. Where on earth did he find that? Did he have it made? He appears to be looking at something with an air of misty reverie. On the print, his shirt and lips have been shaded pink with pencil or watercolors. By his own hand? Were these the private obsessions of a young man? A portrait of the artist as a flower.

The same floral pattern appears again in a series of photographs of a notably older Levon, dated 1939 and 1940. In this series, he strikes diverse poses and uses motley props, especially hats (pith helmet, cap, bowler). In one image, he dons blackface and has wrapped a cloth around his head, like a turban. In two others, he's slipped into what appears to be a silky woman's bathrobe, or a kimono. Lipstick has been smeared on his lips, and conspicuous rouge limns his cheeks. Only the slightest glimpse of a hairy arm reveals his sex. The words "In the Chinese House" are faintly scrawled in pencil on the back of one photograph. It is an altogether enigmatic piece of chinoiserie.

※

"Photography is an art, and if you are born an artist, which is a gift from God, it must be appreciated by the people. One photograph is worth ten thousand words." Van Leo wrote these words in 1966, in response to a question about "gainful employment," on an immigration form. He never gained much money as a photographer, and spoke extensively, even relentlessly, about the suffering his devotion to his art—to Art—had brought him over the years.

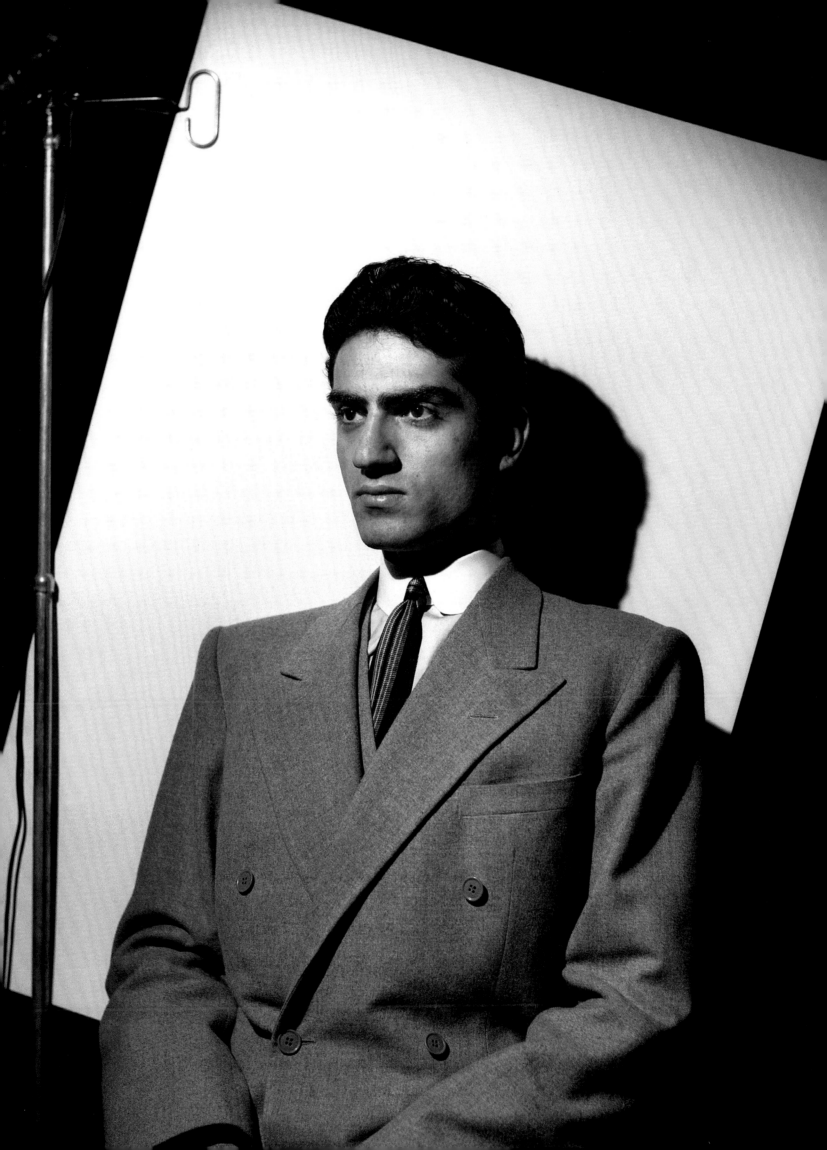

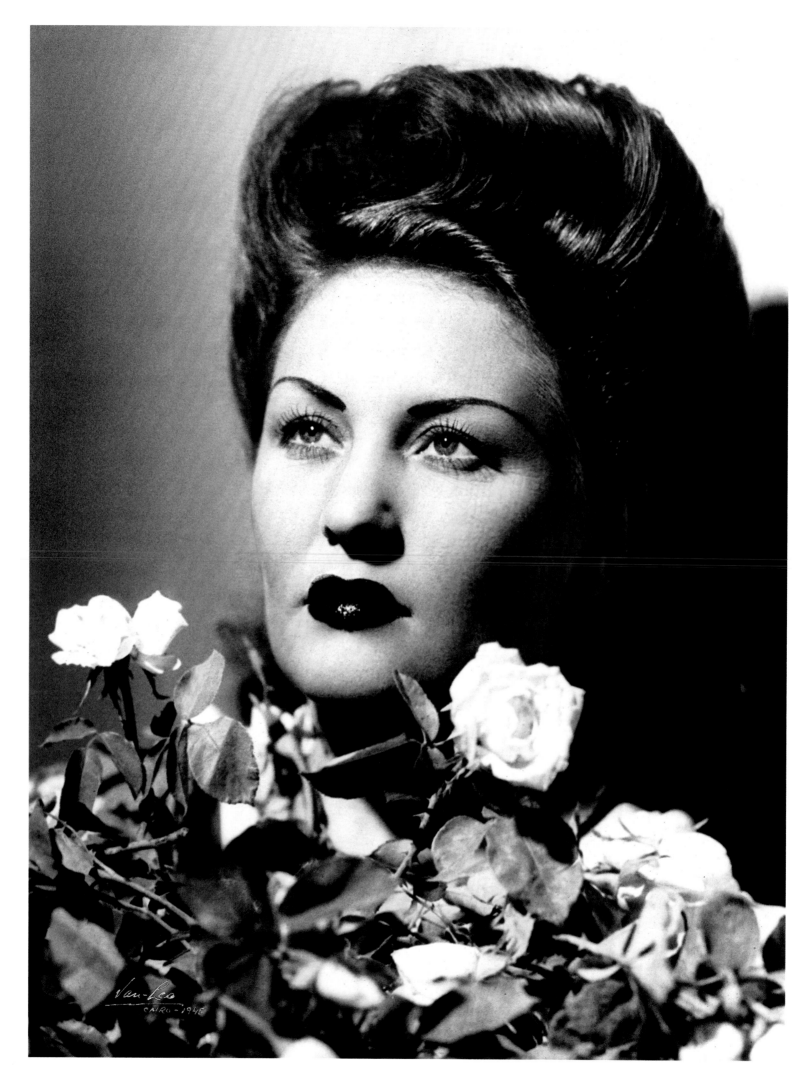

Van Leo was proud of his craft and dismissive of his rivals. But his conviction in the power of photography had little to do with the gritty photorealism of Robert Frank, or even Walker Evans's poetic depictions of impoverished lives. He had no interest in bearing witness to ugly or inconvenient truths: amid his thousands of photographs, there are no more than a handful of unstylized documentary images. Nor was he turned off by what the writer Janet Malcolm once referred to, in an article about Richard Avedon, as the "bazaar of false values" in fashion and other forms of high-gloss photography.

On the contrary, Van Leo reveled in surfaces, sheen, and gloss. And, unlike Avedon, who underwent a transformation in the mid-1950s, opting to show his subjects as they were—saggy, lumpy, wrinkled—he played plastic surgeon to the end. His art never aspired to truth. Truth was unseemly. Art was fantasy and illusion. Beauty, for him, seemed to have a moral quality about it. Photographs, motion pictures, magazines—these were the stuff of dreams. In a notebook, he carefully and obsessively listed famous actresses alongside their date and place of birth. "Mae West: born 1893, Queens, USA." "Jean Harlow: March, 1911, Kansas City, USA." Hollywood was where dreams came true. The photography studio was itself a kind of dream machine.

The Egyptian film industry became Van Leo's Hollywood, offering up a steady stream of volunteers upon whom he could practice his alchemy. The 1940s, '50s, and '60s were the golden age of Egyptian cinema; movie houses like the Rivoli and Miami screened homegrown productions, as well as the latest American films. Like the wartime entertainers who walked into Studio Angelo, Van Leo subsidized would-be stars and starlets, convinced that their future fame would pay its own dividends down the road. One such figure was Rushdy Abaza, a half-Italian insurance agent who worked in the same building. Abaza, tall and smolderingly handsome, yearned to be an actor. Years later, when he became famous, Abaza sent many others to be photographed by his old friend.

By the mid-1950s, Van Leo's studio was probably the most celebrated in Cairo. Dozens of his portraits from that time are indelibly linked to the public images of the individuals they feature. There is the Druze singer-actor Farid al-Atrash, playing the oud in his overdecorated apartment on the Nile. There is buxom Berlanti Abd al-Hamid, who Van Leo took out to the pyramids on horseback; Faten Hamama, seductively leaning back on Van Leo's studio floor; and Abaza himself, cigarette in mouth and pistol in hand, his body playing a shadow game against the photographer's studio wall.

In constructing these images, Van Leo was working in a vein of high-contrast celebrity photography perhaps best exemplified by Studio Harcourt in Paris and its magazine *Stars*. (Some say that he, in fact, worked for Harcourt at some point, but if he did, he left no trace.) But the inspiration that mattered most to him may have been Yousuf Karsh, another Armenian exile, world famous for his portraits of celebrities and politicians, and for his masterful use of light. Dozens of carefully clipped-out articles about Karsh reside in Van Leo's archive.

And yet the majority of the people who appeared before his camera never quite made it. Van Leo's most unforgettable images are not necessarily of the *déjà arrivés*, but of the almost famous. In *Camera Lucida*, his 1980 meditation on photography as a new form of consciousness, Roland Barthes wrote that each time a subject stands before a camera, four people are implicated: the person the individual thinks he is, the person he wants others to think he is, the person the photographer imagines him to be, and the person the photographer will make use of to realize his art. In thinking about Van Leo, one might add a fifth: the photographer himself. In these photographs, it's as if Van Leo's own aspirations for recognition and fame found echoes and companionship in those

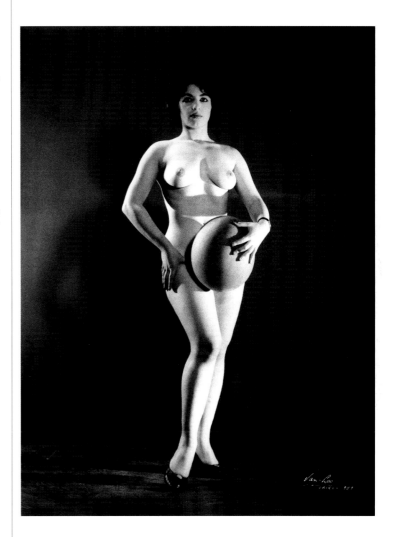

The photography studio was itself a kind of dream machine.

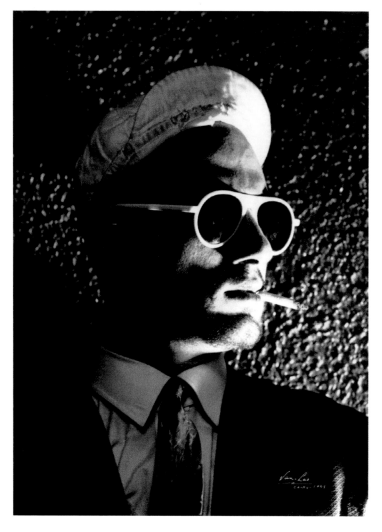

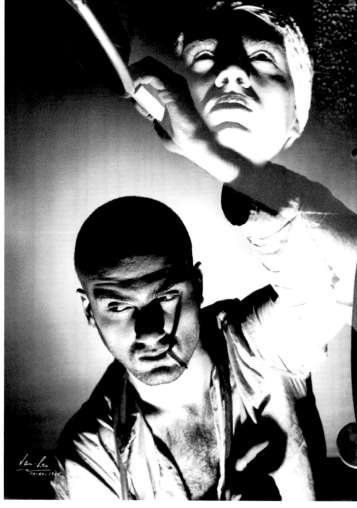

This page, left:
Self-Portrait, Cairo,
January 8, 1945
Arab Image Foundation/
Van Leo

This page, right:
Self-Portrait, Cairo, **1945**
Arab Image Foundation/
Van Leo

Opposite, left:
Self-Portrait, Cairo,
January 7, 1945
Arab Image Foundation/
Van Leo

Opposite, right:
Self-Portrait, Cairo,
November 1, 1942
© Rare Books and Special
Collections Library,
The American University
in Cairo

In the same way that he removed every last imperfection from his subject's face, Van Leo was a master of illusion.

of others. The would-be leading men and women who lined up to have their portraits taken held a mirror up to his own desires, and he lost himself in their faces along the way. (On the back of a photograph of a young actress named Elham Zaki, he wrote, heartbreakingly: "She wanted to be a star.")

Ragaa Serag, a woman who served as Van Leo's assistant, muse, model, and very probably his lover, once confided to me her belief that he'd always "wanted to be an actor." She continued, "He was *amar*. He was as beautiful as the moon." An actress who ended up with bit roles in dozens of films, Serag's near fame was not entirely different from Van Leo's own.

Of course, the bulk of his customers were ordinary people— a predictable parade of families, brides and grooms, passport applicants (overweight, asymmetrical, imperfect). These photographs are perhaps not altogether different from studio images anywhere in the world at that time. Witness the same devastatingly canned poses. But on occasion, fortune would strike. One day, for example, a woman came to the studio with her daughter—a long-haired girl of eight or nine—and a suitcase full of costumes to be photographed in: ballerina, sheriff, cowboy, oriental dancer. The girl's name was Sherihan, and she swiftly became one of the most beloved icons of Egyptian television and cinema.

Or consider the case of a housewife named Nadia Abdel Wahed, who arrived at the studio one day and instructed Van Leo to take step-by-step photographs of her elaborate striptease routine. In each image, she removes a single piece of clothing. The final image in the series features her perfect, melon-shaped breasts exposed, holding a beach ball over her pubis, ready to take on the world. A five-digit phone number scribbled on the back always made her seem vividly real to me.

✳

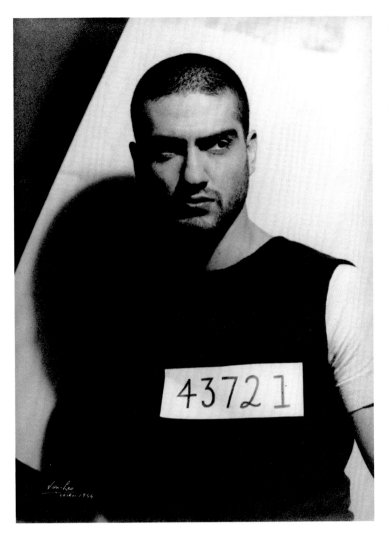

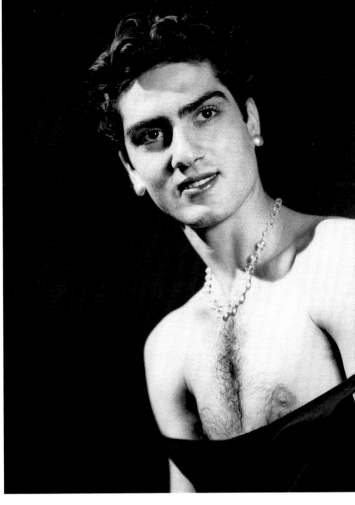

When Van Leo took time away from the studio—which was not all that often—he traveled. The list of countries he visited time and again was for the most part the stuff of humdrum bourgeois dreams: Austria, Switzerland, Italy. Album after album reveals fastidiously arranged traces of these trips—still crisp maps, ticket stubs, labels torn off bottles of wine, receipts, and photographs. The Eiffel Tower figures in many of his images, its familiar triangular thrust unchanging, even as he grew ever more haggard and jowly.

Mysteriously, Van Leo never made it to the United States, the El Dorado of his fantasies, though he went through the motions repeatedly. At the age of thirty, Van Leo initiated a correspondence with ArtCenter in Los Angeles about enrolling in classes there, having seen an advertisement for the school in a magazine. His queries are typed out neatly, requesting help with a visa and finances. "I am interested in all that photography offers," he wrote. But as with the emigration papers he filled out at regular intervals—to the United States or to Canada— he couldn't bring himself to leave Egypt. He was accepted to ArtCenter once, and then twice, but never went. Perhaps he preferred it that way—how could the real Hollywood have held up to his dream of it? He would never suffer that disappointment, at least.

So what do we make of this man who dreamed of leaving Egypt—Emma Bovary in Arabia—but couldn't take the fateful step? A painfully shy fellow who nonetheless was so sure of himself that he left every scrap behind for a future museum? The shape of his life remains remarkably opaque. Sphinxlike, even. Until the end, he insisted that he had never worked with assistants. And yet we know that Ragaa Serag toiled by his side for more than a decade, a devoted Véra to his Vladimir. One childhood friend says that Van Leo's birthplace was not Jihane, as he claimed, but a village

called Deurt-Yol. In the archive, there's a letter from a former girlfriend that refers to "our child," but neither girlfriend nor child are mentioned again. In the same way that he removed every last imperfection from his subject's face, Van Leo was a master of illusion.

And finally, what to make of Van Leo, the closeted queen? One can surmise that the queering of Van Leo is a game at least as old as his thirtieth birthday. Or his fortieth? As every milestone year came and went, the dashing Armenian remained, to the immense chagrin of his mother, a bachelor. (There are postcards and letters that attest to short-lived adventures with girlfriends.) In thinking about him, the question of his sexuality inevitably crops up—call it the Cavafy syndrome. Curators linger over the well-oiled physique of a muscly bodybuilder or the sensitive close-up on the face of his dashing Armenian friend, Noubar. The theatrical narcissism of the self-portraits, to say nothing of the cross-dressing, only seems to bolster the case many have made.

Van Leo used to say that he had taken many nude photographs of women, but had burned them in the 1990s for fear of being attacked by Islamic fundamentalists. This may well be true—and yet, to a discerning eye, there is something markedly abstract about the seminudes that we have seen. The women are more or less sexless, too finished to breathe with eroticism. They evoke a limp formalism and seem apropos for a photographer who was ever prone to trading in surfaces. Whether Van Leo was queer in the contemporary sense, we will almost certainly never know.

But he was without question a perpetual outsider. Van Leo was wont to bemoan the passing of his beloved Cairo, a city once populated by a cosmopolitan mélange of Jews, Greeks, Armenians, and Europeans of all stripes. The ascendance of former president Gamal Abdel Nasser, narrowly nationalist as he was, had all but destroyed that world. Van Leo would woefully evoke the plight

This page:
Coptic Girl, Cairo, 1949
© Rare Books and Special
Collections Library,
The American University
in Cairo

Opposite:
Florence Véran. French,
Cairo, 1952
© Rare Books and Special
Collections Library,
The American University
in Cairo

All photographs © Arab
Image Foundation

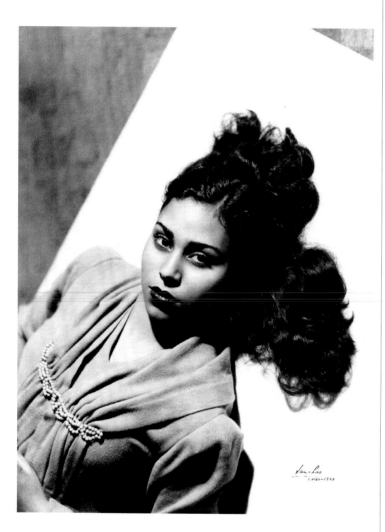

of the Armenian Christians—people of the wrong book—to account
for his lack of success. Egyptian Muslims had become overreligious
and obscurantist, he said, poorly mannered and badly dressed.
At the end of his career, Van Leo's customers were mostly expatriates
and the occasional tourist.

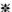

Van Leo stopped taking photographs in 1998. And yet, he had really
stopped decades before, with the advent of color film. Color had
sullied the cool elegance of black and white, he said. It was the
opposite of progress. A modern pestilence, it showed people as
they really were: garish, uncultivated, base. It was as if the angel
of history had propelled the photographer, against his will, into
an awful, tacky present. Van Leo's was a story of betrayal—by God,
Egypt, technology, style. About the pernicious effects of color
film he remained agitated until the end. About this, and so many
other things.

By the late 1990s, a global interest in vernacular studio
photography—and, indeed, in black and white—finally attracted
the world to his door. Curators such as André Magnin and
Okwui Enwezor had brought about unprecedented visibility for
photographers like the Malians Malick Sidibé and Seydou Keïta,
and the art world began to consider studio photography a variety
of fine art. Groundbreaking exhibitions, including *In/sight: African
Photographers, 1940 to the Present* at the Guggenheim in 1996,
helped create a market for such work. The following year, the Arab
Image Foundation was established in Beirut to survey photographic
practices across the whole of the Arab world, in all their complexity.
Van Leo was one of the first photographers to figure into its growing
collection. Not long after, the foundation nominated him for a
Prince Claus Award, which he won in 2000. Images of him at the
award ceremony reveal a bearded Van Leo in a tuxedo, beaming.
Bit by bit, he began to achieve the fame he had dreamed of for six
decades, or more.

The photographer died on March 18, 2002. At the time,
I had been organizing a small show of his portraits at the French
Cultural Institute in Cairo, and wasn't able to visit him that
afternoon as I had almost every other—bringing him the chocolate-
covered prunes he liked so much and the occasional half bottle
of just barely drinkable Egyptian wine. It is said that he was having
an overanimated conversation with his helper, Amadou, and had
a heart attack. Reduced to wearing a corset for his bulging hernia,
Van Leo had been looking forward to the show, and talking
a great deal about the museum to be inaugurated in his honor,
which he thought would surely follow. He was waiting for us to
raid the cupboard, you might say. He's been waiting for us all along.

Negar Azimi is a senior editor of *Bidoun.*

This essay is adapted from the forthcoming
publication *Becoming Van Leo,* by Karl Bassil
in collaboration with Negar Azimi, to be
published by the Arab Image Foundation
in partnership with the Prince Claus Fund
and Sharjah Art Foundation.

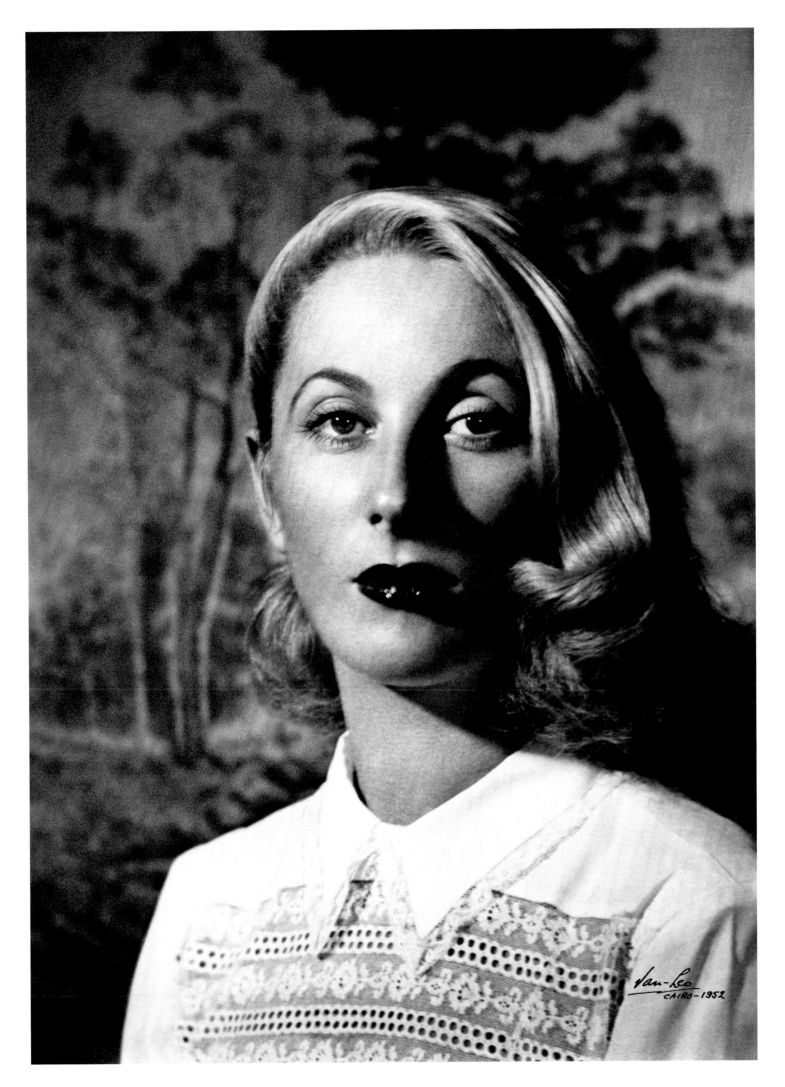

In her recent series *9-ja_17*, photographed in Lagos in 2017, Nadine Ijewere relied on street casting—inviting random people she saw to be a part of the project, and asking friends to invite others. Ijewere, a twenty-five-year-old photographer who lives and works in London, emphasizes that her work is a collaborative labor, and in an unusual move, she credits both the subjects of her photographs as well as others who were involved in the process of making the images come to fruition.

For *9-ja_17*, Ijewere worked with stylist Ibrahim Kamara, known for his spectacular and futuristic visions of African masculinity. Here, Kamara used more muted local fabrics, accentuated by the ubiquitous effluvia of Lagos—footballs deconstructed into hats, plastic ShopRite bags shaped into skirts, black-and-yellow traffic-barrier tape to accentuate a lean limb. The resulting images are a conversation with Lagos, a city that seems to always be in the process of reconstructing itself. *9-ja_17* is also a dialogue with the city's youth, who—despite throwaway economic and political conditions—are not disposable, or incapable of finding beauty and grace. Ijewere, whose mother is Jamaican and father is Nigerian, was born and raised in London, and frequently collaborates with Kamara, an in-demand stylist who was born in Freetown, Sierra Leone, and also raised in London. Ijewere's identity, like Kamara's, is an amalgamation of multiple locations and cultural experiences that do not allow for an easy sense of belonging. Art provides a space for experimentation and a fluid sense of self.

Challenging reductive stereotypes has always been part of Ijewere's oeuvre. This approach can be seen in a project made during her studies at the London College of Fashion, *The Misrepresentation of Representation* (2014), in which she explored how orientalist and colonial concepts repeatedly creep into the ways beauty is conceptualized. She purposefully included the apparatus of photography within the frames—boom lights and a visible studio—to show that beauty does not exist outside the political, and that fashion is instrumental in forcing certain people's identities into restrictive frameworks that, problematically, continue to be read as both representative and desirable.

Ijewere's *#StellaBy Nadine Ijewere* (2017)—her interpretation of Stella McCartney's spring/summer 2017 collection—was also shot in Lagos. For the project, she wanted to bring her Nigerian identity to the brand, and to question restrictive ideals of beauty and gender. Given creative control, Ijewere interpreted McCartney's clothing in ways that highlight the freedom and possibility of personal style. Ijewere was adamant that she work in Nigeria with the local community; the resulting images project confident interactions between her subjects and the landscape. Despite Nigeria's reputation for being "quite a conservative place, we were shooting women's wear on men, and the young men were all for it," Ijewere told me. "They were all about celebrating different types of beauty, and it was really refreshing to witness."

Fashion consumers are familiar with the go-to stories that editors and photographers mine, again and again, when it comes to Africa, in particular the colonial fantasy. Ijewere's photographs and Kamara's styling offer a refreshingly different tableau to that reductive landscape. Ijewere acknowledges that clothing and style are powerful forms of expression with which we might shape our subjectivities. Her images convey the lived realities of Lagos youth—a narrative of petrochemicals, disposable plastics, hazy sunshine, an obsession with ceremonial headwear, and *Thriller*-era glam. She shows us that through statements of individual beauty we become embodiments of our art practice, and more authoritatively inhabit the world.

Nadine Ijewere

M. Neelika Jayawardane

All photographs from the series *9-ja_17*, April 2017
Stylist: Ibrahim Kamara.
Subjects: Victoria, Tolani, Ola, Blessing, Michael, and Joseph. With thanks to Dafe Oboro, Steven Tayo, Adesua Obagun, James Gilbert, Keziah Quarcoo, and Stephen Ijewere.
Courtesy the artist in collaboration with Getty Images

M. Neelika Jayawardane is Associate Professor of English at the State University of New York Oswego and an arts contributor to Al Jazeera English.

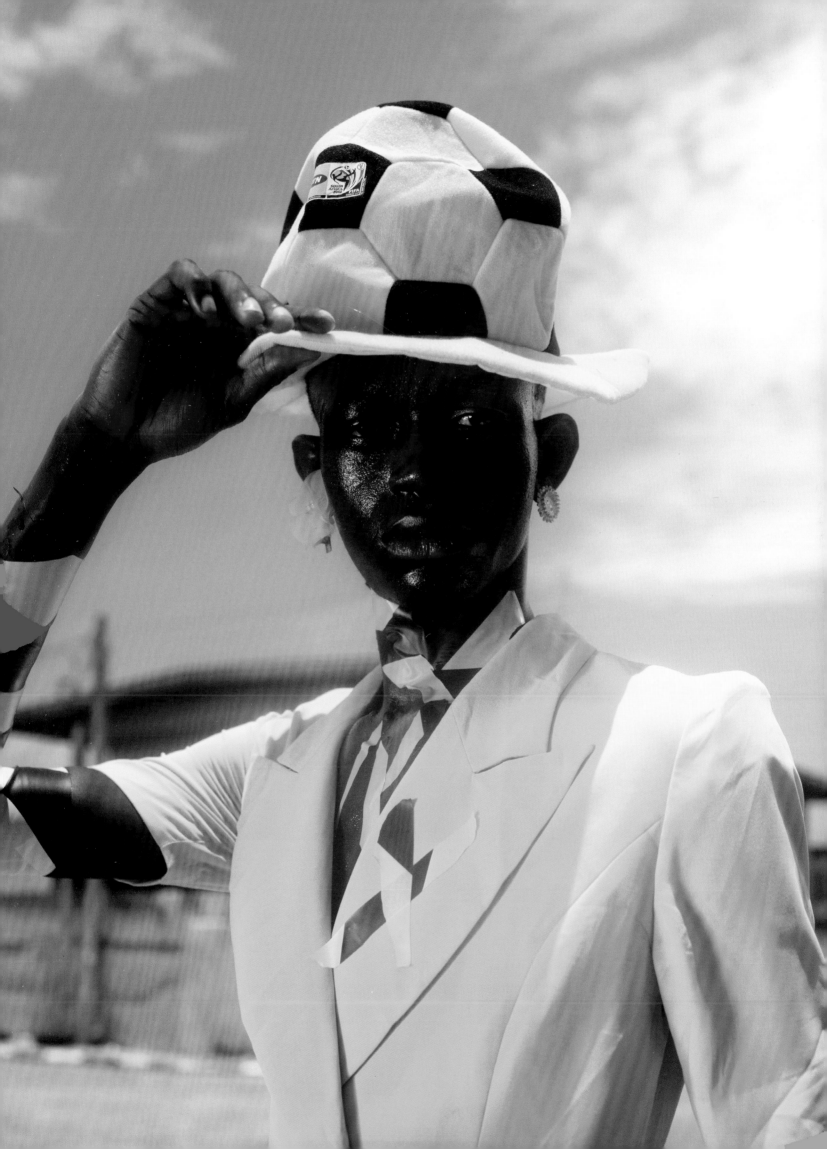

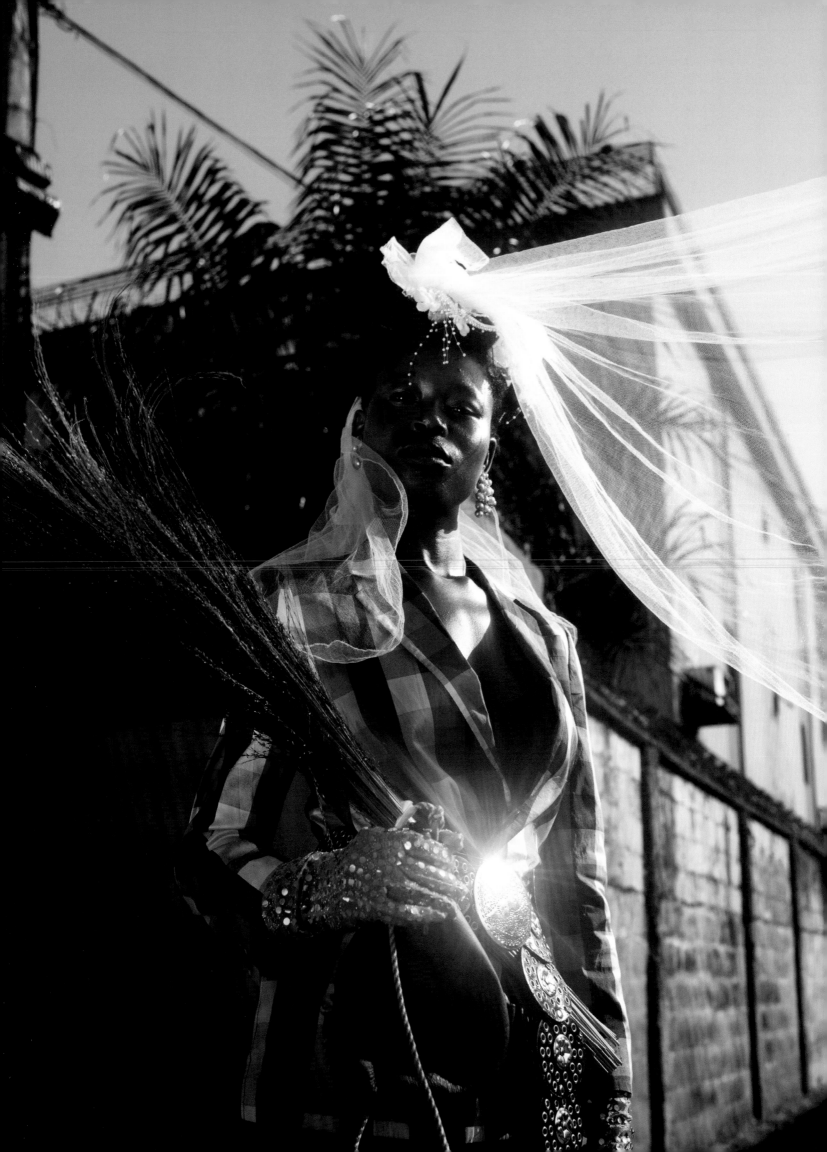

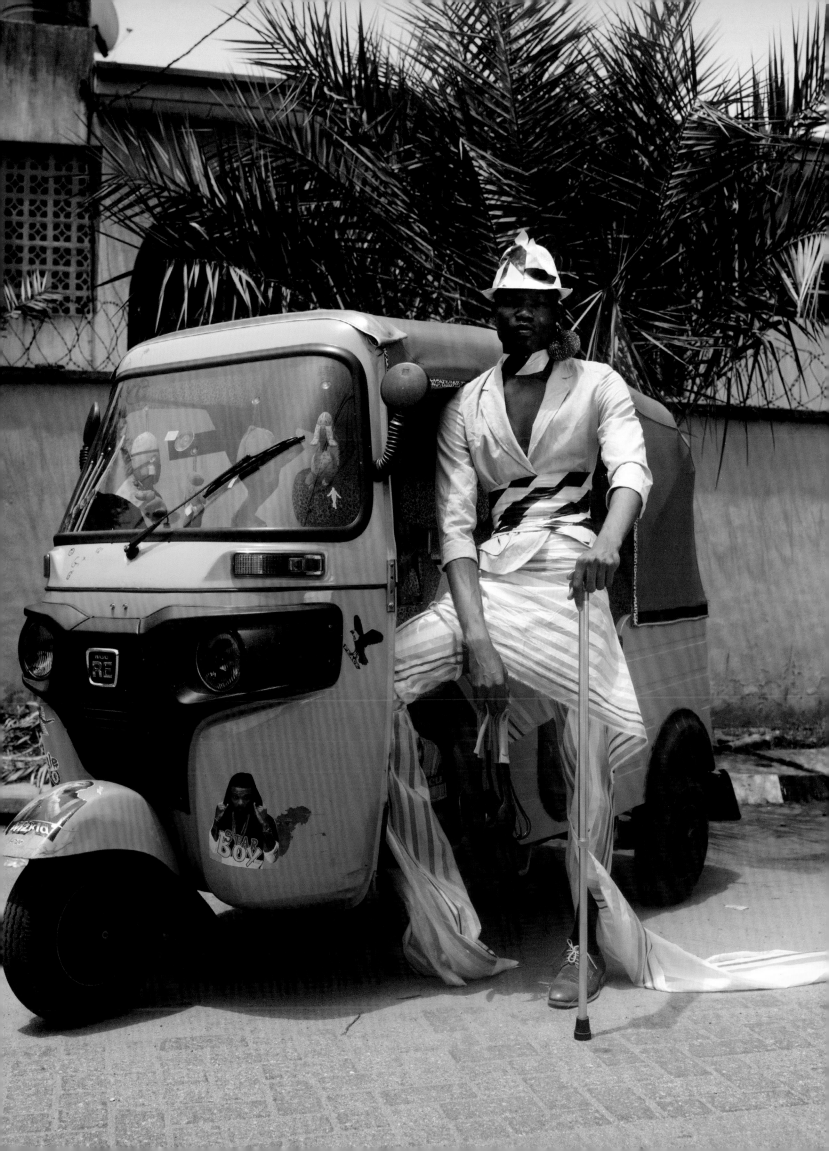

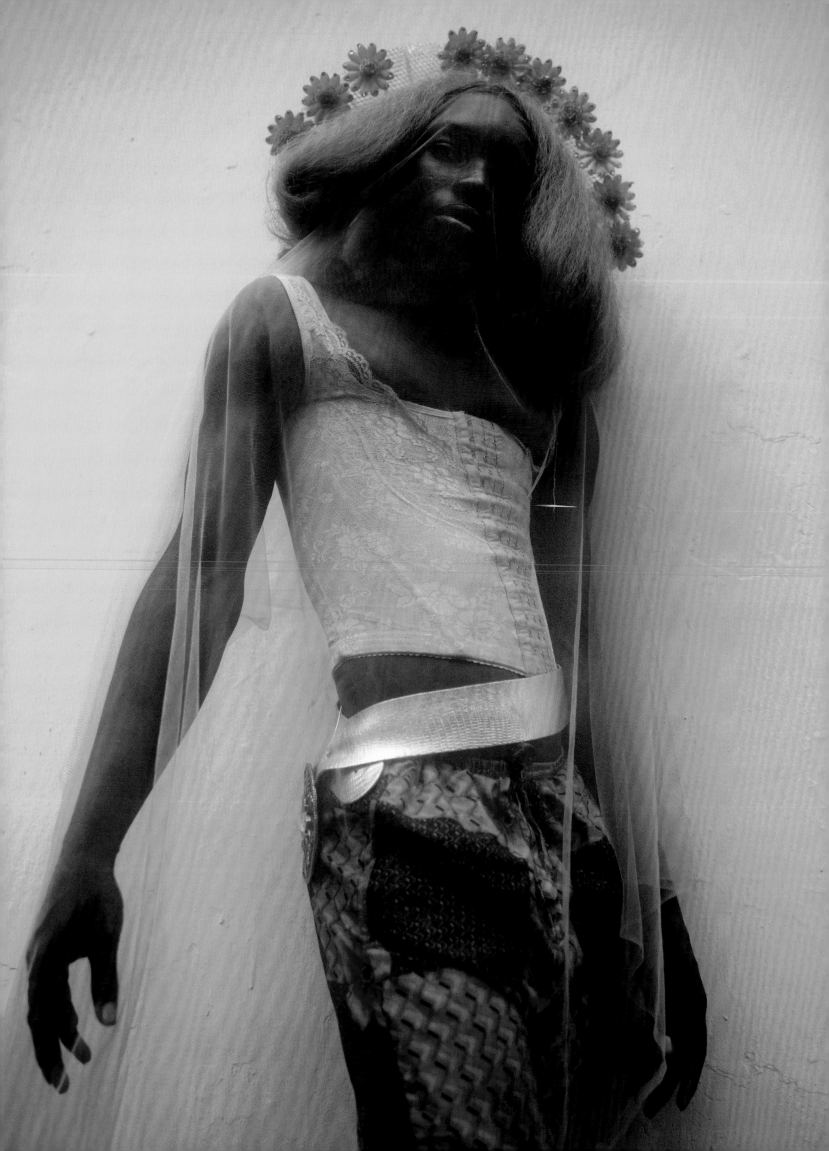

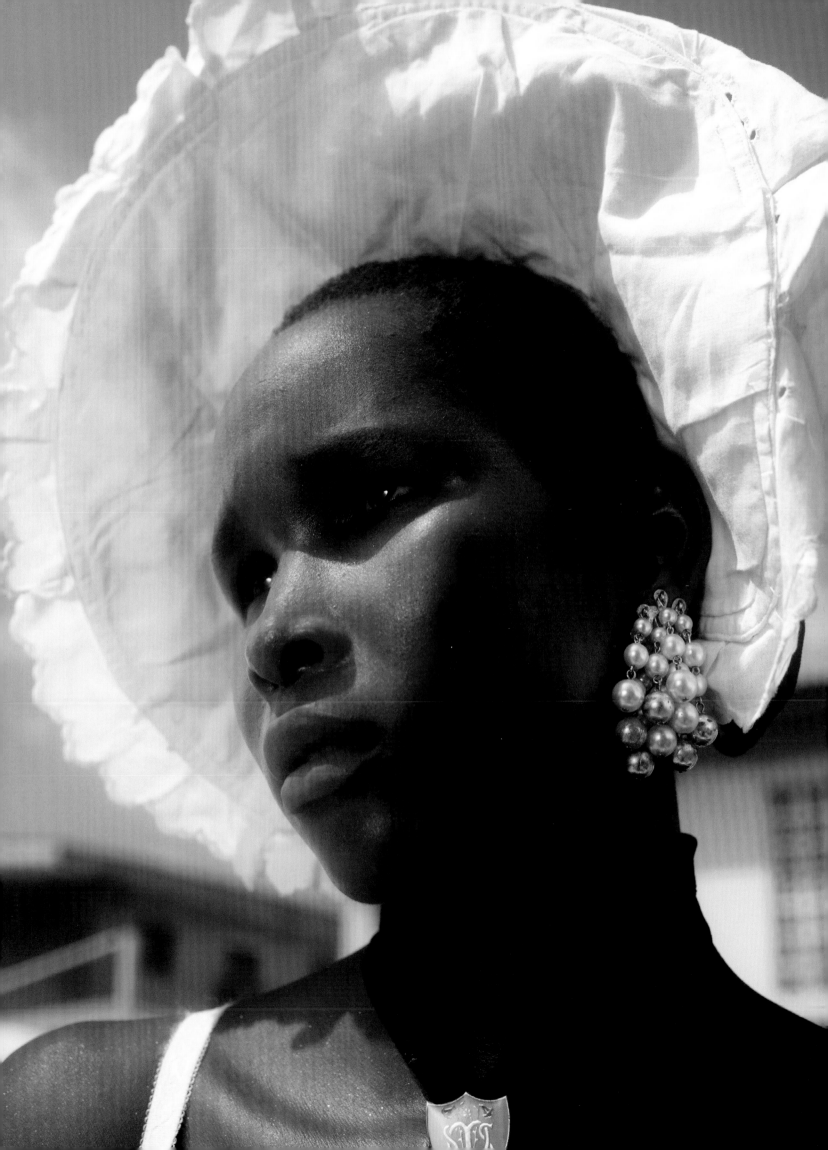

Helga Paris

Daniel Berndt

Although Helga Paris, born 1938 in Pomerania, was self-taught and more interested in amateur photography than in so-called fine art photography, a friend suggested she work professionally after he saw a picture she had taken of her two kids. In 1967, she followed his advice. She had finished her degree in fashion design in East Berlin right before the Berlin Wall was built and was working in the textile industry and teaching costume design, yet eventually became frustrated with the constraints of these fields; the rigid standardizations of East Germany's planned economy didn't offer much creative leeway. Paris then took a job as a photographer's assistant and began to explore her neighborhood, Prenzlauer Berg, capturing its inhabitants and street scenes in melancholic images. In a recent conversation, Paris, now seventy-nine and still residing in Prenzlauer Berg, remarked, "My motivation had nothing to do with my studies as a fashion designer; my interest was always rooted in a documentary approach."

Originally a working-class district, Prenzlauer Berg became the center of East Germany's counterculture in the late 1960s: bohemians, intellectuals, artists, and the gay community moved into the area's run-down *Gründerzeit* houses, which had been built around 1900. There, Paris encountered the men who became the protagonists of her first series: a group of garbage collectors she followed on their route, from the early morning until they went for after-work drinks in neighborhood bars. Paris chronicled a wide swath of Berlin's social spectrum—from teenagers and young punks to elderly people in retirement homes to female textile mill workers—creating an image of real socialism that speaks of both the system's ideals of social equality and its failures.

Most of the self-styled young punks pictured in Paris's work were photographed in the early 1980s in her apartment or her building's stairwell. Despite intimidating appearances, Paris was struck by their sensitivity and tenderness. "Only years later I discovered that Almö, whom I had photographed at the door, was always holding his hand under his burning cigarette so that the ashes would not fall to the ground," she said. "This gesture always touched me. When I was working on a bigger exhibition, I decided to photograph other, quite normal-looking teenagers to present a more diverse picture of Berlin youths."

In contrast to many of her peers, Paris exhibited her work widely, in and outside of the German Democratic Republic. Still, making a living from art was difficult. She earned extra income by taking on commissions, most often making reproductions of other artists' paintings and sculptures, or shooting portraits of writers, including Sarah Kirsch and Christa Wolf. Only recently, as interest in her generation of East German photographers (such as Sibylle Bergemann and Arno Fischer) developed, has Paris received the recognition she deserves; in 2004, she was awarded the prestigious Hannah Höch Prize, followed by a major retrospective at the Sprengel Museum, in Hannover, that same year. In the spring of 2017, Wolfgang Tillmans organized a small exhibition of her photographs, titled *Berlin*, at Between Bridges, his Berlin project space.

Paris stopped photographing in 2008 and has since focused on sifting through her archive, rearranging and compiling the works into new constellations. Her series *Berlin, 1972–1982 / Mappe 3* (2010), shown at Between Bridges, mixes images from two of the artist's earliest series—*Trash Collectors* and *Berlin Bars* (both 1974)—with shots of friends, family, and neighbors. Not unlike a Tillmans installation, these arrangements create links between different subject matters and periods of work. However, her recent exhibition was, above all, an homage to Berlin, or rather the Prenzlauer Berg neighborhood that has shaped her work deeply and consistently over the past fifty years.

Daniel Berndt is a research associate for the Politics of the Image project at the German Literature Archive, Marbach.

Opposite:
Self in Mirror, 1971

Overleaf:
Ramona, Kollwitzstrasse, 1982; *Esther,* from the series *Berlin Youth,* 1981–82

Pages 82–83:
Pauer, from the series *Berlin Youth,* 1981–82; *Manuela,* from the series *Berlin Youth,* 1981–82
All photographs © the artist

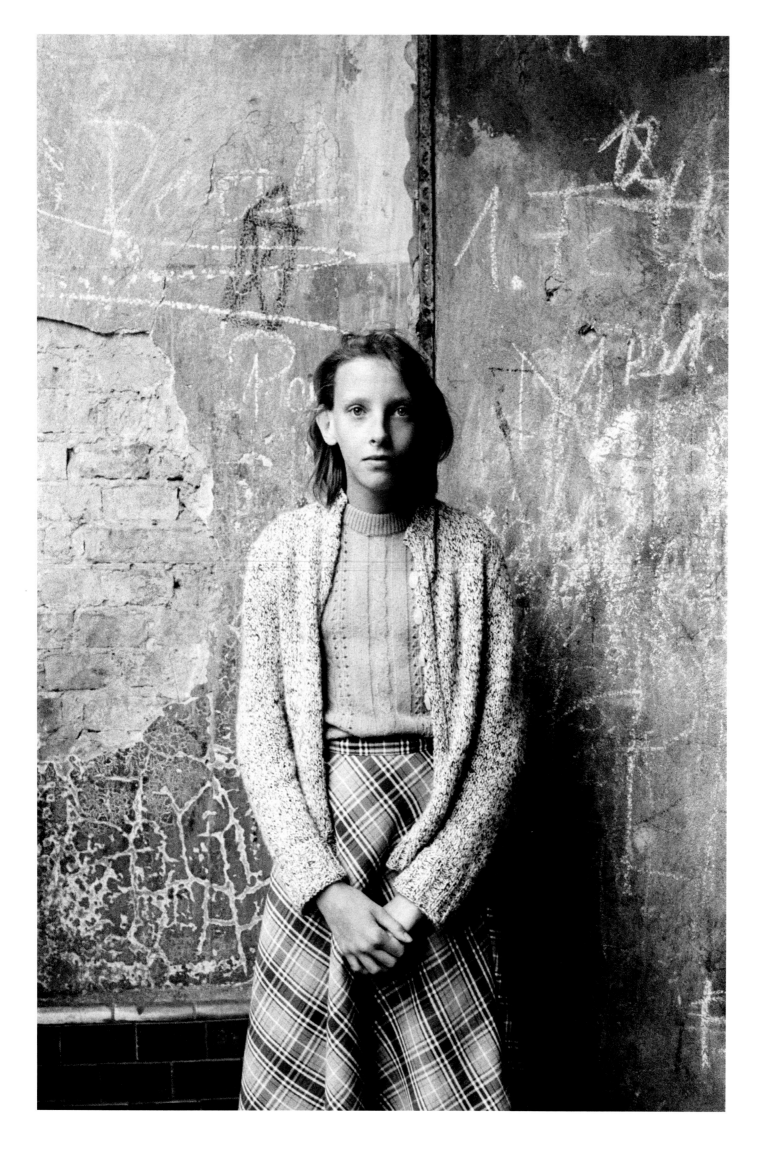

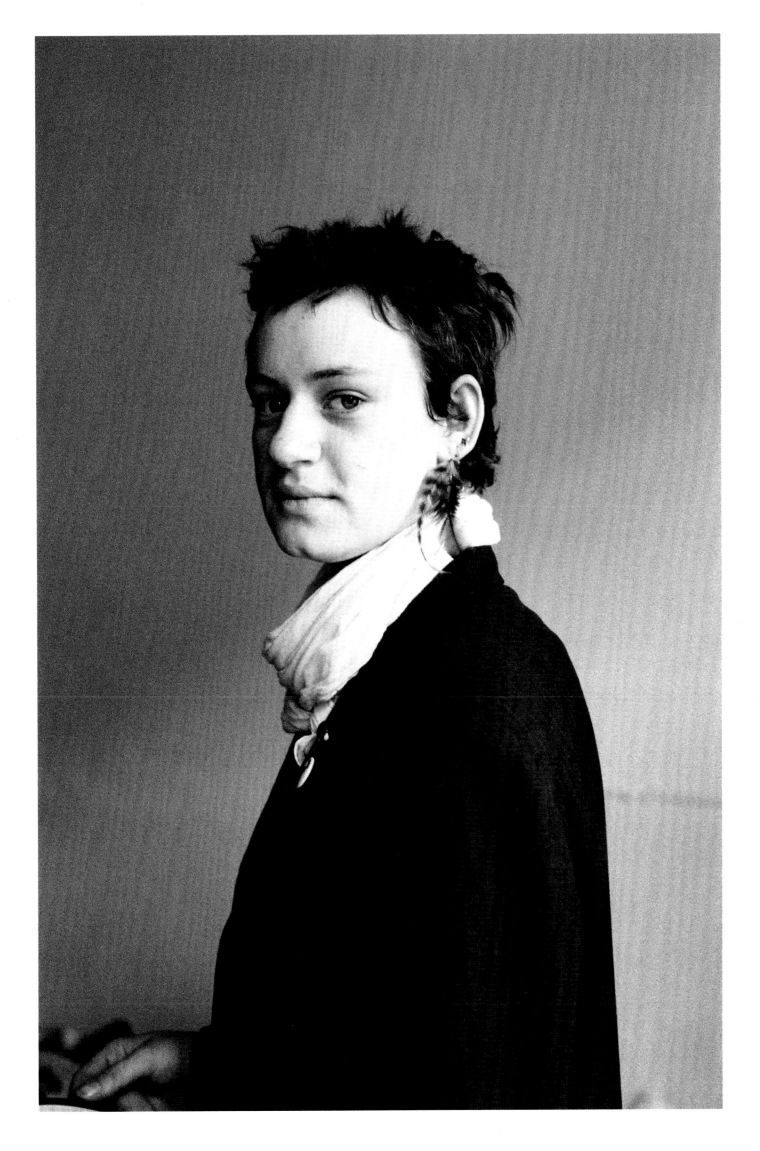

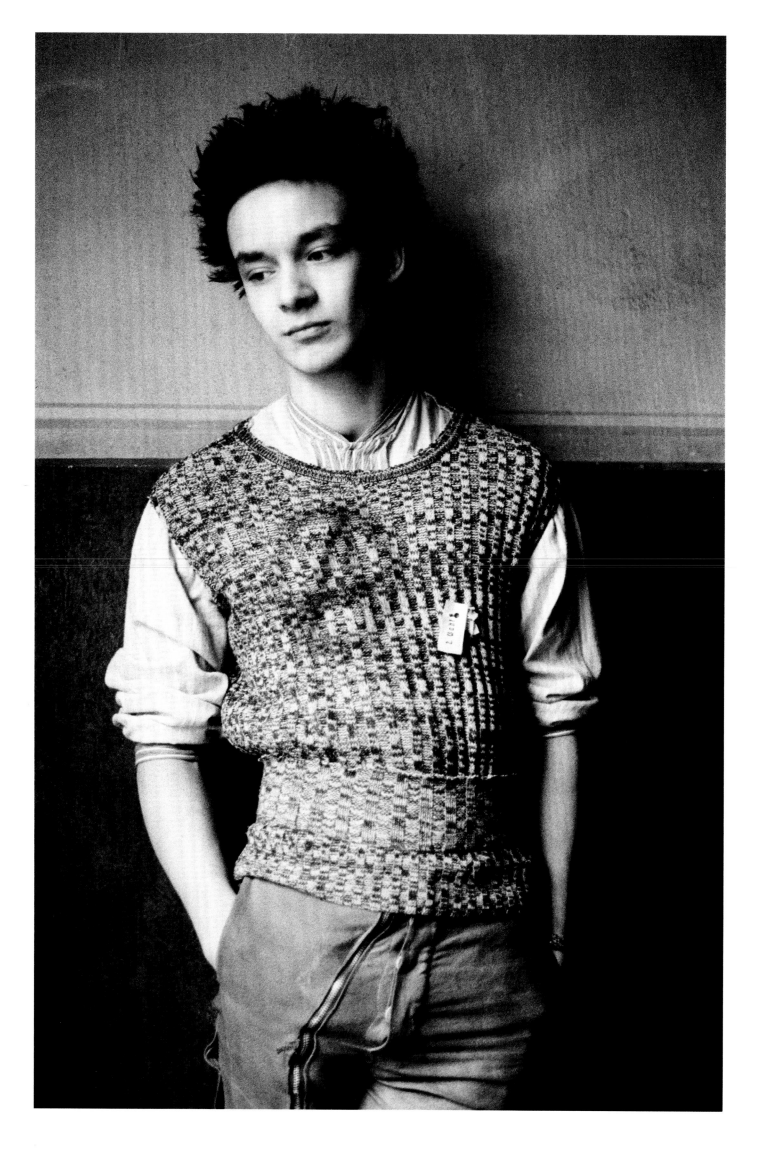

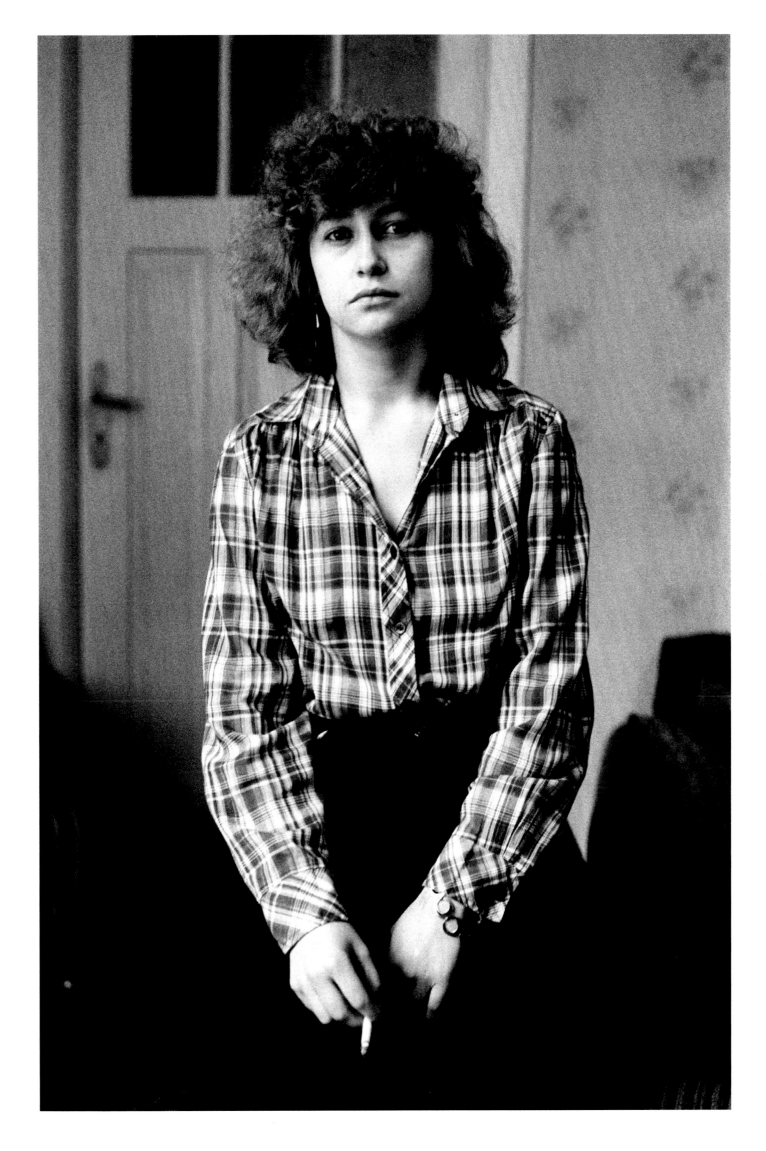

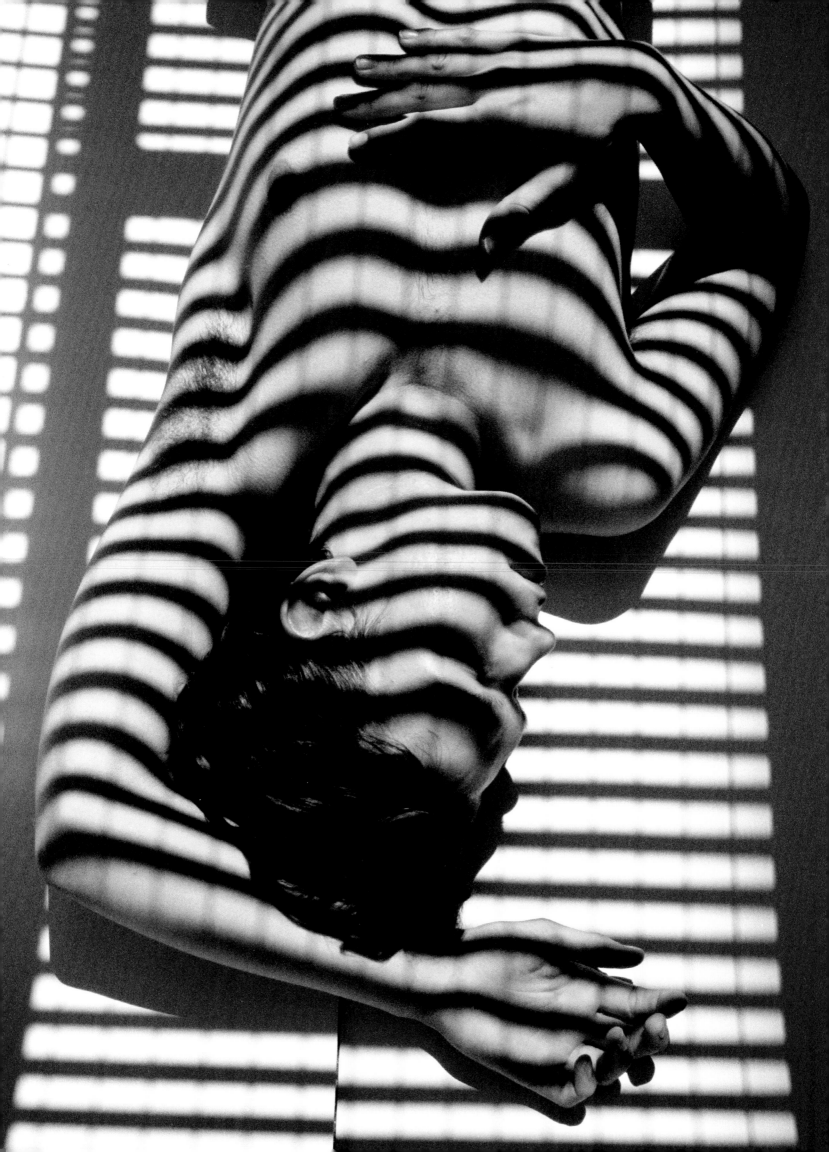

Delighting in male beauty and gender play, a prolific Swiss photographer reinvented the rules of attraction.

The Cult of Walter Pfeiffer

Alistair O'Neill

Visiting the photographer Walter Pfeiffer in his studio in Zurich, you find an orderly space, painted white, possessing the trappings of a typical design studio: swivel chairs, Pantone pens, and a white Formica tabletop on trestles. Yet, lining the walls are exquisitely arranged mood boards, wrapping paper, photographs, posters, plastic props, and a Technicolor cornucopia of cascading bolts of cloth. Early in his career, Pfeiffer was a window dresser for a department store, where he learned the skills of arrangement. Today, he still employs this way of working to test environments and themes for commissions, as if he always has the shopwindow in mind.

Now in his early seventies, Pfeiffer has never been in greater demand. His photographs are exhibited and published worldwide, and he continues to work commercially, represented by a leading fashion-image agency, Art + Commerce, which handles the likes of Steven Meisel, Patrick Demarchelier, and Paolo Roversi. Pfeiffer's style readily connects with the preoccupations of contemporary image makers with whom he is now identified, such as Jack Pierson,

Untitled, 2009

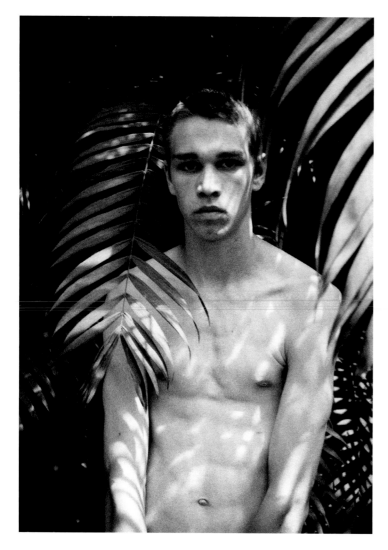

Pfeiffer's training in the commercial gaze taught him how to construct visual seduction.

Wolfgang Tillmans, and Ryan McGinley. Yet, he emerged in the 1970s with an earlier generation of photographers that included Larry Clark, Duane Michals, and Peter Hujar, who explored the instability of gender and sexuality in relation to the male body. To look at a Pfeiffer photograph, such as the lead image for the 2017 exhibition *Smoke Gets in Your Eyes* at F+F design school, in Zurich, of a bare-chested young man exhaling a curling puff of yellow smoke between cupped hands—like a modern-day satyr performing at a party—is to be reminded that masculinity is now rooted in self-awareness, a kind of disruptive sexualization. This is the legacy of the liberation movements of minority groups who undermined the hegemony of heterosexual masculinity in the 1970s.

Pfeiffer's work first garnered attention in 1974 as part of the group exhibition *Transformer: Aspects of Travesty* at the Kunstmuseum Luzern, in Switzerland, curated by Jean-Christophe Ammann, who would become Pfeiffer's long-term editor. The title references Lou Reed's 1972 album; *Transformer* was the first museum exhibition to explore transvestism and nonnormative sexualities as represented in art, fashion, and music. The show brought together American and European practitioners such as Andy Warhol, the Cockettes, Jürgen Klauke, Luciano Castelli, and Urs Lüthi. Pfeiffer exhibited a set of photographs of a young transsexual, Carlo Joh (pictured opposite, bottom right), taken over a number of months in 1973. They charted, across black-and-white images printed on cheap photo paper, a boy in differing states of gender, oscillating between nakedness and drag with the aid of makeup and accessories. Pfeiffer recalls that the sequence "started with Carlo Joh in his blossoming beauty and every time when he came—we photographed maybe once a month—he got thinner, and you see this in the pictures." Carlo Joh died unexpectedly soon after the photography sessions ended, and before Pfeiffer first worked with Ammann on selecting the photographs for display.

The work has an intense beauty, depicting a person at their moment of becoming, just before that beauty is taken from them. As portraits, they show the strength and vulnerability of the trans boy in the visual register of both his glamour and decline. Writing in the introduction to Peter Hujar's 1976 book, *Portraits of Life and Death*, Susan Sontag identified two impulses in photography: one that "converts the world itself into a department store," and another that "converts the whole world into a cemetery." The theory evoked how photographs aestheticize and commodify subjects as much as they ossify them, by marking the beauty of their moment in front of the camera as time passes. Like Sontag's theory, Pfeiffer's photographs of Carlo Joh invoke the department store and the cemetery, just like Hujar's *Candy Darling on Her Deathbed* (a portrait of a Warhol superstar in declining health, now regarded as a significant image of trans identity), also taken in 1973. What makes Sontag's formulation particularly relevant to Pfeiffer is that he actually worked as a department-store window dresser before becoming a photographer.

In the mid-1960s, Pfeiffer was employed at the Globus department store in Zurich, where, he recalls, "you had to create an atmosphere because it was a stage. So you learned what works up and what works down, and about depth, height, and framing, even though I never touched a camera." Pfeiffer's training in the commercial gaze taught him how to construct visual seduction, and it translated readily into a self-taught mode of photography that placed value on the look of things. This made Pfeiffer adept at backgrounds, scenarios, and settings, as well as how to direct a model's gesture and how to frame elements within an image.

Pfeiffer was soon promoted to assist the art director of *Globus* magazine, the department store's promotional catalog, learning illustration, typography, photography editing, and layout design. This led him to enroll in the newly opened private art college F+F (a reference to *Form und Farbe*, the Bauhaus term for form and color),

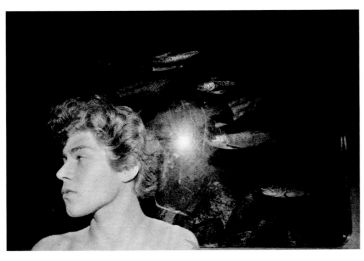

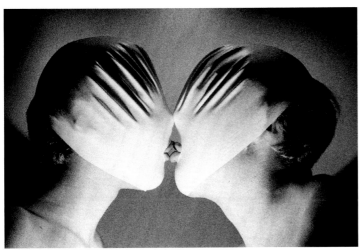

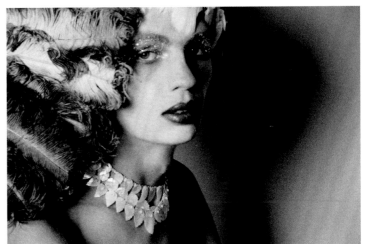

established in 1971 by Serge Stauffer, a Marcel Duchamp specialist, and the artist Hansjörg Mattmüller, who greatly influenced Pfeiffer and first revealed to him that Warhol was a homosexual. It was much later that Pfeiffer found out that Warhol also had an early career as a window dresser and fashion illustrator, but the revelation of his sexuality encouraged Pfeiffer to be open about being gay. At F+F, Pfeiffer, a student of painting and drawing, was exposed to art history via Dada, a movement that started in Zurich at the Cabaret Voltaire, and to contemporary Swiss design, typified by graphic designer Josef Müller-Brockmann. The design principles absorbed during his schooling are visible in his 1977 portrait series *Chez Walti*, which includes Pfeiffer as a model, and makes use of brightly colored backgrounds and matching food props. His ongoing, confident handling of saturated color and graphic motifs were born out of a calibrated approach to art directing his own work.

After being introduced to British Pop artist Peter Phillips via Phillips's girlfriend, who ran a fashion boutique in Zurich, Pfeiffer arrived in London for a short trip in 1970. He met shoe designer Manolo Blahnik (who had seen Pfeiffer's shoe illustrations in *Twen* magazine) at the opening of an exhibition at Arthur Tooth & Sons by Pop artist Allen Jones, which displayed fetishistic female mannequins posed in furniture forms—a chair, a table, a hatstand—that would incite feminist criticism. Staying with Blahnik in his Notting Hill flat, Pfeiffer unwittingly entered a small enclave of fashionable creatives who were obsessed with nostalgia and fed on old movies shown at the Electric Cinema on Portobello Road. They included artist David Hockney, textile designer Celia Birtwell, fashion designer Ossie Clark, and fashion editor Anna Piaggi, and, as such, the scene connected to the culture of Warhol's underground superstars in New York, which reprised the star system of Hollywood's golden era and an interest in the aesthetics of the 1920s.

Returning to Zurich, Pfeiffer continued his job as a commercial illustrator, living in a small white room simply furnished with a bed, a table, and a television. "When I made my illustrations, I worked on the table, and when friends came round they sat on

Pfeiffer anticipated nearly all of the contemporary strategies for queer representation by more than two decades.

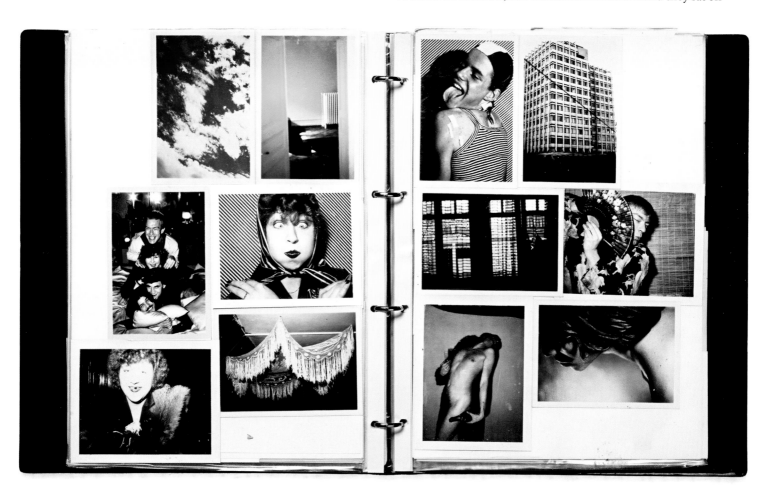

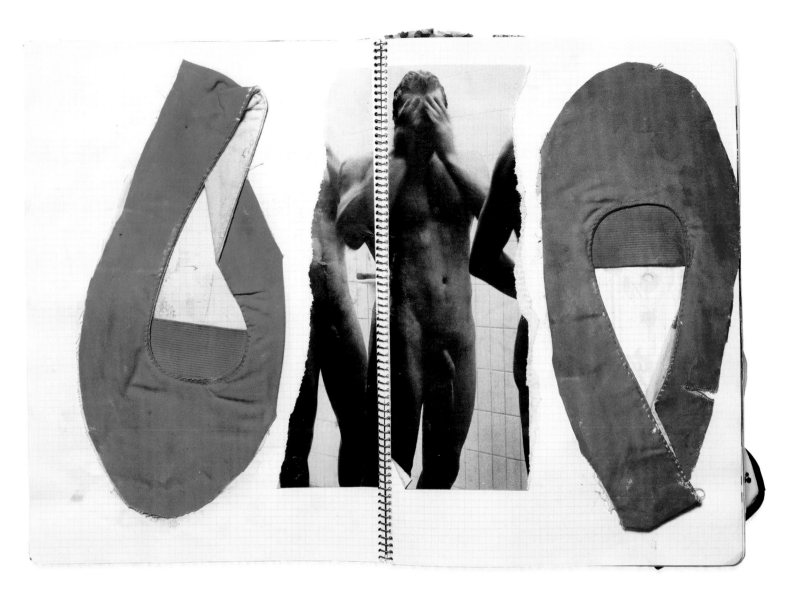

the bed, and then I started to use this camera to take pictures of them," Pfeiffer remarked, referring to a small white Polaroid with which he shot copies of his illustrations. By turning the camera on his guests, he took his first photographs. Incorporating discarded window-display props from his day job, he created his own one-room nostalgic star system.

The scale of his site-based, theatrical photography soon expanded when Pfeiffer, in the early 1970s, rented a large villa near the lake in Zurich to live in, regularly staging parties where guests would be sprayed with perfume on arrival and directed to be "always on camera" for the duration of the evening. But all the campy exultation these scenarios produced was tempered by Pfeiffer's wish to segue into the everyday life of his friends, what he called "their habits, objects, and traces." The edited, Muybridge-like run of connected images he took at these events was shown in 1974 at Galerie le Tobler, in Zurich, where photographs were collaged over textile samples set into cheap frames and bound photo albums of portraits were set out on tables for visitors to look through. The display offered glimpses into a way of life carried out by a group of young confidants without much money, but possessing the will to reinvent themselves by being photographed.

The presentation of the photo albums is reminiscent of Pfeiffer's scrapbooks, made for his own satisfaction from 1969 to 1985, which are now celebrated for their incongruous and iconoclastic juxtapositions of found images, mixing male anatomy, objects, flora, fauna, and food to startling effect. In Pfeiffer's world, everything is intense and nothing is natural; it is a queer material culture of sorts. Yet the color and combinations of Pfeiffer's scrapbooks are far from the aesthetic found in the black-and-white

photobook that made his name. First published in 1980, with a second edition printed in 2004, *Walter Pfeiffer: 1970–1980* was, according to a 2003 *Artforum* profile, one of the two most thumbed-through photobooks during the 1980s at Printed Matter, a specialist bookshop in New York. (The other was Larry Clark's 1981 *Teenage Lust*, which also operates in a terrain that is neither documentary nor pornography.) Pfeiffer's book features young men he knew from teaching drawing classes at F+F, as well as those he met in local bars and clubs. The photographs show close crops of mostly naked bodies in a variety of positions. In some instances, modeling was brokered; the subject decided which frames could be used and which had to be destroyed. The final images were selected by Ammann, who insisted on including full-frontal nudity. As Pfeiffer recalls, "Without the cocks it still would have been a good book, but with those forceful things it was better."

International recognition came to Pfeiffer much later, in the form of a survey exhibition and publication titled *Welcome Aboard*, shown at Galerie Schedler in Zurich in 2001 and the Scalo Project Space in New York in 2002, followed by a retrospective at the Centre Culturel Suisse in Paris in 2004. But a more prescient indicator of the changed world of visual culture is a 2005 profile that appeared in *Butt*, a Dutch gay-interest fashion magazine printed on pink paper and published by Gert Jonkers and Jop van Bennekom. *Butt* (and for a short time its sister title, *Kutt*, which means "cunt" in Dutch) aimed to make a virtue of the number of gay creatives involved in the fashion world, promoting a European aesthetic for making queer sensibilities visible in fashion photography that veered away from the look of American hetero "porno chic" developed by Terry Richardson.

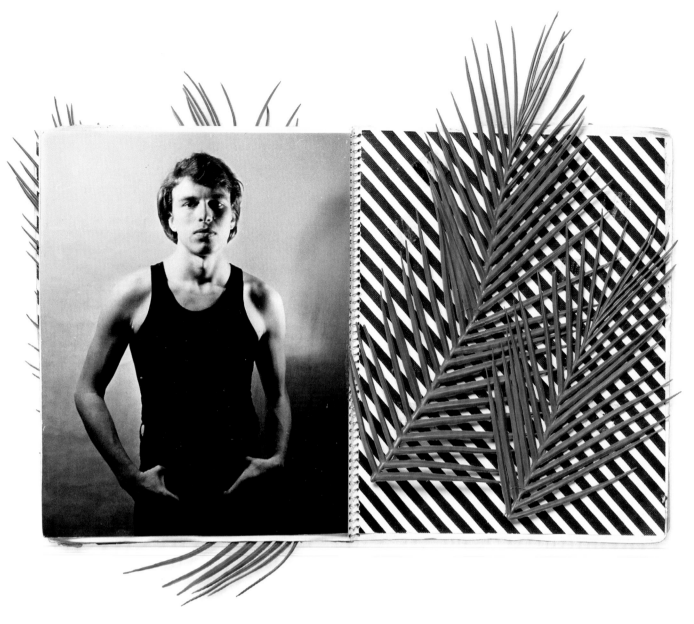

In addition to an interview with Pfeiffer and a survey of his photographs, issue fourteen of the publication contains a Marc Jacobs advertising campaign of Rufus Wainwright shot by Juergen Teller, an advertisement for a Wolfgang Tillmans monograph by Taschen, an article on fashion stylist Simon Foxton's homoerotic scrapbooks, and a readers' section, "Buttstuff," featuring amateur photographs of readers' behinds. It must have been a curious "arrival" for Pfeiffer, who had anticipated nearly all of the creative strategies for queer representation presented in the issue by more than two decades.

Jonkers and Van Bennekom went on to launch the fashion magazines *Fantastic Man*, in 2005, and *The Gentlewoman*, in 2010. By continuing to commission Pfeiffer for editorial work, they helped bring him to the attention of other fashion titles, including French *Vogue*, *i-D*, *Self Service*, and *Dazed*, as well as fashion labels such as A.P.C., MSGM, Pringle of Scotland, and Hermès. One of the reasons for Pfeiffer's late-blooming success with fashion is his ability to direct an attitude about bodies without having to rely on clothes, which suits the homogenous nature of much contemporary fashion. As a young man with aspirations to be an artist, Pfeiffer knew about the closed, elite world of fashion: in the '70s he traveled to Milan to buy his shoes and he read fashion magazines, loving the otherworldly photographs by Guy Bourdin. It is telling that the world of fashion, so distant to Pfeiffer as a young man, would not only come to embrace him as one of their own, but would also co-opt his territory of image making, produced on the periphery, as their own.

When shooting the images for his first photobook, Pfeiffer was told by his editor, Ammann, that he must publish the full extent of what he had captured, as the future might not be so permissive. It would be easy to argue that Ammann got this wrong, as the twenty-first century heralds a newfound visibility for queer visual culture celebrated not just in museums and galleries, but also within aspirational commercial imagery. And yet, just like the subject matter that this aspect of photography tends to coalesce around— what Pfeiffer calls his "beauties"—this visibility might yet be merely provisional, particularly as we enter our new political landscape. Asked what propels him to photograph beauty, Pfeiffer responds, "Because you do not know how fast she is fading."

This page:
Untitled, 1975

Opposite:
Untitled, 2004

Overleaf:
Untitled, 2004;
Untitled, 2009
All photographs courtesy the artist and Art + Commerce

Alistair O'Neill is professor of fashion history and theory at Central Saint Martins, London.

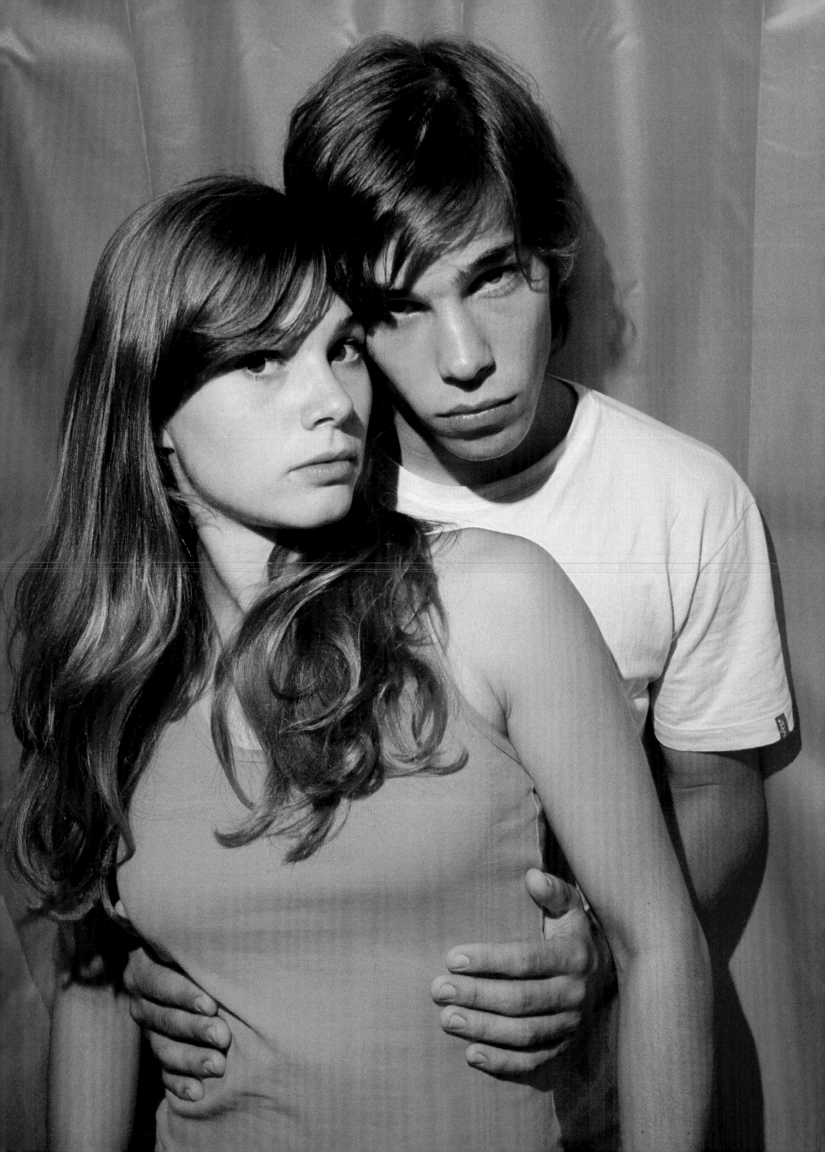

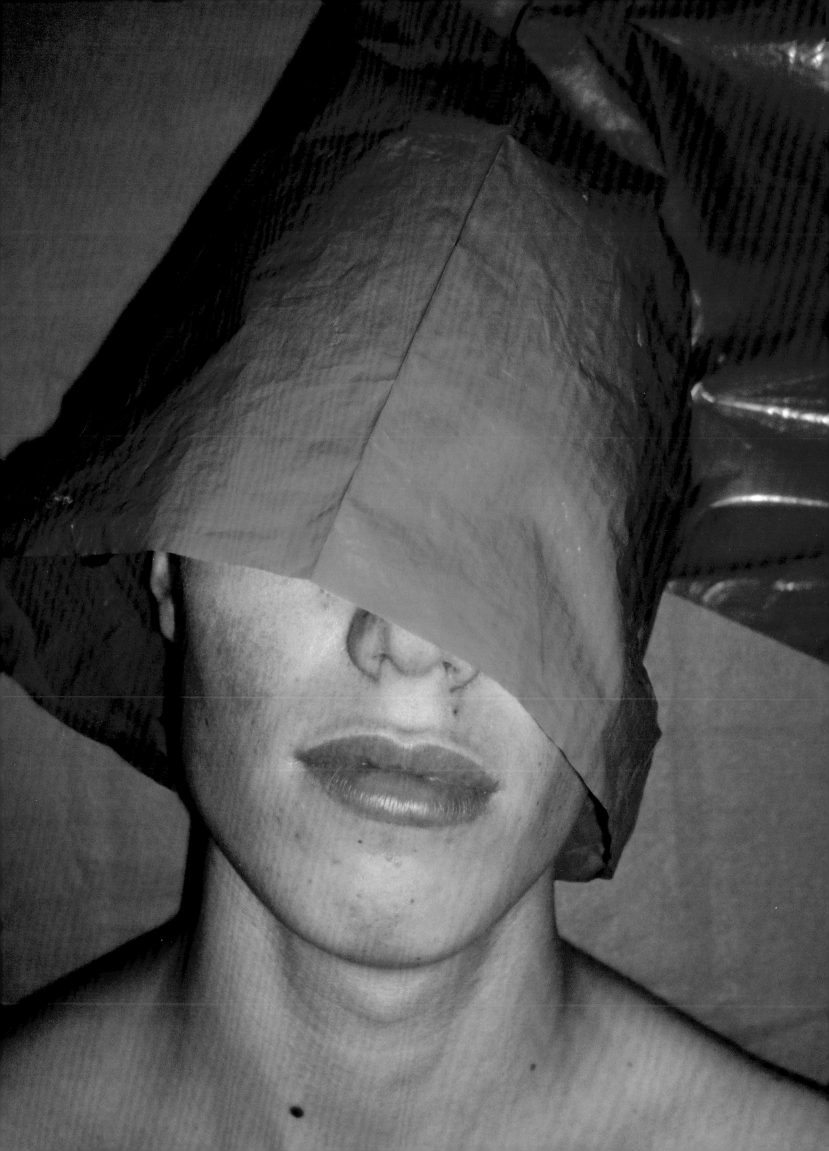

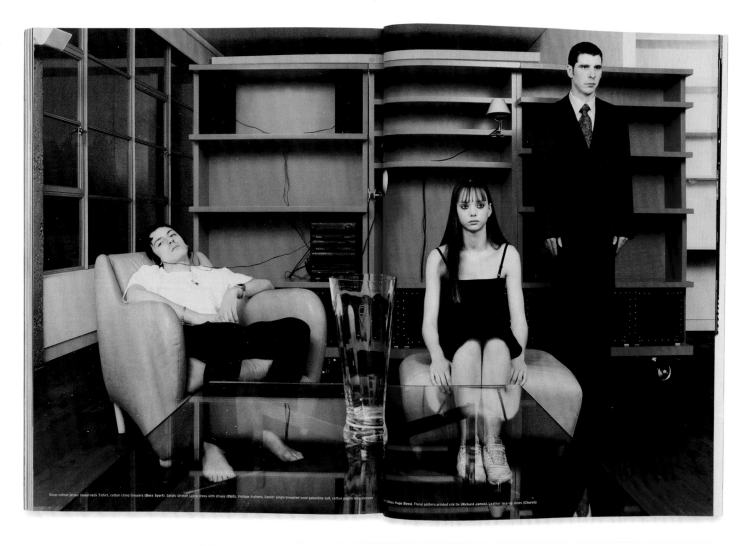

Enzo: cotton jersey round-neck T-shirt, cotton chino trousers (Boss Sport). Sarah: stretch Lycra dress with straps (D&G). Vintage trainers. Daniel: single-breasted wool gabardine suit, cotton poplin long-sleeved ... (Boss Hugo Boss). Floral pattern printed silk tie (Richard James). Leather lace-up shoes (Church)

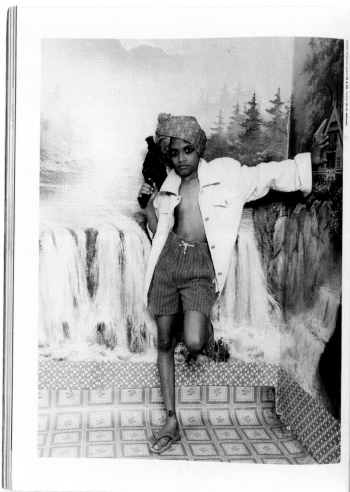

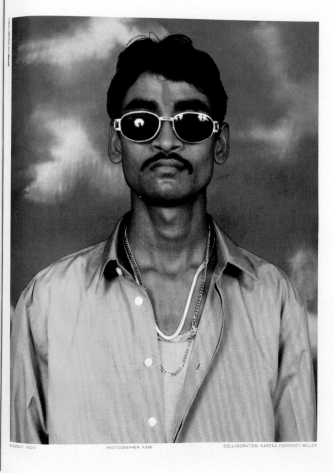

BOMBAY INDIA PHOTOGRAPHER: KAMI COLLABORATION: KARENA PERRONET-MILLER

The International Style

In the late '90s era of *Vogue Hommes International*,
a cosmopolitan vision of fashion
Adam Murray

The aim was to "make people look like they are wearing their own clothes," Phil Bicker told me recently, on a gray afternoon in central London. Bicker was the art director of *Vogue Hommes International* from 1997 to 2000, a short tenure considering that, as the magazine is a biannual publication, this meant working on just six issues. Nonetheless, it was an influential moment in the history of fashion image making, occurring at a time when stalwart British youth culture bibles, such as the *The Face* and *i-D*, struggled to navigate the digital revolution that had usurped their position as gateways to culture.

Bicker had come to prominence in the 1990s as art director of *The Face* during its heyday, where he gave an early platform to Corinne Day, Nigel Shafran, Juergen Teller, and David Sims, young photographers who, at the time, were each developing a recognizable style informed by diaristic, snapshot sensibilities. At *Vogue Hommes International*, a magazine intended for an older, cosmopolitan audience, Bicker experimented by commissioning established photographers, some of whom would not usually produce work for a fashion context, such as Samuel Fosso, Philip-Lorca diCorcia, Joseph Szabo, and Joel Meyerowitz. "The dominant way of working for an art director was to find a reference point," Bicker explained, "then commission a fashion

This page:
Nadia Benchallal, from
autumn 2003/winter
2004 issue, "CH'ADORE."
Stylist: Leïla Smara
Courtesy the artist

Opposite:
Koto Bolofo, from "Soweto
Swings," spring/summer
1998 issue. Stylist: Andrew
Dosunmu
Courtesy the artist

Could a fashion publication identify a zeitgeist and also engage social ideas?

photographer to interpret the work, rather than commissioning
the photographer who produced the original reference." Even
today, it's still rare to see a mainstream publication commission
such a range of photographers so prolifically.

Bicker was of course aware of the work of Alexey Brodovitch
and Alexander Liberman, art directors during the mid-twentieth
century at *Harper's Bazaar* and *Vogue*, respectively, who understood
how a fashion publication could not only identify a zeitgeist,
but also engage social and political ideas through the lens of fashion.
Koto Bolofo, a South African–born photographer and filmmaker
who moved to London with his family as a child in 1963, was an
active contributor to *Vogue Hommes* during this time. For the
story "Soweto Swings," featured in the spring/summer 1998 issue,
Bolofo produced a series in Soweto, a township of Johannesburg,
with stylist Andrew Dosunmu. "My objective was to show what
township style was like," he told me. "You can crush a person down
to the lowest common denominator, but there is still that blossom
of dignity. Andrew was good at simulating how the local people
would dress." Bolofo and Dosunmu drove around and cast models
from the street. "The people were proud to hear that a black person
could be in *Vogue*. There was a proud element between all of us,
people became very open."

While the current trend in styling is for clothing that appears
obviously unnatural, almost costume-like, to the person being
photographed, in a Bicker-era *Vogue Hommes International* editorial,
the clothing does not feel imposed on the model. Each person
wears the clothes; the clothes don't wear them. There is a subtle
modesty to the styling and an awareness of the role clothing
plays in everyday life. "Each stylist is demonstrating an awareness
of clothing that is worldly, not just fashion worldly," Bicker noted.

While Bicker would move on from the magazine in 2000,
his legacy continued. Under the editorship of Richard Buckley and

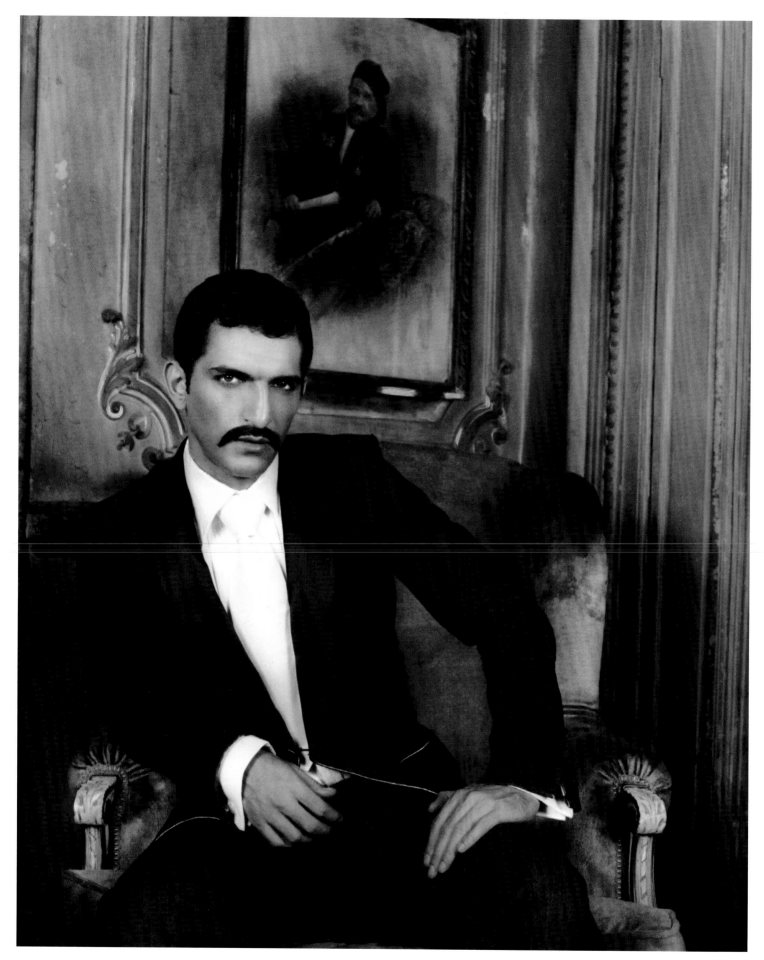

This page:
Youssef Nabil, from
"Cairo Story," autumn
2003/winter 2004 issue.
Stylist: Paul Mather
Courtesy the artist and
Galerie Nathalie Obadia,
Paris and Brussels

Opposite:
Hannah Starkey,
*Marc (Raf Simons)
and Tanya (Jean Paul
Gaultier),* spring/summer
1998 issue. **Stylist:
Melissa Moore**
Courtesy the artist

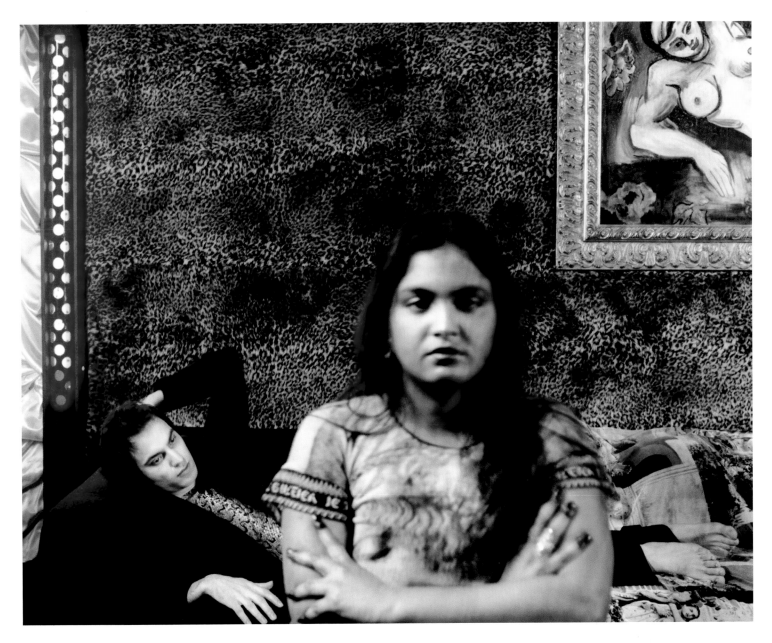

art direction of Donald Schneider and Robin King, photographers such as Stefan Ruiz, Taryn Simon, and Collier Schorr were commissioned to continue to use photography that explored society and culture at a global level. The autumn 2003/winter 2004 edition focused entirely on the Middle East. Released during the height of post-9/11 jingoistic rhetoric in the U.S. and U.K., this feature could have read as cultural tourism from the fashion world, or as a clumsy response to an urgent geopolitical crisis.

But Buckley, Schneider, and King understood the power of commissioning photographers who had personal experience within the region. This helped to avoid clichés, or worse. Egyptian artist and photographer Youssef Nabil produced a series of portraits in Cairo in the hand-painted style for which he has become known. French Algerian photojournalist Nadia Benchallal, whose major project *Sisters* (1992–ongoing) explores the private and public lives of Muslim women in Algeria, Palestine, Bosnia, and Iran, among other places, traveled with the publication's fashion editor, Leïla Smara, to Ramallah, in the West Bank. There, she photographed a street-cast series of young men hanging out at a café, a cinema, beside a taxi, and downtown. Smara also collaborated with Turkish German photographer Timur Celikdag in Kuwait City on a series of images that arguably share the most in common aesthetically with fashion images that we are familiar seeing shot in Western megacities, each image in "straight-up" style, with the person posed in front of a hyperreal cityscape.

Two decades since Bicker began at *Vogue Hommes International*, the fashion image remains, alongside photojournalism, the dominant mode of photography engaged with in daily life throughout the world. And while there is greater awareness of the need for diversity, the pitfalls of cultural appropriation, and the importance of global awareness, the fashion world tends to play it safe. At the establishment level of the industry, a regular roster of not exclusively but largely white Western men produce most of the editorials and advertising photographs that we see. This overlooked period of image making is a reminder that, as Hannah Starkey, now a celebrated artist who was commissioned by *Vogue Hommes* during this era, put it, "A fashion image can be many things, but for me in these shoots, they are allegories of and for our time."

Adam Murray is a lecturer at Central Saint Martins, University of the Arts London, and Manchester Metropolitan University. He recently cocurated *North: Identity, Photography, Fashion* with Lou Stoppard at Open Eye Gallery, Liverpool.

Buck Ellison

Rebecca Bengal

For Buck Ellison, a California-based photographer who stages deadpan, meticulously stylized pictures of people in elite, banal-seeming scenarios, privilege is defined in minute details and practically unseen movements. Elise Silver, a model cast in *Oh* (2015), a study of innocuous teenage expression, will be recognizable to those who have seen her as a glamorous figure in luxury car advertisements. In *Untitled (Cars)* (2008), when Ellison ventures into the world of automobiles, two Land Rovers are parked at ridiculously steep angles. It captures a dealership's demonstration of the vehicles' rugged capabilities—cartoonishly tough, masculine, expensive. At closer glance, one of the cars bears a vanity license plate reading MARIN, the name of the Northern California county where Ellison was raised, one of the most affluent in the country.

Growing up, Ellison says, "I felt guilty that I was attracted to symbols of wealth, because they are often facilitated by things I find reprehensible." When he was fifteen, Ellison saw an editorial campaign for the brand Kate Spade that he later learned had been photographed by Larry Sultan. It depicts, in staged scenes, an upper-middle-class family's tourist trip to New York to visit their daughter, with their accompanying forays into consumerism. A photographer himself since 2008, Ellison sets about re-creating deliberately artificial depictions of the kind of life he was born into, crafted with the precision of commercial shoots.

For a commission by *Arena Homme +*, Ellison cast agency models to portray members of his own family, approximating the idea of a traditional, seated portrait. ("It was always my dream to do a portrait of my family," he says, "but they didn't share my enthusiasm.") Working with the stylist Charlotte Collet, Ellison shot nearly four thousand frames, purposefully exhausting his subjects until they stopped acting. Embedded are subtle codes and imperfections: the stiffened smiles, the wrinkles and rumples in the carefully dressed-down clothing, the silver tray of cocktail tumblers, the child with his face in a phone.

Ellison's stage-managed casualness brings to mind Tina Barney's complex, intimate photographs of her family; they share Barney's rarefied milieu and immersive feeling without being documentary. "It's not about capturing a moment before it disappears, but finding something that's almost invisible or illegible to the rest of us," he says. His pictures are an investigation of small gestures—a frank, off-kilter conversation between advertised and unspoken wealth, somewhere between aspiration, imagination, and projected reality.

The similarity between the minimalism of *Hilda* (2014) and the cool detachment of Thomas Ruff and the photographers of the Düsseldorf School—in particular the painterly, late 1980s and early '90s family portraits of Thomas Struth—isn't a coincidence. Ellison studied German literature at college in New York before relocating to Germany for graduate school, a move that added another dimension of distance from which to view the visual projections of privilege in the United States. At the Städelschule Frankfurt, Ellison collected advertisements for Deutsche Bank and luxury watches—"images of prudent investment," he says a little wryly. He looked at early U.S. colonial portraits, particularly those by less technically skilled painters: "There was so much insecurity about who we were as a country." In his studio, he pinned Bruce Weber's photographs from Ralph Lauren campaigns to his wall: contemporary, idealized renderings of the American West as envisioned by the Bronx-born fashion designer who changed his name from the Belarusian Ralph Lifshitz to create a global brand.

In their own way, Ellison's photographs lift the taboo that still protects the upper echelons of American life. "It's like, 'don't talk about money,'" Ellison says from Los Angeles, where he lives and works now. Instead, he borrows that attitude of reserve to provoke dialogue, allowing complicated social dynamics to play out beneath the exterior of clean, formal arrangements. Using the inner vocabulary of privilege, Ellison shows the fissures that seep through its idealized surfaces.

Rebecca Bengal is a writer and editor based in New York.

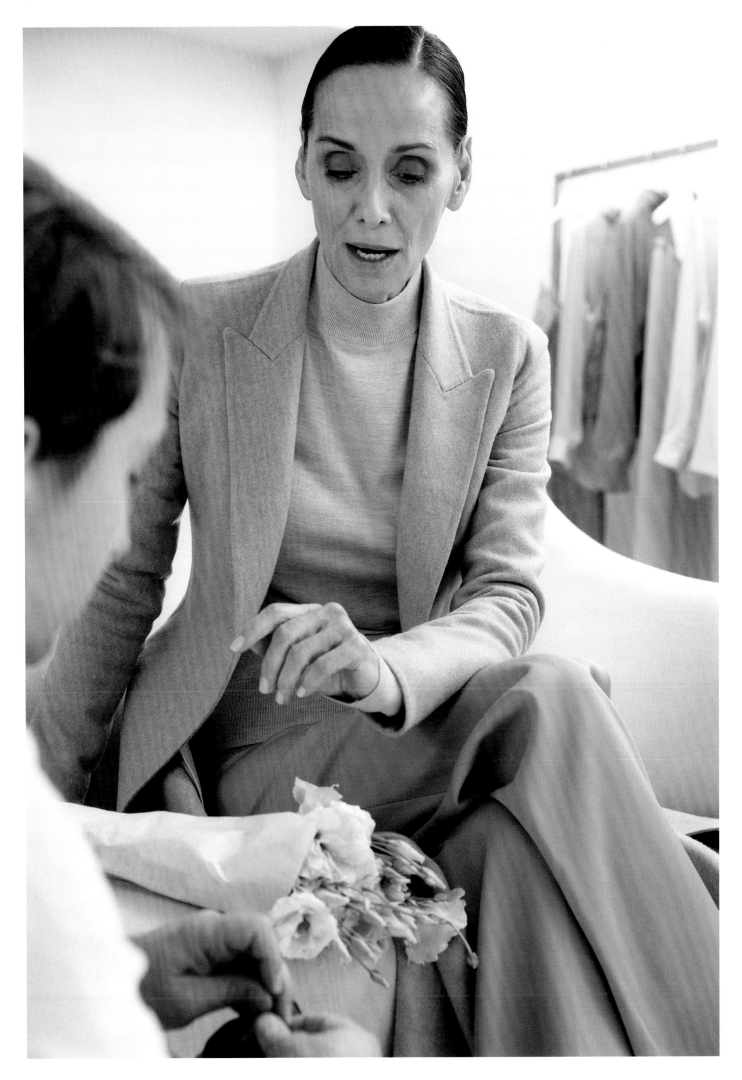

Previous page:
Mama, 2016

This spread:
Untitled (Family Portrait),
2017

Oh, 2015

Anxious Avoidant, 2016

Hilda, 2014

Untitled (Cars), 2008
All photographs courtesy
the artist and Balice Hertling,
Paris

Olgaç
Bozalp

Kaya Genç

Olgaç Bozalp's photographs are like Georges Simenon novels. They feature characters who appear to hold many secrets: one wonders whether they are what they seem. In his fashion shoot *Manufactured Self* (2016), Bozalp's subjects wander along corridors of a London school in varying poses of distress. In *Misfits* (2017), a group of young men wear garments too loose for their bodies. These discrepancies between clothes and skin, and between the way Bozalp's characters self-represent and the photographer's presentation of them, result in delicious instances of awkwardness that turn those uneasy figures into mysteries.

For Bozalp, the rift between how we present ourselves and how we are perceived by others hits close to home. When he traveled to Istanbul last year for a Gucci commission, Bozalp was aware of his reputation in London as a rising fashion photographer. Yet, he has steered his career toward more artistic and journalistic projects. He enjoys investigating and discovering his subjects and describes his work as reportage. This does not quite fit into the world of fashion photography, where brands and consultants, rather than people themselves, are the ultimate deciders of how a subject is framed. Bozalp wants his subjects to speak through their garments.

From his apartment in London's Ealing neighborhood, Bozalp recalled his excitement when the French fashion magazine *Antidote* commissioned him for its summer 2017 "Borders" issue. This assignment took him on a two-and-a-half-month journey across geographies as diverse as South Africa, Lebanon, Turkey, and France. Bozalp had long dreamed of traveling to Iran for work, since he had never seen a photo shoot from there in a fashion magazine, thanks to the country's postrevolution restrictions; to his delight, Tehran was also on the list.

Bozalp is no stranger to closed cultures. He was born in 1987 in the central Anatolian city of Konya, located in Turkey's conservative heartland. When he visited his hometown for the "Borders" project, Bozalp ended up photographing his grandmother and her next-door neighbor. "I have a random and guerrilla working technique," Bozalp says. "I meet my subjects and often spend not more than fifteen minutes before taking their pictures."

This technique has led to unexpected encounters. During the "Borders" shoot in Beirut, Bozalp found himself in a neighborhood that reminded him of his Turkish hometown; he looked through the windows and spotted an apartment filled with the kind of furniture he sees in Turkish homes—traditional rugs, prayers on the wall, net curtains—which attracted his attention. He knocked on the door to ask if he could use the house for a photo shoot. Although in mourning for her husband, who had died the previous week, the woman who answered his knock said yes. "She wanted to dress up for something. I could sense the electricity in the air. This is how photography works: through chance events."

Bozalp's photographs for *Numéro Homme Berlin*'s November 2016 issue, documenting the lives of Turkish immigrant families in Berlin, constitute some of his most striking work. In one picture, a tall Turkish man, dressed in a mustard-colored outfit, is kneeling on the oriental rug of his apartment. A picture of himself as a child hangs on the wall: we get not one, but two versions of his self-representation. Another image shows two remote controls from the Turkish man's apartment. Wrapped in transparent plastic, even electronic devices have their own garments.

"I don't like dressing people up. I am okay with adding an accessory to their outfit, but that is about it," Bozalp says. And this provides us with the central dilemma, and strongest quality, of his work: in their authenticity—which is often coupled with the touch of a fashion stylist—Bozalp's characters resist an orientalist representation of non-European subjects. But they are also fictions: they appear like fashion models with no interest in selling anything other than their mysteries. The more Bozalp desires to capture the truth of his subjects, the more fictional they appear to our eyes.

Kaya Genç is an Istanbul-based essayist and novelist. His latest book, *Under the Shadow: Rage and Revolution in Modern Turkey*, was published in the United States in 2016.

Opposite:
*Turkish Immigrant,
Berlin*, 2016

Overleaf:
Lebanon, 2017;
Tehran, 2017

Pages 112–13:
Lebanon, 2017;
Gucci x Istanbul, 2016
All photographs courtesy
the artist and Industry Art,
London

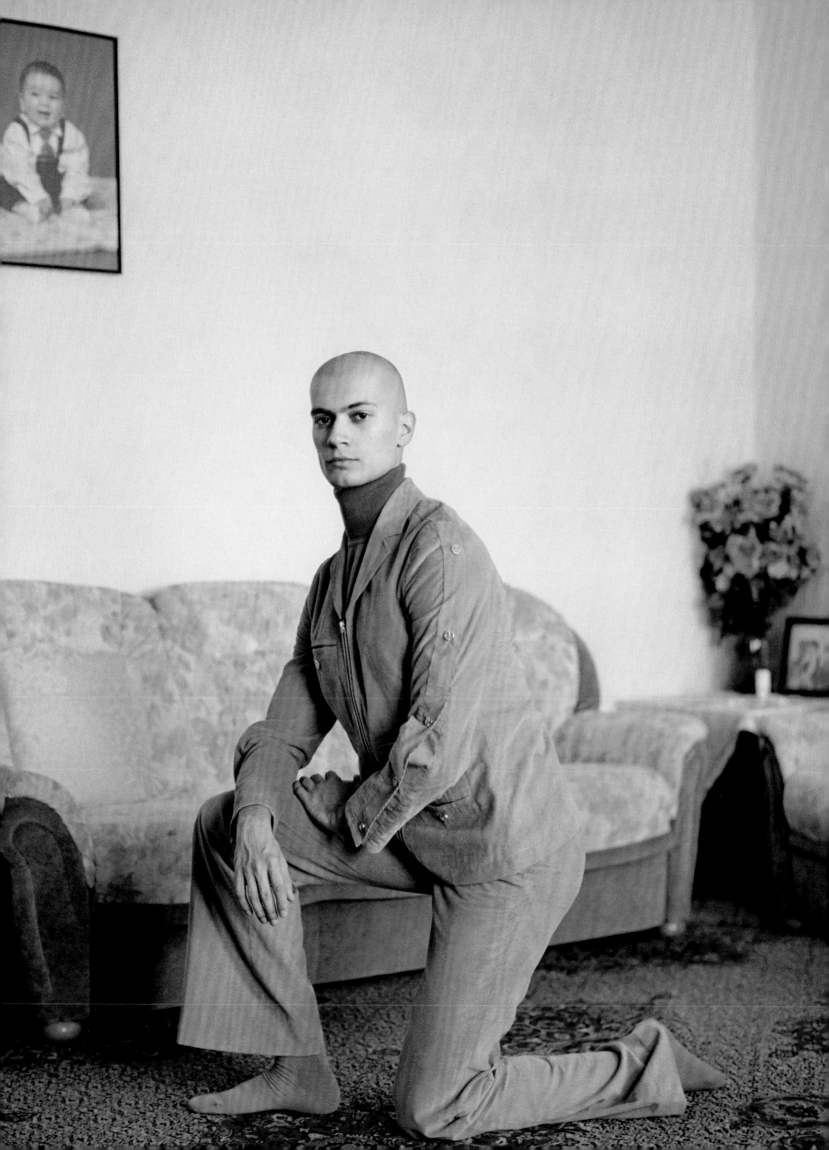

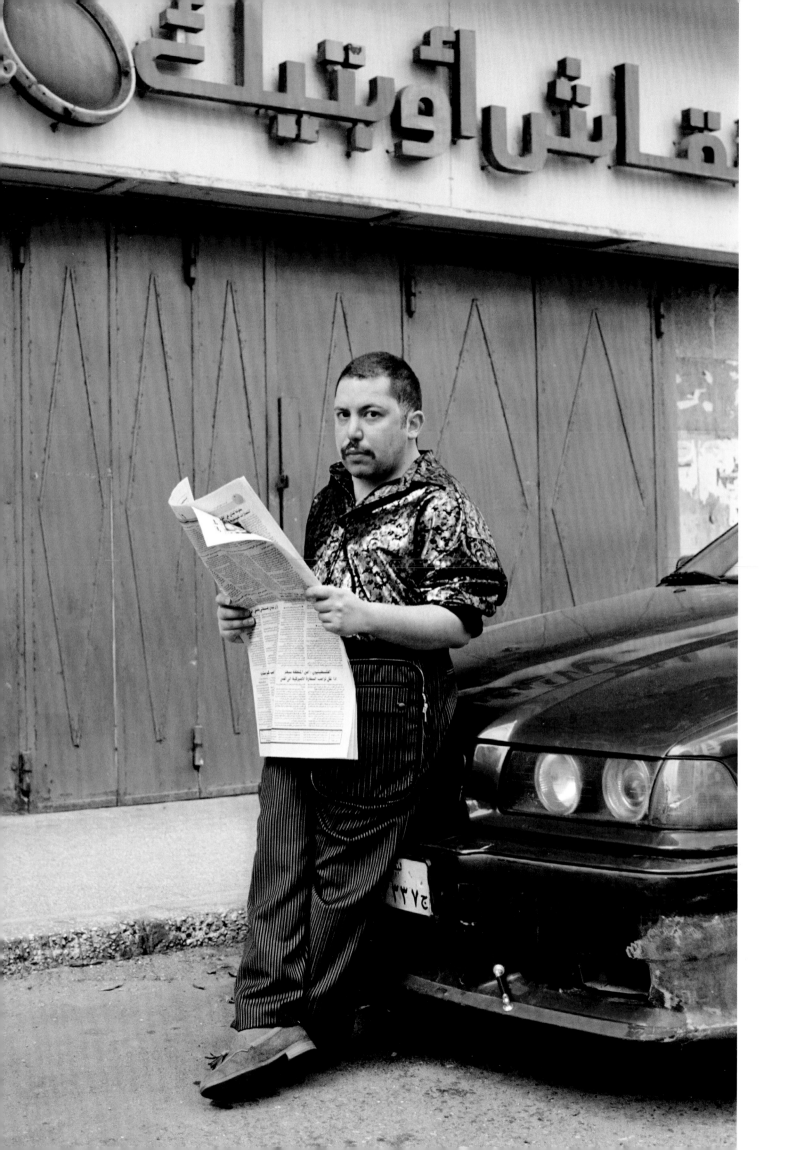

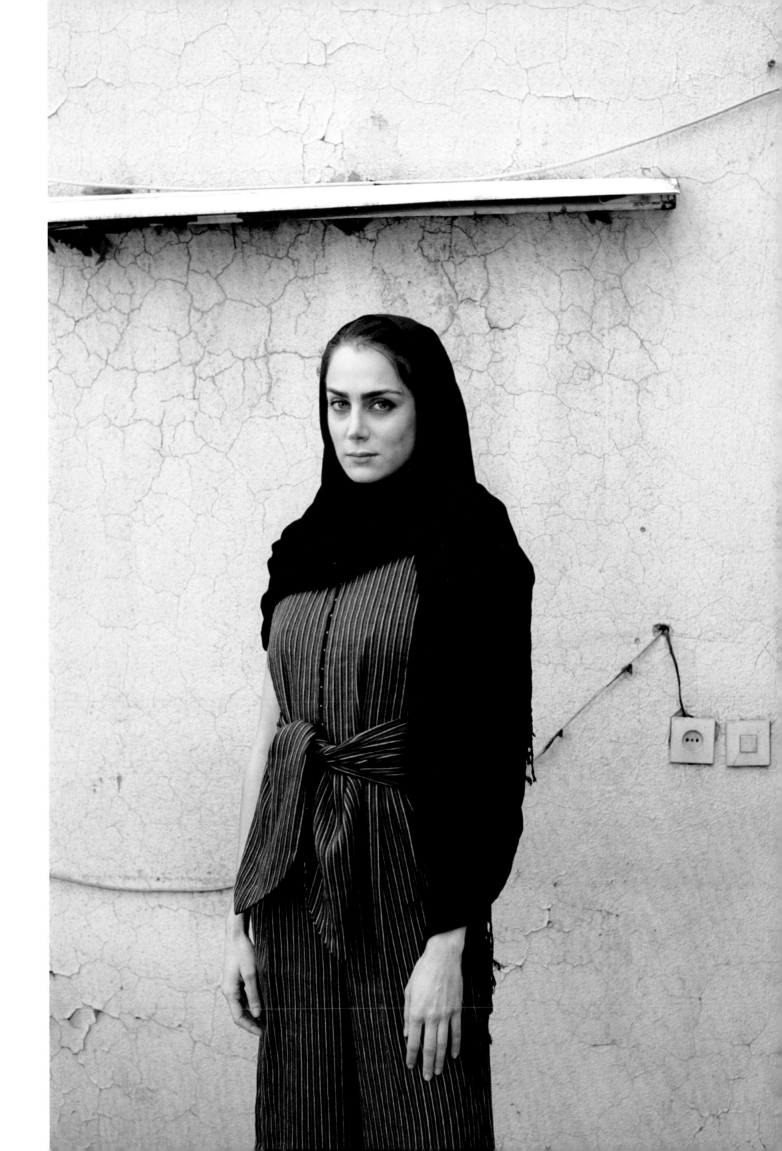

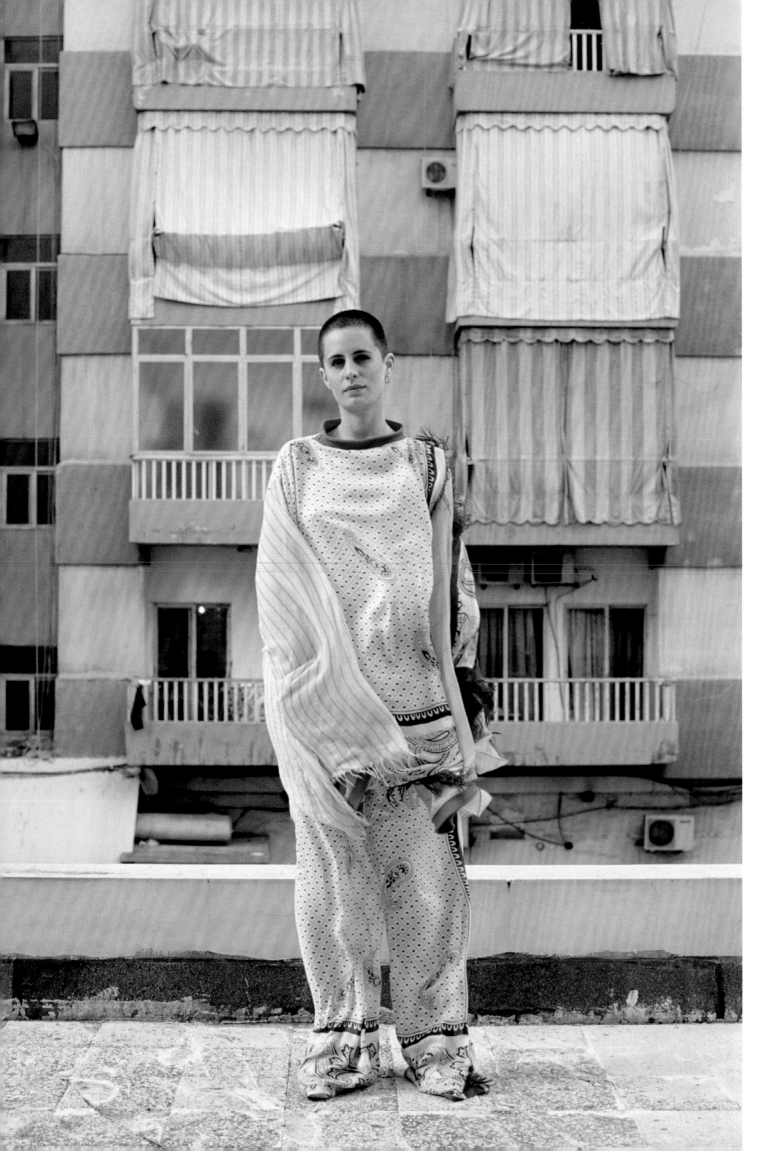

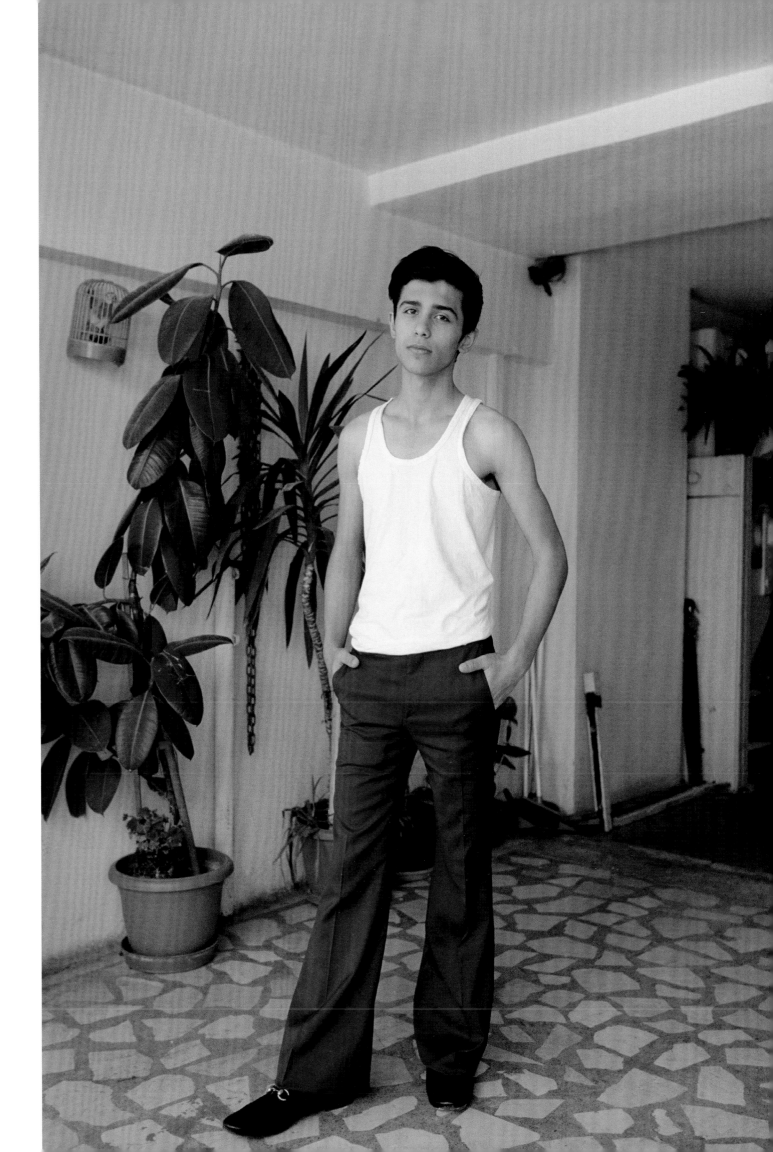

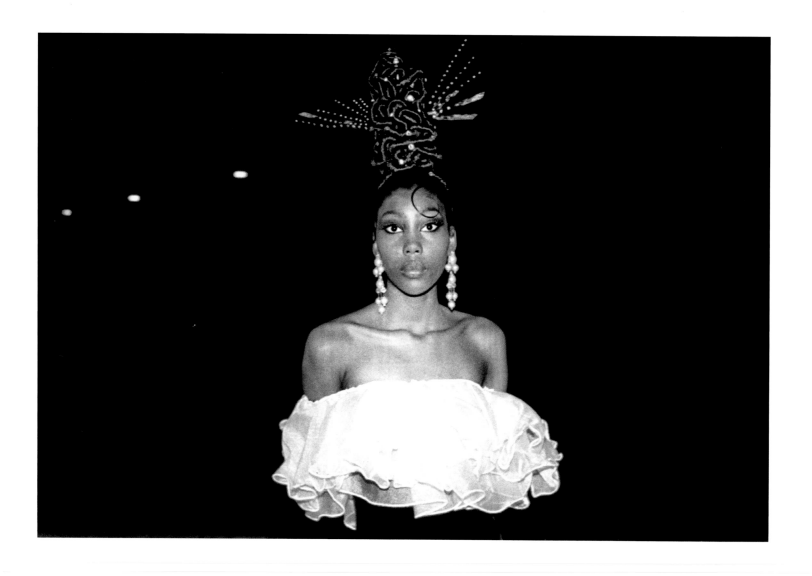

Bill Gaskins

Andrianna Campbell

India, Bronner Brothers International Beauty Show, Atlanta, Georgia, 1991

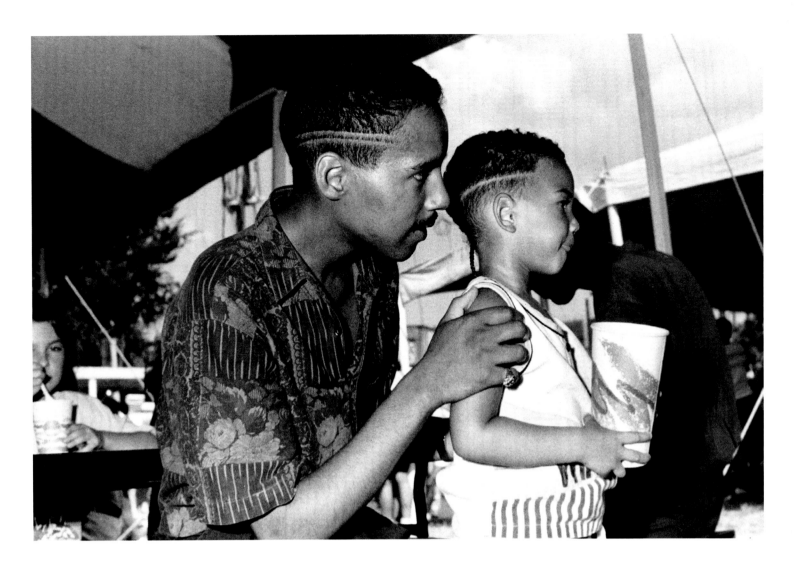

*Father and Son, Artscape
Festival, Baltimore,
Maryland, 1993*

Last spring in a black hair salon in downtown Brooklyn, the hairdresser kept asking me if she *really* should take off more. "It is so long," she lamented, "and there is all this good hair in the back." "Coolie hair," my grandfather would say, using the derogatory term to refer to his own Southeast Asian heritage. My recent haircut made me think of Bill Gaskins's groundbreaking series of photographs collected in the book *Good and Bad Hair* (1997). Hair is intrinsic to the way we define ourselves in African American communities and is so natural to speak about: in a conversation last fall, Lorna Simpson reminisced about the scandal of her mother getting an Afro in the late 1960s when she was supposed to be a good middle-class woman with a bob perm. "Good hair" and "bad hair" are terms deeply embedded in the fabric of the African diaspora and African American communities.

Bill Gaskins came to photography after reading *The Hidden Persuaders*, Vance Packard's 1957 nonfiction work on the psychology behind advertising. Gaskins remembers coming across the text as a high school student in 1970 and being struck, he recalled, by how Packard "proposed visual culture as a persuasive tool to change how people think, and the way photography could have an effect on the future. I was someone who was interested in affecting how people thought about black people. I mean blackness as an expansive and complex social, political, cultural state of being and condition that can be fixed, fluid, and at times contradictory. If photographs can affect the way people think, then I needed to be engaged in photography."

These thoughts about hair as a unique form of expression and communication began in 1990, and the following year, Gaskins got on a plane from Columbus, Ohio, bound for Atlanta, Georgia, to visit the Bronner Brothers International Beauty Show. Over the

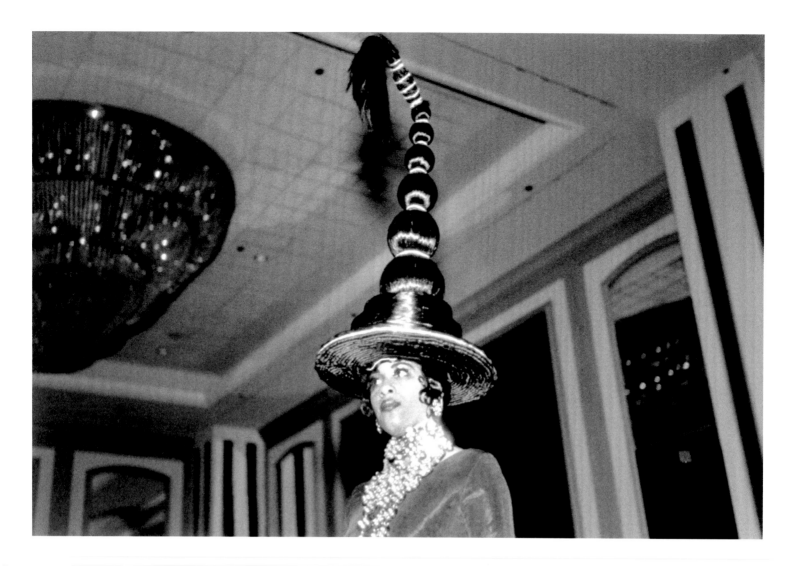

next six years, Gaskins visited eight other cities. Touring to these different places, he encountered a range of subjects and regional hairdos.

Tender and close moments, such as in *Father and Son, Artscape Festival, Baltimore, Maryland* (1993), are where we find Gaskins's relationship to his subjects. Some styles are striking, like the fierce frontal poses set off by the rounded towers of hair in *Tamara and Tireka, Easter Sunday, Baltimore, Maryland* (1995). Their clothes set up a contrast between the girls: Tamara in dark leather and Tireka in a lighter fabric. Yet, they look so similar: their eyes at equal level, their hair piled high in crisp dark crimps, their long, dangling earrings acting as counterweights. Gaskins's careful composition even exposes the particularities inherent in the industrial waterfront of Baltimore stretching across the back of the frame.

"Zora Neale Hurston was quoted as saying, 'All my skinfolk ain't kinfolk,'" Gaskins said. "I've experienced the perception of having the advantage—perhaps an unfair one in the view of some—of a so-called insider status as a black artist making portraits of black people through photography, as if the subjects of my portraits are all family members. This is an essentialist view of blackness that obscures the social, psychological, and sensory tools and skills required for me or any photographer to work in portraiture successfully."

Gaskins peered in from the margins, but it is where he aimed his camera that seems most telling. After all, one of the few popular books written by an African American woman in the nineteenth century is Eliza Potter's 1859 *A Hairdresser's Experience in High Life*, which documents her travels working as a hairdresser for white families during slavery. For Potter, as well as for Gaskins—who grew up over a century later—hair standards have been set according to the dominant culture, with African American hair culture documented at its peripheries; and yet, can we conceive of Bo Derek without her braids, or of the 1990s without the iconic box haircut?

Gaskins's photographs speak to traditions in various black communities going back over a hundred years: styles and hairdos that have only in recent decades become the focus of attention (think of the 1999 Chris Rock documentary *Good Hair*). His project extends beyond recuperation, or even the persuasive impulse that spurred its naissance. *Good and Bad Hair* reveals his ability to capture the range of these interpersonal images—from graceful to glamorous—which enables their ongoing resonance in our present time.

Andrianna Campbell is a scholar, independent curator, and a doctoral candidate in art history at the Graduate Center, CUNY.

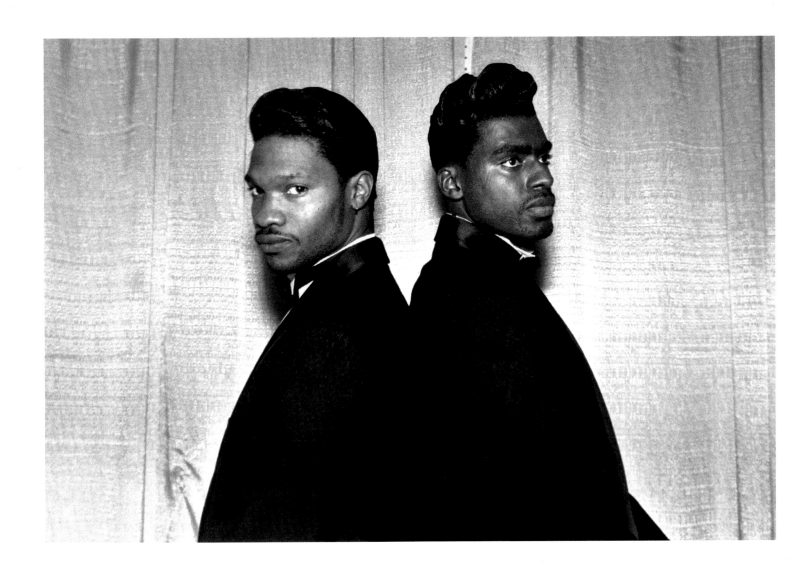

Opposite:
*Stylist's Model, Proud Lady
Beauty Show, Chicago,
Illinois*, 1994

This page:
*Kirk and Coke,
International Beauty Show,
New York*, 1994

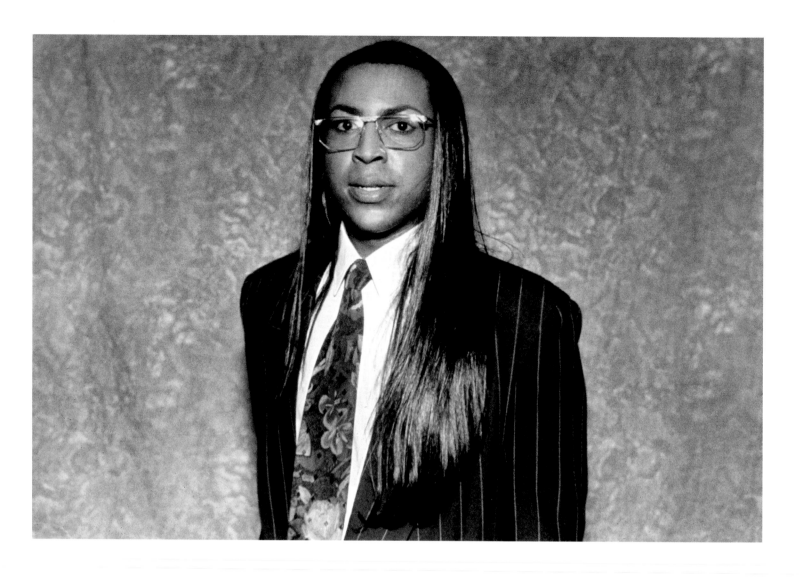

*Kenny, Proud Lady Beauty
Show, Chicago, Illinois,*
1994

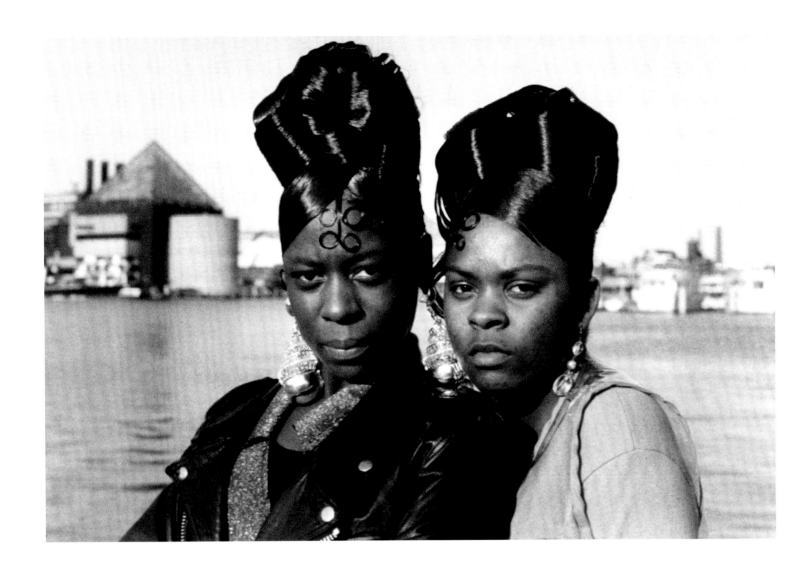

Tamara and Tireka,
Easter Sunday, Baltimore,
Maryland, **1995**
All photographs courtesy
the artist

"It will not be a style or fashion show; it will not display costumes; it will not offer specific dress reforms," reads the press release for Bernard Rudofsky's 1944 exhibition *Are Clothes Modern?* at the Museum of Modern Art (MoMA). "The purpose of the exhibition is to bring about an entirely new and fresh approach to the subject of clothes." That approach is perhaps the wishful thinking of every curator who has ever mounted a fashion exhibition—and yet by all accounts Rudofsky organized an incisive show and catalog that prompted the public of its day to reconsider their relationship with the clothes they wore, and the designers and systems that produced them.

More than seven decades later, MoMA's second foray into exhibiting fashion design, titled *Items: Is Fashion Modern?* (2017), returns to Rudofsky's inquiry by considering items—accessories, icons, objects of desire, and mass-produced staples—that have had a strong influence on the world in the past century. These include humble masterpieces like the clog, the keffiyeh, and Levi's 501 jeans; high-fashion ensembles from Pierre Cardin's 1964 Cosmos collection and from Comme des Garçons's 1997 Body Meets Dress–Dress Meets Body; and culturally specific items such as Breton shirts, door-knocker hoop earrings, Panama hats, and kente cloth wrappers.

In the catalog for *Items*, a new interpretation of all 111 exhibition "items" is entrusted to five young photographers— born between 1980 and 1992 and from Japan, the United States, Senegal, the United Kingdom, and South Africa—chosen for their strong, idiosyncratic talents and points of view: Omar Victor Diop, Bobby Doherty, Catherine Losing (in collaboration with stylist Anna Lomax), Monika Mogi, and Kristin-Lee Moolman (with longtime collaborator Ibrahim Kamara). Each photographer was given eight pages to fill with an equal portion of the items arranged in alphabetical order: Losing got *Air Force 1s* through *bucket hat*; Mogi, *burkini* through *fur coat*; Diop, *Gore-Tex jacket* through *monogram*; Doherty, *Moon Boot* through *Snugli*; and Moolman, *Space Age Cosmos collection* through *YSL Touche Éclat*. Given free rein in terms of approach, some chose to shoot the exact objects on the exhibition's list, while others took the items as prompts from which they abstracted. The results speak to five very different strategies of documentation that are as much still life as fashion photography, and mine the histories of advertising and graphic design as well as conventional modes of sartorial presentation.

Diop created a set of twenty-one playing cards silhouetting doppelgänger items against boldly colored backgrounds. Doherty shot a ripe watermelon nearly bursting a two-piece maternity outfit at its seams. Losing pictured, among other pieces on her list, balaclavas haunting a 1950s-era shopwindow. Over a series of eight photographs, Moolman and Kamara synthesized wholly new ensembles culled from a second-hand clothes market in Johannesburg's city center, each encapsulating several of the twenty-four items on their list. Mogi homed in on a *kawaii* teen decorating her Converse kicks, kitted out in capri pants and a Fitbit—checking off three items on her list in one shot. Each focused intervention plays against the denser heterogeneity of over four hundred images in the catalog that illustrate the alphabetic texts. Each photographer has used the 111 items as lenses through which to investigate form, color, gesture, environment, and more. The result embraces fashion photography and carries us beyond fashion into the realm of design and its many intersections with culture, technology, art, anthropology—in other words, with the world.

Is Fashion Modern?

Paola Antonelli and Michelle Millar Fisher

Paola Antonelli is Senior Curator,
Department of Architecture and Design,
and Michelle Millar Fisher is Curatorial
Assistant, Department of Architecture
and Design, at the Museum of Modern Art,
where *Items: Is Fashion Modern?* is on view
from October 1, 2017–January 28, 2018.

PIETER HUGO

Stephanie H. Tung

BEIJING YOUTH

Gong Yining, a design student at Beijing's Central Academy of Fine Arts, changes her style in the same way one might switch skins in a role-playing game. Wearing a blouse with a mandarin collar in brilliant red and matching red lipstick, she's adamant that it's all just appearances anyway. Chinese millennials of Gong's age have been shaped by the growth of market forces in China. Born in the 1980s and 1990s, at the beginning of communist leader Deng Xiaoping's "reform and opening up" program, they've seen the whole social structure of China change as the country lurched from a planned economy to a socialist market model.

"When I was still a child, the standard of success for a family patriarch was whether he dared to participate in the emergence of Chinese capitalism. The best children would continue their father's work," recalled Li Lei, a Beijing-based rocker and club owner, when I spoke with him last April. But Li and his peers, now in their thirties, have seen how the market affects their lives, for better or worse. "The country has put all the responsibilities of socialism into the market economy, and more and more young people can only depend on themselves to plan their lives, instead of the situation ten years ago, when you had to depend on bribing the government." The legacies of communism and consumerism strike an uneasy balance in rapidly changing China.

During a residency at Beijing's Rosewood Hotel from 2015 to 2016, South African photographer Pieter Hugo focused his camera on young Chinese people—ranging in age from Gong to Li's toddler—for his series *Flat Noodle Soup Talk* (2015–16). Hugo's title riffs on *piantang huar*, the colloquial Beijing phrase for sitting around and gossiping. Most of the young creatives who appear in the series have grown up comfortably middle class. They sport piercings and tattoos, and adorn themselves with makeup, dyed hair, and even plastic clothing of their own design, styles that would have been unimaginable to their parents' generation.

"Young people are very open-minded and independent," says Mu, a student who goes by a single name and is shown in a black button-down shirt and newly cropped bangs. "They decorate their own space. They dress in their own style. They invent their own jobs. They have their own sexual orientation." Accustomed to choice, they, like millennials the world over, self-consciously seek opportunities for individual expression, cultural discernment, and authenticity.

Hugo was drawn to the contrasts and juxtapositions that animate present-day China as seen through the eyes of this younger generation raised in a postrevolutionary society. Best known for his disquieting portraits of communities in South Africa, Nigeria, and Ghana, Hugo explored similar social themes in *1994*, his 2016 series that portrays children born after the Rwandan genocide and at the end of South African apartheid.

The future can be hazy for the young people of Beijing. Mu wonders how to make "new ideas still work when we have to participate in a social structure—I mean family and marriage—that is much older," whereas, Li, himself a new father, questions the increasing anxiety and pressure to succeed felt by many of their generation. Income inequality adds to the growing psychological divide between young workers hustling in metropolises like Beijing and Shanghai, and their counterparts in third-tier cities and rural villages, who are relegated to staid government, corporate, or agricultural jobs. Unmoored from traditional social structures and presented with a smorgasbord of cultural options, Beijing's creative class is free to find its own way.

Page 127:
Mu, Beijing, 2015–16

Opposite:
Lin, Beijing, 2015–16

Stephanie H. Tung is a PhD candidate focusing on modern and contemporary Chinese art at Princeton University. She is a contributing author to *The Chinese Photobook*, published by Aperture in 2015.

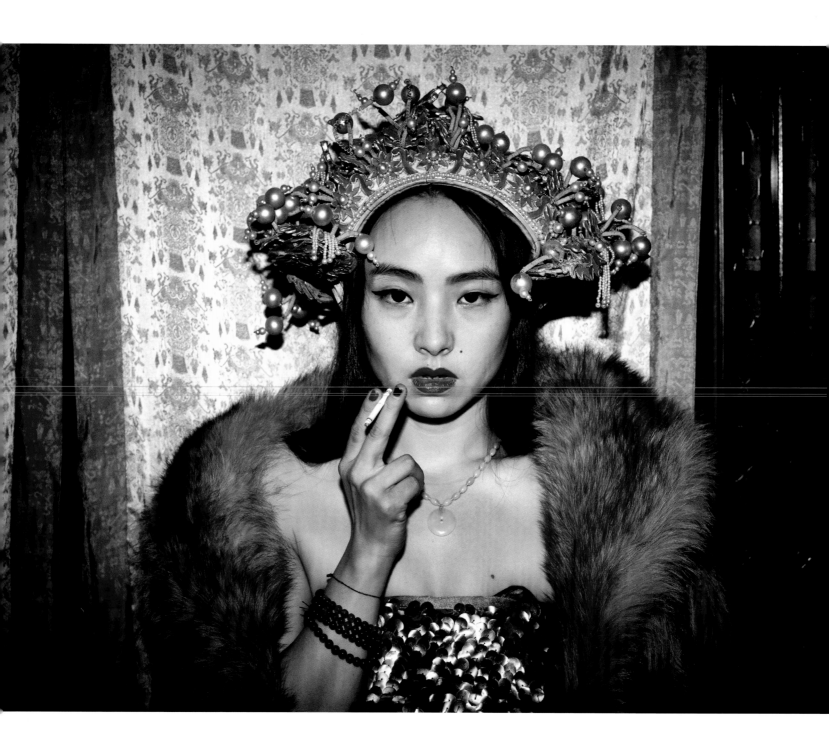

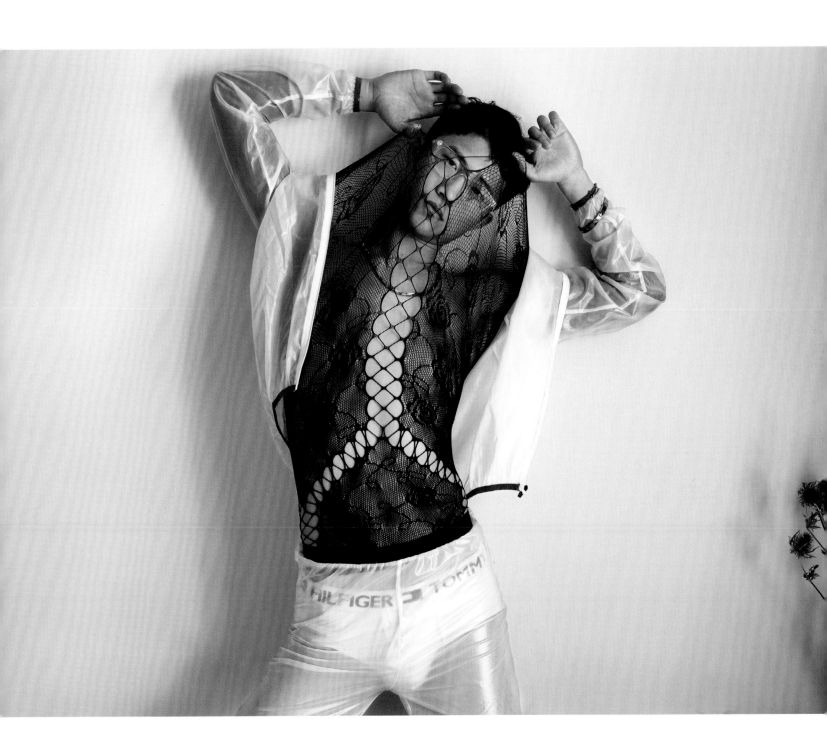

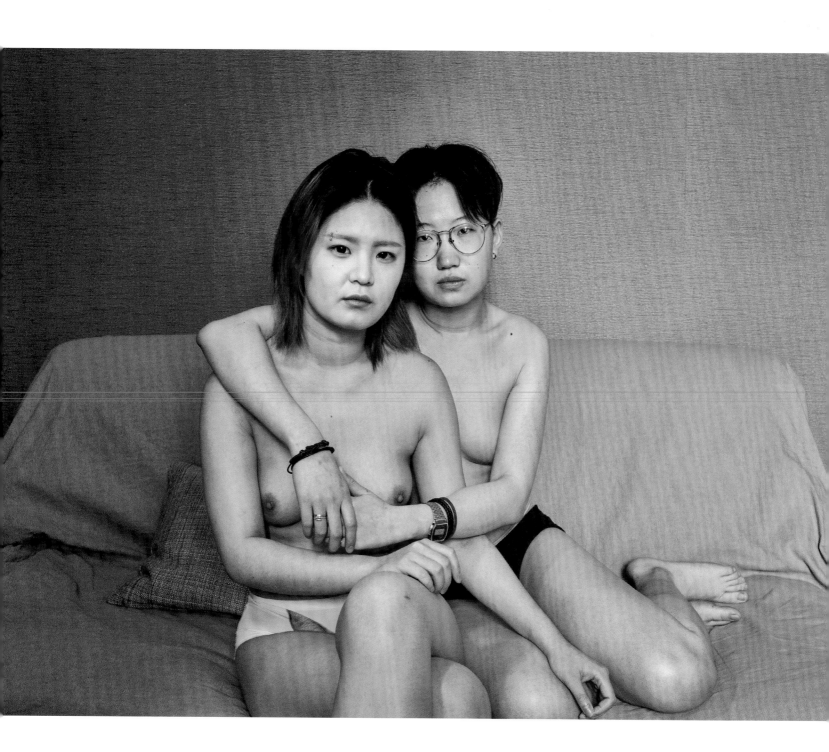

Tan Yunfei, Beijing,
2015–16

**All photographs from
the series** *Flat Noodle*
Soup Talk
Courtesy the artist;
Stevenson, Cape Town and
Johannesburg; Yossi Milo
Gallery, New York; and
Priska Pasquer, Cologne

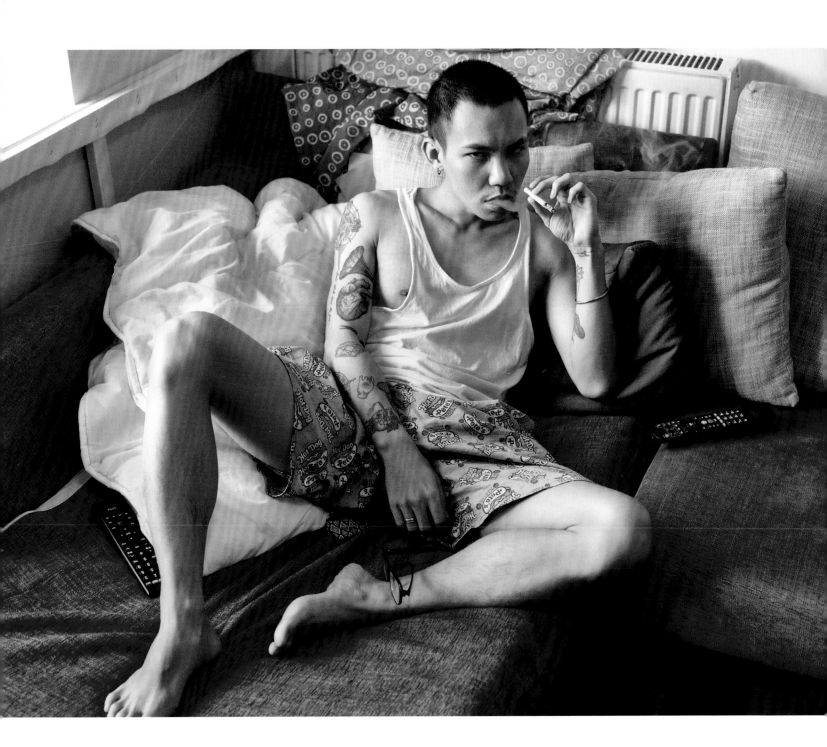

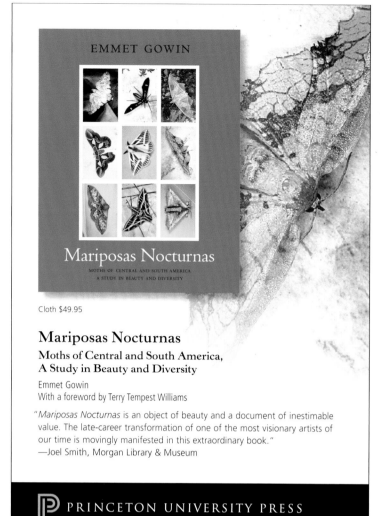

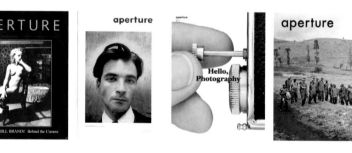

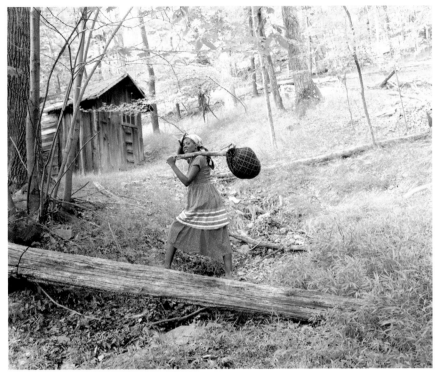

Aperture Beat

*Stories from the Aperture community—
publications, exhibitions, and events*

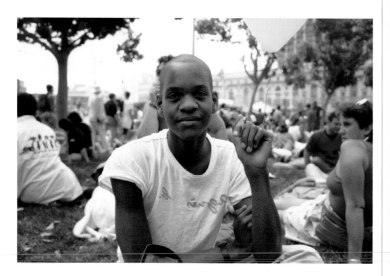

Lyle Ashton Harris

"This was at my first gay pride parade on the West Coast," Lyle Ashton Harris says, "my first time seeing Dykes on Bikes." A New York native, Harris had recently finished his first semester of graduate school at CalArts when this snapshot was taken. Harris's *Ektachrome Archive (New York Mix)* (2017), a multimedia installation presented in the 2017 Whitney Biennial, included cameos from counterculture stars of the 1980s and 1990s, such as John Greyson, a Canadian filmmaker, political activist, and CalArts professor. "I'm smoking either a Parliament or a Marlboro Light—often bummed and never bought. I was sporting my signature look of the time: bald head, white T-shirt, and blue overalls."

***Lyle Ashton Harris: Today I Shall
Judge Nothing That Occurs,
Selections from the Ektachrome Archive*
will be published by Aperture in
October 2017.**

Inspired by Vinyl

A new portrait of Elizabeth Kahane, by Doug and Mike Starn, the result of a commission bought at Aperture's 2016 benefit auction, was unveiled at an Aperture patron cocktail party hosted in May by the portrait's subject. Featuring a cut-up inkjet print applied to pieces of LP album covers and magnets, so that each element may be reversed to reveal its music-reference B side, the piece belongs within the artists' new portrait series. "The pictures of people are alive and they change—like our work *Big Bambú*," say the Starns. "When we were thirteen years old, our lives were saved by rock 'n' roll, from the Sex Pistols to the Stones. Album covers were visual embodiments you could hold and love. Music is the lens through which we see the world."

**Elements of Style, Aperture's 2017 gala and auction, will take place
on October 30, 2017, at the IAC building, New York.**

Lyle Ashton Harris, *Lyle, Gay Pride Parade, San Francisco,*
1989
© the artist

Doug and Mike Starn, *Elizabeth*, 2017, from the series *Portraits*
Courtesy the artists

Future Gender

Zackary Drucker has long been fascinated by pioneers. In 2014, together with the writer Diana Tourjee, she helped to establish the Flawless Sabrina Archive, a nonprofit organization that supports the collections of Flawless Sabrina, the trailblazing performer and creator of the 1968 documentary *The Queen*. As the guest editor of *Aperture*'s winter issue, "Future Gender," Drucker, the artist, activist, and producer of the acclaimed Amazon series *Transparent*, is looking to past images and icons of trans identity as a way of redefining the future. "We will be unearthing archives, rediscovering forgotten gems, navigating the masters, and seeing what lies ahead on the horizon of gender expression," she says. "As both subjects and image makers, trans and gender-nonconforming people have a unique relationship to photography as a means to imagine themselves outside the confines of their physical reality."

***Aperture* Issue 229, "Future Gender," will be available December 2017.**

Zackary Drucker, *Untitled*, from the series *5 East 73rd Street*, 2005
Courtesy the artist

Deutsche Börse Prize

In May, Dutch photographer Dana Lixenberg won the 2017 Deutsche Börse Photography Foundation Prize for her long-term work *Imperial Courts*, a collaborative study of a Los Angeles housing project made between 1993 and 2015. Lixenberg patiently traced the complex arc of life in Imperial Courts; subjects pictured as children reappear as adults who are now parents themselves. "The playground next to the parking lot at 115th Street and Croesus Avenue, the spot of my first introduction to Imperial Courts, is where I made this portrait of China, who went missing in 2009," Lixenberg says. "Over the years, I would connect with her whenever I rolled into the Courts, and she was much loved in the neighborhood. She was funny and incredibly charismatic." Lixenberg's photographs are presented in a traveling exhibition, together with short-listed nominees Sophie Calle, Awoiska van der Molen, and Taiyo Onorato and Nico Krebs.

***Deutsche Börse Photography Foundation Prize 2017* will be on view at the Aperture Gallery from November 15, 2017–January 11, 2018.**

Dana Lixenberg, *China*, 1993
Courtesy the artist and Grimm, Amsterdam

Object Lessons
Richard Avedon's Datebook, 1969

"The first part of the day is free because Allen Ginsberg has postponed," James Martin said, looking through Richard Avedon's datebook for a "typical Richard Avedon schedule." Martin, the executive director of the Richard Avedon Foundation, was referring to August 14, 1969. With the morning open, Avedon met with Doon Arbus, the daughter of Diane Arbus, to discuss a project that grappled with portraiture at a time when the world was in revolt. That summer, the photographer aimed to reinvent his technical style, stripping away everything but the subject and the background. An intense, singular focus on his sitter and a plain white seamless backdrop would become Avedon's signature in some of the twentieth century's most memorable portraits. But in the summer of 1969 that signature was only two weeks old.

On the afternoon of August 14, Andy Warhol and the self-styled members of the Factory showed up at Avedon's studio for an attempt at a group portrait. Ultimately, Avedon rejected the images: they did not achieve the formal intensity of his individual portraits. He was still experimenting with this new style. (Avedon would photograph the Factory members four more times before making the final version two months later, *Andy Warhol and Members of the Factory, October 30, 1969*. Printed larger than life across three enormous sheets of photographic paper, it would become an American icon.) In the evening, Avedon photographed models Cynthia Korman and Ulla Bomser for a Lurex ad campaign; advertising was crucial in funding his serious work.

Avedon's datebooks evidence an indefatigable work ethic. The following August morning was penciled in for civil rights lawyer Henry Aronson, who represented the Student Nonviolent Coordinating Committee, the NAACP, and Martin Luther King, Jr. Later that morning, Avedon photographed feminist and African American activist worker Dorothy Pitman Hughes, a cofounder of *Ms.* magazine. At four o'clock, he made an advertisement for Clairol with Maud Adams. All before taking the 9:45 p.m. train to Montauk—where he was scheduled to shoot Willem de Kooning, Edward Albee, Saul Steinberg, and a Kleenex television commercial in the following days. —**The Editors**